# AN ILLUSTRATED GUIDE *to*

# 50

# MASTERPIECES

*of*

# CHINESE PAINTINGS

By Huang Kunfeng

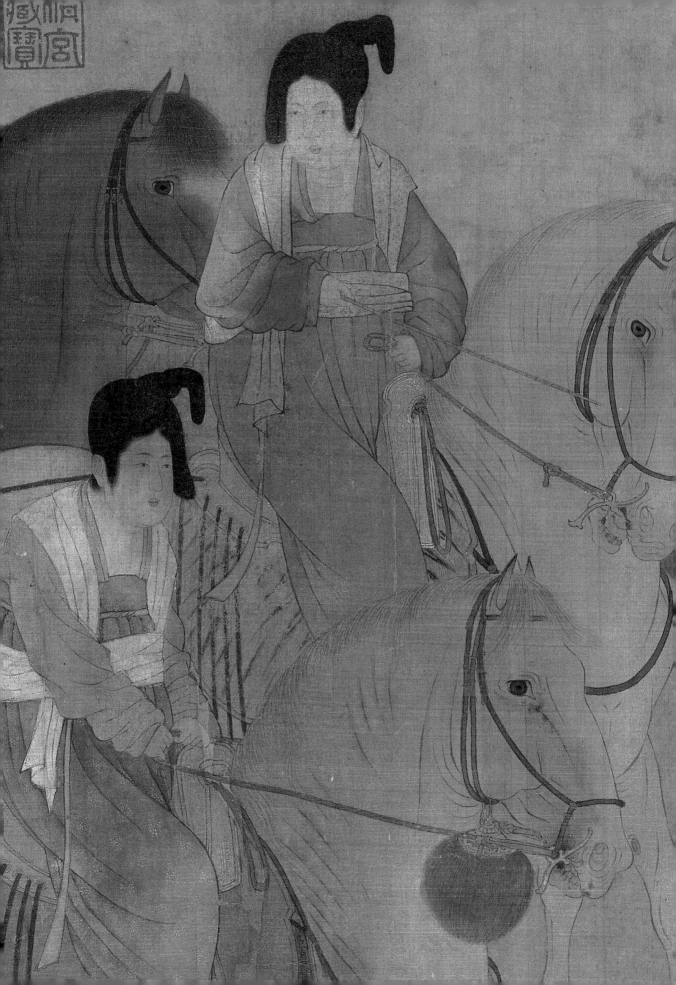

# AN ILLUSTRATED GUIDE TO *50* MASTERPIECES OF CHINESE PAINTINGS

By Huang Kunfeng

Translated by Shelly Bryant

Better Link Press

Copyright © 2019 Shanghai Press and Publishing Development Co., Ltd.

This book is edited and designed by the Editorial Committee of *Cultural China* series.

Text by Huang Kunfeng
Translation by Shelly Bryant
Cover Design by Wang Wei
Interior Design by Li Jing and Hu Bin (Yuan Yinchang Design Studio)

Editor: Wu Yuezhou
Editorial Director: Zhang Yicong

Senior Consultants: Sun Yong, Wu Ying, Yang Xinci
Managing Director and Publisher: Wang Youbu

ISBN: 978-1-60220-161-3

Address any comments about *An Illustrated Guide to 50 Masterpieces of Chinese Paintings* to:

Better Link Press
99 Park Ave
New York, NY 10016
USA

or

Shanghai Press and Publishing Development Co., Ltd.
F 7 Donghu Road, Shanghai, China (200031)
Email: comments_betterlinkpress@hotmail.com

Printed in China by Shenzhen Donnelley Printing Co., Ltd.

1    3    5    7    9    10    8    6    4    2

On page 1
***Autumn Colors among Rivers and Mountains*** (detail, see page 102)

On page 2
**Copy of *The Painting of Lady of Guo State on a Spring Outing* (Song Dynasty)** (detail, see page 84)

On page 3, above
***Sketch of Rare Birds*** (detail, see page 38)

On page 3, below
***Flower Album*** (detail, see page 136)

Above
***Gathering at the Orchid Pavilion*** (detail, see page 120)

# CONTENTS

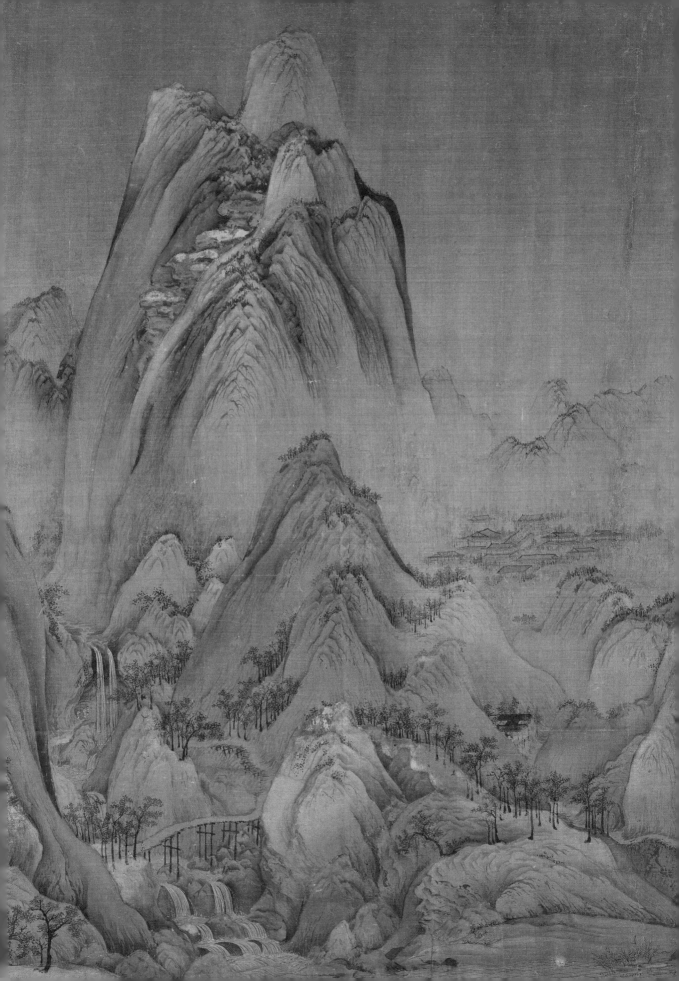

# CONTENTS

***A Vast Land*** (detail, see page 92)

# COPY OF *THE ADMONITIONS SCROLL* (TANG DYNASTY, 618–907)

Attributed to Gu Kaizhi (348–409)
Ink and color on silk
Height 25.5 cm × Width 377.9 cm
The British Museum, London

Throughout the history of Chinese painting, figure paintings, landscapes, and bird-and-flower paintings did not develop simultaneously. The earliest independent subjects were figure paintings, with landscapes and bird-and-flower paintings first appearing as attachments to figure paintings. Figure paintings mainly served an educational function, being used to fill in the gaps in literary texts in a way that allowed the viewer to intuitively understand and accept various moral and ethical norms. Gu Kaizhi's *The Admonitions Scroll* was produced in this milieu.

There are two copies of *The Admonitions Scroll*. One is ink and color on silk, and is part of the British Museum Collection, while the other, a *baimiao* line drawing, is part of the collection at the Palace Museum in Beijing.

The academic community generally holds that the scroll held by the British Museum is more refined, while the one at the Palace Museum is more complete.

## Based on Literary Texts

*The Admonitions Scroll* was produced in the period of the Emperor Huidi (290–307) of Jin dynasty (265–420). In 290, Sima Yan's (236–290, reigned 265–290) son Sima Zhong (259–307) was crowned and named the Emperor Huidi. He was known to suffer from a mental defect and was incompetent, and the rule of Taikang established by his father was on the verge of collapse. The Queen Jia Nanfeng (257–300) was ambitious, leading her to usurp power and disrupt political

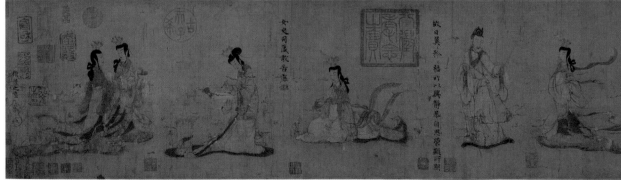

affairs. Although she was violent in nature, she was very dependent on Prime Minister Zhang Hua (232–300) and entrusted him with great responsibility. Zhang was obsessed with feudal moral education, and was also loyal to the Sima family. When he saw the incompetence of Emperor Huidi and the ambition of Jia Nanfeng, he was determined to address the situation. Zhang Hua collected numerous stories of the obedience and good deeds of virtuous women, and he wrote *The Admonitions Scroll* and had it widely circulated during that time. "Admonitions" were a popular style in ancient times, used for persuasion and instruction. The reference to a "female history" in the original title (*nüshi* in Chinese) points to the court ladies in the Qin (221–206 BC) and Han (206 BC–AD 220) dynasties and their expansive refinement, etiquette, and rules of court. Zhang Hua borrowed from the hands of historical female figures to represent to Jia Nanfeng how she might correct her behavior and character.

Later, Gu Kaizhi used this text as the

**Gu Kaizhi**, a native of modern day Wuxi, Jiangsu Province, was born to a scholarly family. Though things did not go smoothly for his political career, he became renowned for his paintings. He also developed a very creative painting theory, which he recorded in numerous writings, including his three most important works *On Painting (Lun Hua)*, *Painting Yuntaishan (Hua Yuntaishan Ji)*, and *In Praise of Prestigious Scholars' Paintings in the Wei and Jin Dynasties (Wei Jin Shengliu Huazan)*. These three essays are the earliest extant texts on painting theories, and from them, we can gain insight into Gu's experience with painting, approaches to creation and composition, and principles and techniques of painting.

source material for painting his masterpiece, illuminating the meaning of the text in images, putting a paragraph from the original text beside each image as a warning. Though the painting is of a didactic nature, the successful creation of the images of various courtly women reflects, to a certain degree, scenes from the lives of women in the artist's time.

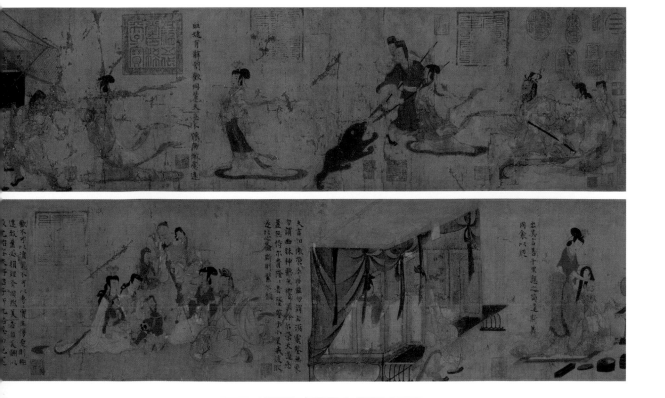

Copy of *The Admonitions Scroll* (Tang Dynasty)   9

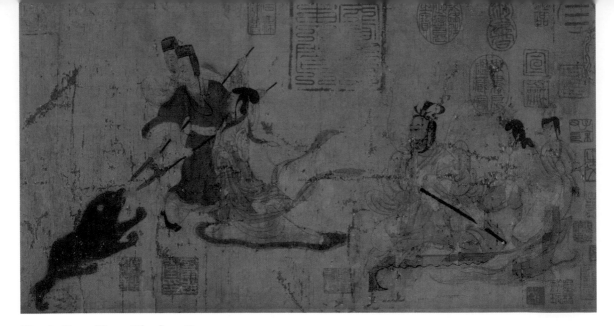

## Fig. 1  Feng Yuan Blocks a Bear

This portion of the scroll depicts the Emperor Yuandi (74–33 BC, reigned 49–33 BC) of Han dynasty in the palace watching the wild beasts, but a black bear has escaped and climbed the pillars of the imperial palace. To the left and right of the emperor, the high officials and nobles have fled, with only his favorite lady, Feng Yuan, rushing forward to stop the bear from attacking the emperor. After the guards kill the bear, the emperor asks her why she stood alone to block the bear. She replies, "If the beast kills me, it will not attack the throne." Her action touched the emperor.

## Fig. 2  Ms. Ban's Refusal of a Ride

This painting is of the Emperor Chengdi of Han dynasty (51–7 BC, reigned 33–7 BC). When he strolled in the rear court, he wanted his concubine, Ms. Ban to sit with him in the cart, but she refused, saying, "Looking at the ancient paintings, it is only the famous officials who accompanied the emperors, and in the Xia (2070–1600 BC), Shang (1600–1046 BC), and Zhou (1046–256 BC) dynasties, only the fatuous and self-indulgent emperors of the last generation were accompanied by their favored concubines. If I accompany you, won't you be the same as the unworthy last generation of emperors of those three dynasties?" The painting depicts the emperor's disappointment at the concubine's rejection of his invitation.

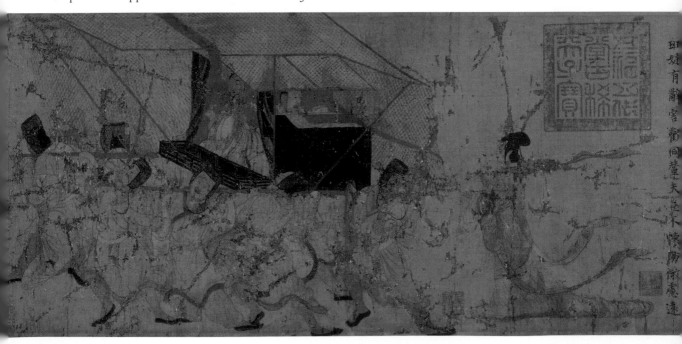

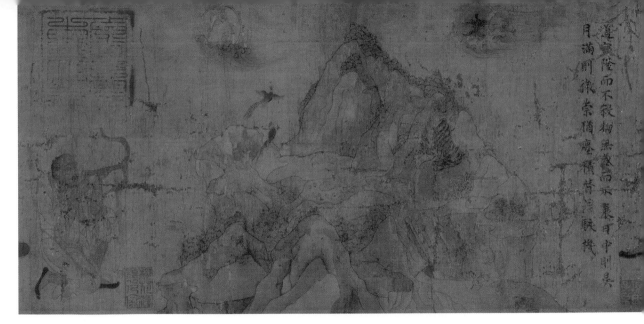

## Lines as Fine as a Silkworm's Thread

We see in the painting that Gu's lines are as fine as a silkworm's thread, but that they are also sleek and powerful, and that they accurately represent the facial expressions and clothing of the characters. In particular, the long skirt and flowing belt on the ground in the image create even more movement.

### Fig. 3   Prosperity and Decline

The sun is painted to the right of the mountains, represented by a three-footed bird, while the moon is on the left of the mountain, represented by a toad. There is a tiger on the mountain, and in the lower left corner, a man practices archery. The message that is conveyed here is that nothing stays at its peak all the time. When the sun reaches midday, it will begin its gradual decline. When the moon is full, it begins to wane. The accumulation of virtue will be as slow as accumulating dust, but once it collapses, its decline will be sudden and much more rapid than its rise, like the arrow leaving the bow.

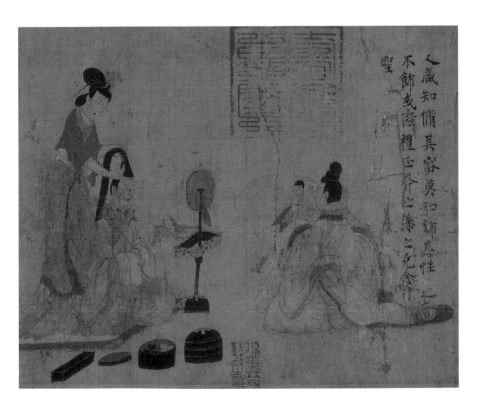

### Fig. 4   Modifying One's Appearance and Cultivating One's Character

The painting depicts three people. Two of them face the mirror and the other is combing the hair of one of them. What the scene is displaying is people who modify their appearance, but pay no attention to self-cultivation. If one does not cultivate his character, he will descend into crudeness. By honing oneself, the character will be perfected.

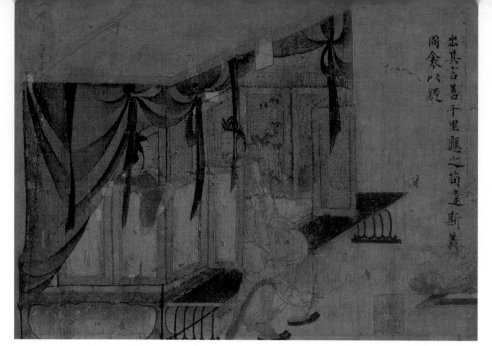

**Fig. 5  Gentle Speech**

This image shows a couple lying on a bed, talking. It depicts the relationship between speech and honor. Kind words will travel to one who is a thousand miles away, and unkind words will cause distrust even between husband and wife. Although words are small, they are intertwined with honor and dishonor. One should not imagine that there is any dark, secret place that is not known by others. Even when the gods are silent, they see the manners of humans. One should never boast, for the gods are most disgusted with arrogant people. One must never value himself too highly, or he will soon face a downfall.

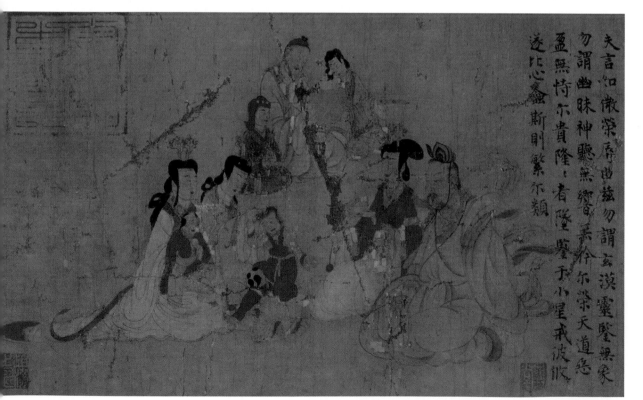

**Fig. 6  The Prosperity of Children**

This painting depicts two men and their wives, children, and grandchildren. The painting points to the hope that if there will be no jealousy among the wives, the children and grandchildren will prosper.

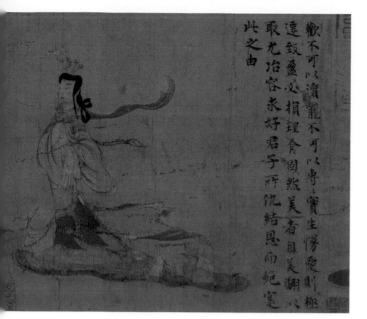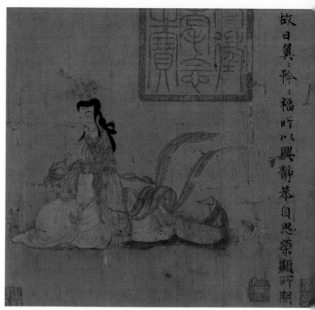

## Fig. 7 Moderate Joy

The painting depicts a man and a woman who discuss the secret for how men and women can get along. If one indulges the other too much, the other might take it for granted. If one shows too much affection, their love is too likely to change. If a nice-looking woman boasts about her beauty and behaves frivolously, she may have to lie on the bed she herself makes. Deliberately putting on airs to seek favor is detestable to a gentleman.

## Fig. 8 Being Reserved and Cautious

The woman in the painting sits properly and in a good manner. The artist intends to warn people to be cautious, and great blessings will arise as a result. If one is humble and introspective, success and prosperity will naturally follow.

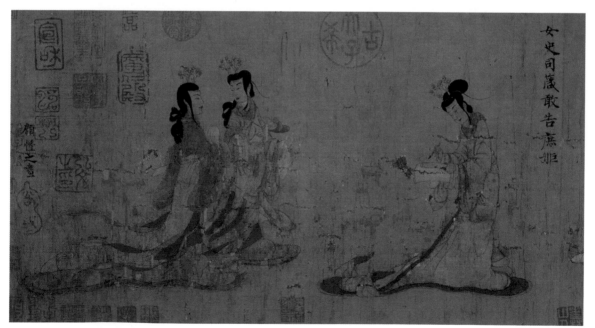

## Fig. 9 Female Official Recording the Admonitions

The final image in the scroll depicts three women, one of whom is holding a brush and making a record, which should be the female official recording the admonitions. Their hair is arranged on the top of the head, with one strand left dangling. They wear a *buyao* on the head, a decorative piece with a flower that can be moved with each step. When they walk, the flower moves with each step. All of the women in *The Admonitions Scroll* are dressesd in this way.

# STROLL ABOUT IN SPRING

Zhan Ziqian (c. 550–604)
Ink and color on silk
Height 43 cm × Width 80.5 cm
Palace Museum, Beijing

*S*troll About in Spring is extremely important in the history of Chinese painting, primarily because it was a pioneering work in the early development of landscape painting. Its panoramic composition and true, complete spatial processing method demonstrate that landscape paintings of this period had been freed from the confines of their early development and already possessed the characteristics of mature landscape painting. It is also the earliest known example

**Zhan Ziqian**, a native of today's Cangzhou, Hebei Province, witnessed the Northern Qi (550–577), Northern Zhou (557–581), and Sui (581–618) dynasties, and served in the Sui court. During the Sui dynasty, he became renowned for his paintings of horses, pavilions, and landscapes. Because of the extreme antiquity of his work, most of his paintings have been lost. *Stroll About in Spring* is the only extant piece today.

## Fig. 1  Techniques for Painting Stone

The stone contours are depicted with delicate lines, and the edges are dyed with colors. This is an example of the outlining-with-no-texture-stroke method of painting, which is characteristic of early landscape painting. Later landscape painting saw the development of numerous methods of texture strokes to depict the mountains and stones.

of the blue and green landscape style (mainly using azurite blue and mineral green), and is for this reason known as "the forefather of Tang painting," since its style became known through the works of Tang dynasty masters Li Sixun (651–716 or 718) and his son Li Zhaodao (dates unknown). The form known as gold-and-green landscape painting (named for the three colors used in it, golden paint made of glue and powdered gold, azurite blue, and mineral green) inherited its style from this work.

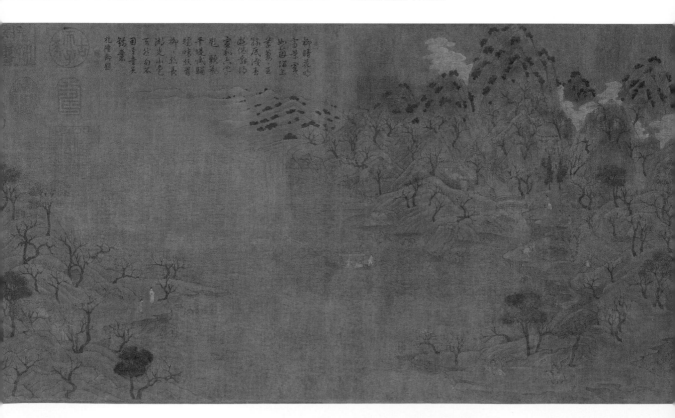

## Fig. 2  Techniques for Painting Trees

According to the records of the renowned Tang dynasty painter Zhang Yanyuan (815–907), *A History of Famous Paintings* (*Lidai Minghua Ji*), the trees and stones in the landscape paintings of the Six dynasties period (222–589) look like "they are tailor made," meaning they had rigid forms. The trees in *Stroll About in Spring* lack changes in posture, but the spatial dimensions can be distinguished, and are somewhat interspersed.

## Fig. 3  Garments

The hats worn by the two figures in the painting are strapped behind the head. This sort of dressing appeared in the late Tang dynasty, leading some experts to question the date of composition and the painter of this painting.

## Spring Tour

*Stroll About in Spring* depicts a spring tour in ancient times. There is a small path at the lower right end of the scroll, which follows the mountain's turns. Several figures walk along it. The banks are covered with greenery, and there are flowers and trees scattered along them. A small bridge spans the space between two hills, and the pontoon on the water blends into its surroundings. In the lower left corner is a mountain village surrounded by flowers and trees in which all sorts of wild flowers grow, displaying brilliant pink and green hues in perfect harmony.

## Landscape as Focal Point

The layout of the entire painting is dominated by natural scenery, with characters, a Buddhist temple, and a smattering of vessels on the water, eschewing the traditional approach by which "people are made bigger than mountains and the water does not sparkle." In the use of both brushwork and color, this painting is an early reflection of the blue and green landscapes of mountains and trees, with only outlines and color rendering but no shading, especially for the pine trees, which rely on only a bit of ochre rather than a detailed depiction to suggest the rough pine tree bark.

The cliff face in the painting is heavily painted with golden paint, while the pavilions, people and horses, and boats are painted in red, white, and ochre, and the rocks and trees are painted in blue and green. For the small forests on the slopes, their branches are painted with ochre, and the leaves in indigo with a wet brush held almost horizontally. The buds on the branches are touched with light color, rendering a variety of colors.

## Fig. 4  Techniques for Painting Figures

There is no focus on details in the figures in this painting. They are formed of dots of white powder, with a bit of color added to suggest the garments.

## Fig. 5  Temple

There is a temple in the top right corner of the scroll. Its columns are painted with cinnabar. Four tall pines serve as a gate, sheltering the temple from the outside world.

# EMPEROR TAIZONG RECEIVING THE TIBETAN ENVOY

Yan Liben (c. 601–673)
Ink and color on silk
Height 38.5 cm × Width 129 cm
Palace Museum, Beijing

*Emperor Taizong Receiving the Tibetan Envoy* is a figure painting and an important documentary record depicting a major event that occurred during the Tang dynasty.

## Proposing Marriage

The original Chinese title of this painting makes reference to one of the transport tools for a long journey in ancient China. This painting depicts the minister of the Tibetan King Songzan Ganbu (617–650, reigned 629–650), Lu Dongzan, who was sent as an envoy to propose a marriage at the court of the Tang Emperor Taizong (589–649, reigned 626–649). Emperor Taizong was an enlightened emperor, and many of his outstanding achievements are recorded in Chinese history.

After he took office, he adopted many open, inclusive national policies, one of which included the marriage of one of his own daughters to the leader of a minority clan as a means of achieving national harmony. The meeting recorded in this painting resulted in the Princess Wencheng (625–680) bringing a great deal of both knowledge and material resources to Tibet, which promoted the development of Tibet.

**Yan Liben**, a native of modern-day Xi'an, Shaanxi Province, was a high-ranking official in the Tang dynasty. However, because his painting skills were exceptional, he was often called upon to paint for the emperor. He is known for his realistic style, and the subject matters of most of his works are political and historical events from his own time.

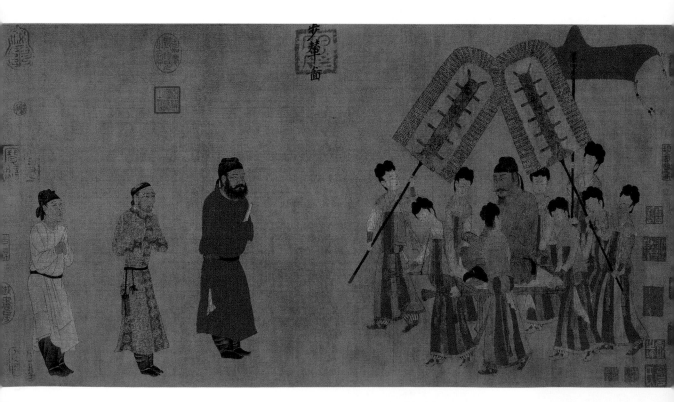

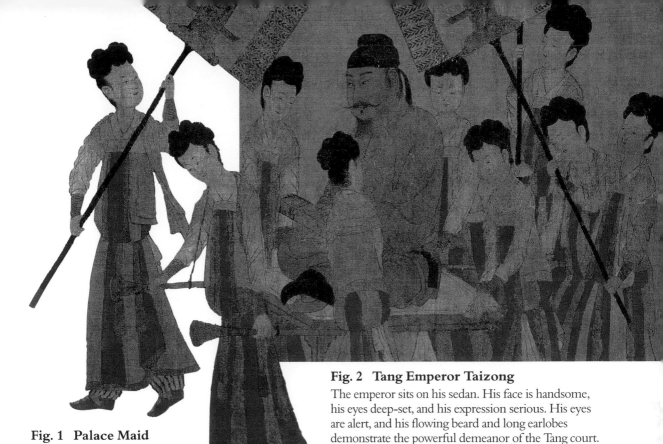

**Fig. 1  Palace Maid**

The palace maid wears a long skirt in red and green, similar to the modern day tube dress. The outer skirt is a shawl made of thin gauze, and the cuffs are wrapped with jewelry around the wrists. As is evident from the ankles, the skirt is accompanied by long striped pants.

## Figures in the Painting

In this painting, a bearded man in yellow and brown clothing and hat sits with several maids fanning him with huge feathered fans. This is obviously Emperor Taizong. He has a serious, kingly demeanor. Proportionally, he is also drawn obviously larger than the other figures, which likewise demonstrates his status as emperor.

At the left end of the scroll, three men deferentially face the emperor. The central figure is dressed differently from the others, wearing a floral gown and boots. This dressing suggests that he is Lu Dongzan. The figures to his left and right are dressed in a style similar to the emperor's and the long white boards they hold indicate that they are meeting the Tang emperor. These

**Fig. 2  Tang Emperor Taizong**

The emperor sits on his sedan. His face is handsome, his eyes deep-set, and his expression serious. His eyes are alert, and his flowing beard and long earlobes demonstrate the powerful demeanor of the Tang court.

are most likely the translator (in white) and the special secretary and protocol officer (in red). In contrast to the calm expression of the emperor, the faces of the three people on the left appear very tense. Lu Dongzan wrinkles his brow, and the translator's lips are closed, perhaps suggesting that the political games are about to begin.

**Fig. 3  Lu Dongzan**

The dressing of Lu Dongzan is different from that of the Han Chinese people in the painting, but is also unlike ancient Tibetan garments. In particular, the "*chenglu* purse" (meaning "showered with the grace of the emperor") was worn as a sign of his respect for the emperor.

# THIRTEEN EMPERORS SCROLL

Yan Liben
Ink and color on silk
Height 51 cm × Width 531 cm
Museum of Fine Arts, Boston

The *Thirteen Emperors Scroll* includes portraits of emperors dating from the Han through the Sui dynasties. From the perspective of the paintings' compositions, the pieces are somewhat stylized, but the figures depicted reflect a great deal of progress when compared to those from the Wei (220–265) and Jin periods, and the hierarchy of the figures in the feudal period is presented in their different sizes.

Yan Liben was a painter in the court of the Tang Emperor Taizong. His paintings were mostly completed under the emperor's direction. Emperor Taizong was interested in the lessons that could be learned from past periods of chaos and from the models provided by various emperors. He hoped to inspire and persuade viewers through the appearance of these model figures, and also urge himself toward greater excellence. Because Yan Liben

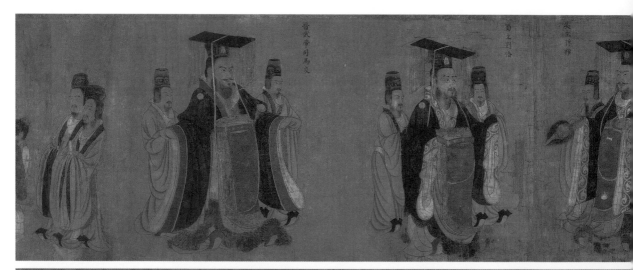

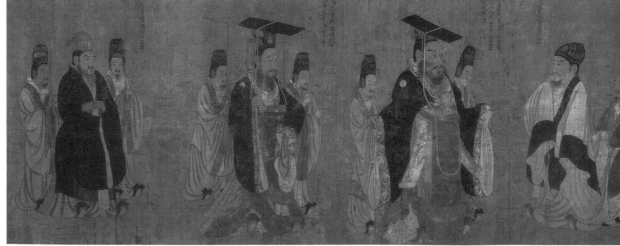

was Taizong's most trusted painter, he was commissioned to execute this plan.

## The Thirteen Emperors

The emperors depicted in the painting are (from right to left): Emperor Zhaodi of Han (94–74 BC, reigned 87–74 BC), Emperor Guangwu of Han (5 BC–AD 57, reigned 25–57), Emperor Wendi of Wei, Cao Pi (187–226, reigned 220–226), the King of Wu, Sun Quan (182–252, reigned 229–252), the King of Shu, Liu Bei (161–223, reigned 221–223), Emperor Wudi of Jin, Sima Yan (236–290, reigned 265–290), Emperor Xuandi of Chen, Chen Xu (530–582, reigned 569–582), Emperor Wendi of Chen, Chen Qian (520 or 522–566, reigned 559–566), the deposed Emperor Chenfeidi, Chen Bozong (554–570, reigned 556–568), the last Emperor of Chen, Chen Shubao (553–604, reigned 582–589), Emperor Wudi of Northern Zhou, Yuwen Yong (543–578, reigned 560–578), Emperor Wendi of Sui, Yang Jian (541–604, reigned 581–604), and Emperor Yangdi of Sui, Yang Guang (569–618, reigned 604–618). Each of the emperors is surrounded by his officials, which puts the total number of figures depicted in the scroll at 46. Each emperor and his attendants form an independent unit in the scroll, with the emperor's name written alongside it. Some of the entries also include the dates of his reign and his achievements.

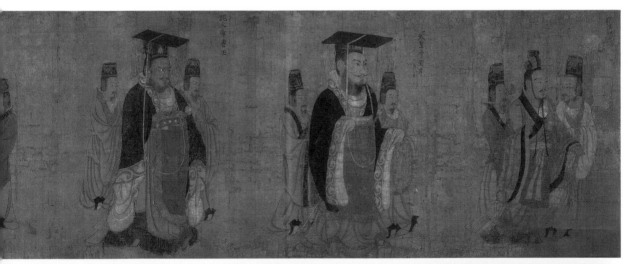

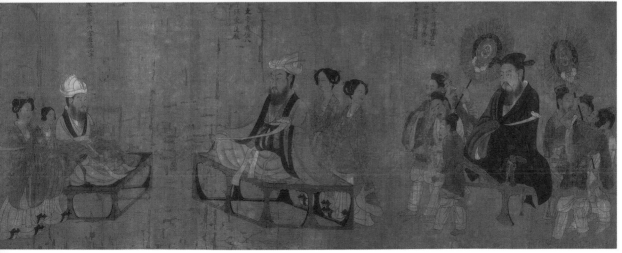

## Fig. 1  Emperor Wudi of Jin's Crown and Garments

Of the first seven emperors, only Emperor Zhaodi of Han wears a mountain-shaped crown, while all the others wear ordinary crowns. The patterns embroidered on his garment is called the "twelve ornaments," including the sun, the moon, the stars, mountains, etc. It often appeared on the garments of ancient Chinese emperors and officials.

## Fig. 2  Emperor Xuandi of Chen, Chen Xu

This section is the most dynamic part of the scroll. There are eleven officials around Emperor Xuandi of Chen. He sits on the dais with a *ruyi* in hand. This scene is very similar to Yan Liben's painting *Emperor Taizong Receiving the Tibetan Envoy*, but the serving women are replaced by male servants and the portrayal of the dais and the fans are much more detailed and accurate.

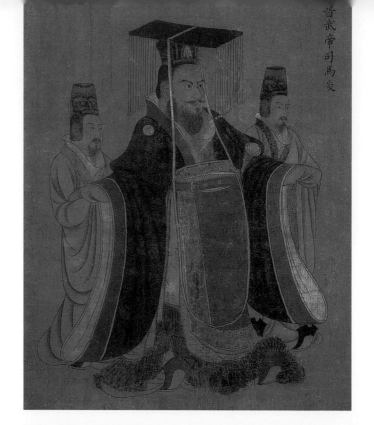

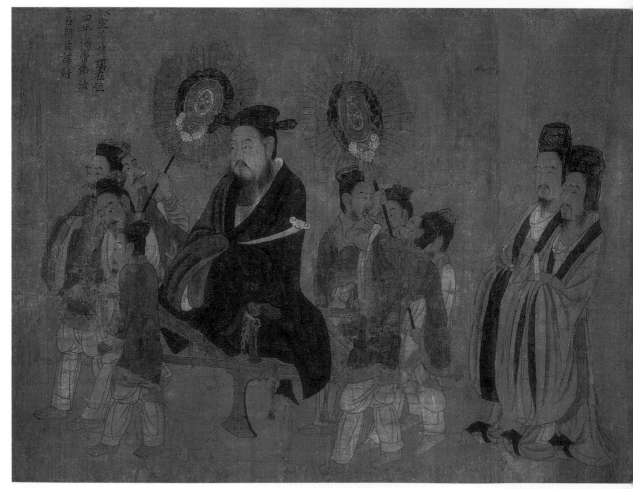

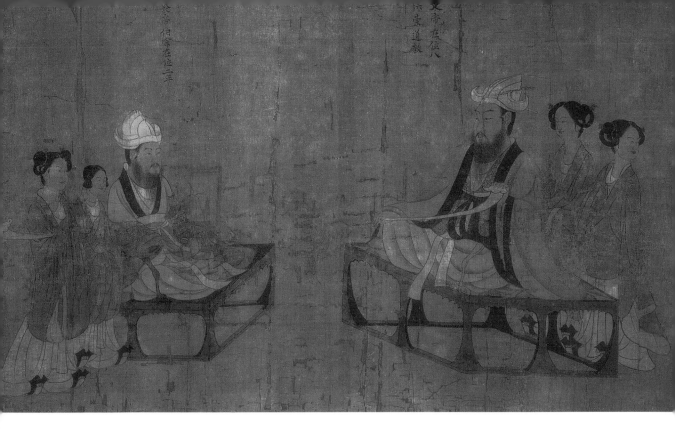

## Characteristics of the Emperor's Appearance

Through the portrayal of the emperor's expression, the artist reveals each monarch's inner world and the judgment of him in history. For instance, the last emperor of Chen during the Northern and Southern dynasties period (420–589), Chen Shubao, ignored political affairs because of his dalliances with

### Fig. 3 Two Chen Emperors Sitting on a Couch

Unlike the other emperors, Emperor Wendi of Chen and deposed Emperor Chenfeidi are each sitting on a couch, accompanied by serving women. They wear white gauze hats and are in fur coats. Emperor Chenfeidi holds a *ruyi* in hand.

various women. This eventually led to the demise of the Chen Kingdom (557–589). In the portrait, he is weak and wretched. By contrast, the Emperor Zhaodi of Han, Liu Fuling, son of the Emperor Wudi of Han, Liu Che (156–87 BC, reigned 141–87 BC), took office when he was just eight years old. He adopted a series of policies that made the Western Han dynasty (206 BC–AD 25) a time when "the people enjoyed their life and all nationalities lived in peace." In the painting, his gait is steady, and his style gentle, reflecting his broad-minded, elegant rule.

### Fig. 4 Technical Features

The figures in the painting are first outlined, then filled, and then color is gradually added to the garments along the lines to create a three-dimensional look to the folds and lines of the clothing. This embossing method is derived from a technique used to paint Buddhist figures.

# SAILING BOATS AND A RIVERSIDE MANSION

Li Sixun
Ink and color on silk
Height 101.9 cm × Width 54.7 cm
Palace Museum, Taibei

*Sailing Boats and a Riverside Mansion* depicts a springtime scene on a riverbank. It is bright, and practically breathes springtime.

## Spring Outing

Spring outings have long been a favorite activity of the Chinese people. Many literary and artistic works depict spring outings, and this is one of them.

In the painting is a vast riverbank meeting the sky. There are three boats on the river, and the two in the upper part of the painting have two cabins on board painted in deep vermilion, with dark roofs. The boat in the lower portion is not colored and it floats on the river, with one passenger rowing and the other pulling the fishing line.

In the lower part of the image is a hill covered with huge pines and a house looming in the gap between the trees. Only one person stands in the house, under a covered walkway. On the trail by the river is a horseman in brown garments, holding the reins and flicking a whip. Three others follow him. On the opposite side of the bend in the river, two people are talking. One raises his hand, as if indicating some object on the river.

The theme of this painting is said to be a spring outing because nestled among the pine needles, painted in green, there are blossoms of red, white, and green arranged harmoniously. Further, the garments worn by the various people in the painting are relatively thin, loose, and comfortable.

## Color Set

Chinese paintings use particular color sets. The main pigments are ochre, azurite blue,

**Li Sixun** was a descendant of the Tang imperial family and a native of modern-day Tianshui, Gansu Province. The mountains and rivers were painted based on the blue and green landscapes style and are outlined with golden paint, giving the painting a golden visual effect. This coincides with the prosperity of the Tang dynasty and was in line with the aesthetic tastes of the court nobles. It had a profound effect on later generations.

## Fig. 1  Sailboat

There are two sailboats sailing against the current on the upper part of the screen, with the sail and mast clearly visible. A simply-sketched figure on the bow seems to be controlling the boat's direction by pulling on the mast.

mineral green, and rouge, and all coloring is done in shades of these colors. Landscapes are one genre of Chinese painting, and the gold-and-green is one subgenre of landscape painting. It uses three pigments: golden paint, azurite blue, and mineral green as its main colors. The colors in this painting are thick. The artist first uses an ink line to trace the outline and level of the mountain, rocks, and trees. The base is made of light ochre, and lightly dyed with mineral green. Shadow

## Fig. 3  Building

There is a building under the pines. According to research, this building is in the architectural style of the late Northern Song dynasty (960–1127). Though Li Sixun is most often credited with this work, the architecture shown in it is late Northern Song style, putting it later than the Tang dynasty. Thus this painting in fact dates no earlier than the late Northern Song dynasty.

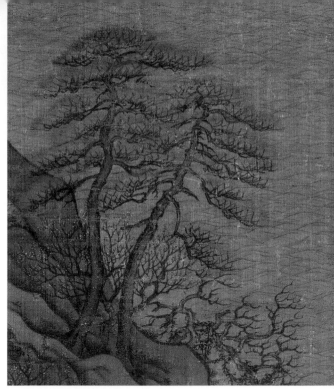

## Fig. 2  Pine Trees

Based on its proportion, it is evident that the pine tree in the painting is very tall. The root of the tree is partially exposed, its trunk curved, and its needles arranged in an umbrella shape. During the period this painting was produced, this technique of depicting pine trees was rare.

and light are distinguished through heavier colors. Then they are spot dyed repeatedly in azurite blue and mineral green. The building is dominated by red and is covered with a black roof, while the outer contours of its eaves are complemented with golden paint. The facades of some rocks are slightly stained with golden paint, giving it a palatial feel. For this reason, it is considered an example of a Chinese gold-and-green landscape painting.

## Fig. 4  Attire of Figures

The characters in the painting wear Tang dynasty attire. Their robes have oblique collars and belts, and their hats are of soft fabric for the head wrap with two strips hanging down the back of the head.

# COURT LADIES ADORNING THEIR HAIR WITH FLOWERS

Zhou Fang (active in the second half of 8ᵗʰ century and early 9ᵗʰ century)
Ink and color on silk
Height 46 cm × Width 180 cm
Liaoning Provincial Museum

During the Tang dynasty, the country prospered and the people were strong. The economy reached its peak during the Tianbao reign (742–756) of Emperor Xuanzong (685–762, reigned 712–756). The Anshi Rebellion took place from 755 through 763. This war, waged by the Tang generals An Lushan (703–757) and Shi Siming (703–761) after they betrayed the Tang court, was a civil war in which the two sides competed for the right to rule, leading to the weakening of the Tang court. Later, when the ruling class sought to whitewash the memory of the event and maintain peace, a series of policies were proposed, including the assigning of festivals and feasts. From that time on, the feasts flourished, and *Court Ladies Adorning Their Hair with Flowers* may be a reflection of women during that period, presenting the true face of a life of leisure. It depicts five aristocratic women and a maid, interspersed with a leisurely scene of frivolity, playing with a dog, crane-watching, fanning, chasing butterflies, and appreciating flowers, displaying extravagance, elegance, and soft, warm femininity as well as the atmosphere of the leisured aristocratic class of the Tang dynasty, giving the work a distinct sense of the times.

This painting is a typical model portrayal of court ladies in the Tang dynasty, and has a high artistic value.

## Damask Figures

"Damask" refers to luxurious silk or silk clothing, which later came to represent aristocratic women. Because Zhou Fang, Zhang Xuan (a court painter in the time of Tang Emperor Xuanzong), and others have vividly depicted these women as sacred, dignified, and luxurious, people called such paintings "damask figures." *Court Ladies Adorning Their Hair with Flowers* is one example of this sort of painting.

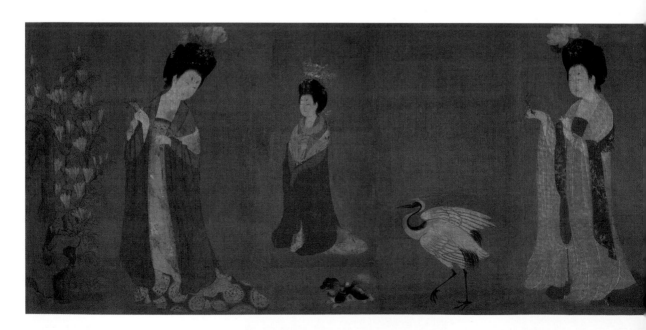

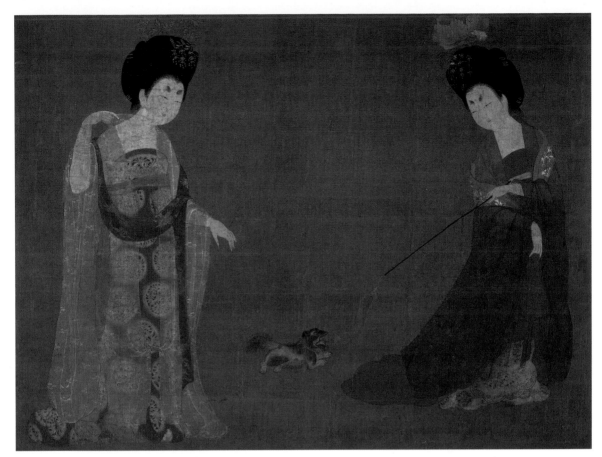

## Fig. 1  Aristocratic Women

The scroll opens on two women facing one another. The one on the right wears a red skirt with a brown gauzy shawl over it. There is a peony in her tall hair bun. She holds a duster, with which she teases a small dog with curly fur. The person on the left wears a red dress with floral print and a white translucent shawl over it and a brown scarf embroidered with a phoenix pattern draped over her shoulders. She is raising a finger to adjust her clothes. The ladies are full-bodied, and they have sleek, dignified, noble faces. They are typical of aristocratic women of the Tang dynasty.

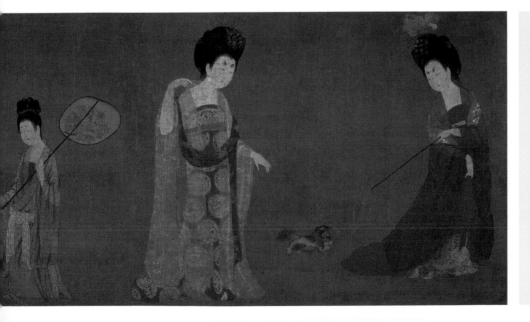

**Zhou Fang**, a native of modern-day Xi'an, Shaanxi Province, was born to a noble family in the Tang dynasty. He worked in the imperial court for a time, and excelled in calligraphy, scrolls of figures, and Taoist and Buddhist paintings. The aristocratic ladies in his paintings are graceful, and they were very popular with the people. His Buddhist paintings set the standard for the genre for a long time.

**Fig. 2  Maid**

Compared to the ladies, the maid's dress is very simple. She holds a fan, with which she seems to be fanning her master. There is a bouquet of flowers painted on the fan.

From the picture, it is evident that the ladies are wearing soft, sleek blouses with wide sleeves and beautiful tunic skirts, which are long, stretching to the ground. Matching patterned shawls are draped over their shoulders. The high hair buns are typical of the style worn during the Tang dynasty. They are not only decorated with hairpins in the forms of phoenixes, golden hair sticks, and *buyao*, but also large flowers, giving the painting its title.

## Possibly a Screen Painting

The six figures in the painting are stand side by side, including four ladies in more prominent positions, with one lady and one maid in smaller positions. The method of painting maids smaller than their masters is commonly seen in Chinese paintings, a technique used to indicate their lower social status. But here, a lady is also painted smaller. Why would one figure be smaller than the others of the same rank? A closer look reveals that the background color of this

**Fig. 3  Crane**

The crane in the painting is graceful and vivid. Its wings are slightly open, and its left foot is slightly raised. The painter uses white for the base feathers, then outlines them in brown, and finally draws the ink lines on the outside, forming a layered visual effect. The crane stands for longevity in Chinese culture.

lady is obviously different from other parts of the painting, indicating that this piece was cut and moved to this painting. Some experts believe that this painting may have originally been a set of screens, each of which contained a figure, an animal, or a maid, but that was later re-cut and decorated into its current form. This is also very common in Chinese painting. If this is the case, it is likely the artist was creating a picture of court ladies' life.

**Fig. 4  Makeup**

The ladies in the painting wear thick makeup. The first layer applied is a lead powder, extending from the face over the neck, creating a whitening effect. The eyebrows are shaved, then re-drawn with indigo naturalis powder in the shape of upside down leaves. The final touch is to apply "a touch of oil to the lips." From the painting, we see that the way women painted lipstick was to first create a white base, then apply rouge to the center of the lips. In addition, a round yellow decoration is visible in the center of the woman's eyebrow. This is called a "flower," and was also a common fashion among women of that time.

## Fig. 7 Magnolia

There is a magnolia on the far left side of the painting. It is an oblong oval shape, and its blossom is purple. Flowers of this color mostly bloom in midsummer, which is consistent with the attire of the women in the painting.

## Fig. 5 Technique

The painter's skills are superb, using delicate, flexible, concise lines for the figures. The textures of the costumes are depicted through different color combinations. In the details of this lady, the texture and transparency of the red gauze are made realistic through the use of subtle changes in color. The crossed hands are faintly visible under the gauze, creating an image of true beauty.

## Fig. 6 Small Curly-Furred Dog

There are two curly-furred dogs in the painting. These small pet dogs were introduced from Gaochang (present in Xinjiang Uygur Autonomous Region) in the early Tang dynasty. Because they were extremely valuable, they were only raised by the royal family.

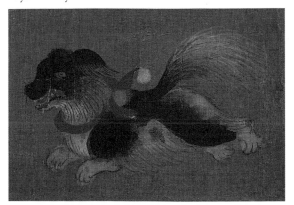

## Fig. 8 Woman with Butterfly

At the very end of the painting, a lady dressed in red-brown gauze looks back at the dog. Her body curved into a "C" shape. On her hand is a newly caught butterfly. The lines of her hands are smooth and supple. The other hand is adjusting her skirt. There are patterns on the skirt, including a pair of mandarin ducks on the top and four flying cranes on the bottom. From her dress, one can guess that she is older.

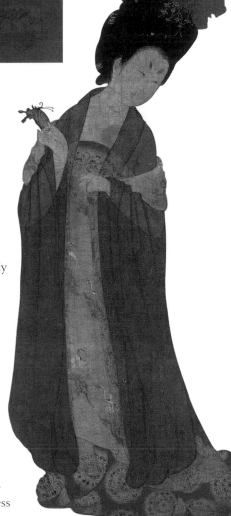

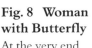

# NIGHT-SHINING WHITE

Han Gan (c. 706–783)
Ink on paper
Height 30.8 cm × Width 33.8 cm
Metropolitan Museum of Art, New York

During the flourishing Tang dynasty, the country prospered, and there were frequent exchanges between China and other countries. A large number of horses from northwestern regions were introduced into the Central Plains and came to be highly valued by the ruling class of that time. As a result, many masters who painted horses emerged, and Han Gan was one of them. *Night-Shining White* is one of his masterpieces, and it is still existing today.

## Background

The horse in the painting is called "Night-Shining White." According to legend, it was the beloved horse of the Tang Emperor Xuanzong. It was so snowy white it could light up the night, giving it its name. At the time, the relationship between the Central Plains and the countries and regions in the west grew increasingly close. Emperor Xuanzong once married off Princess Yihe to the faraway

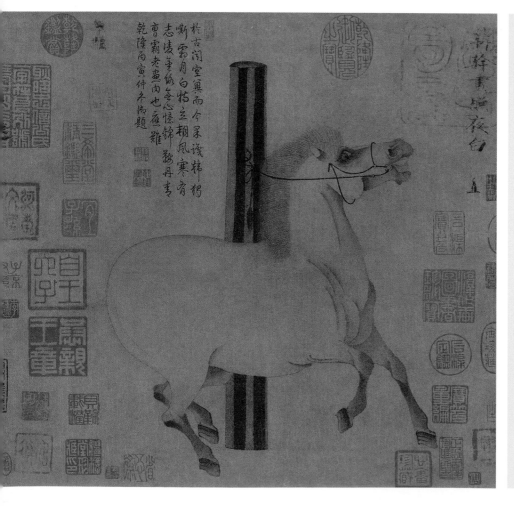

**Han Gan**, a native of modern-day Xi'an, Shaanxi Province, was born from poor families and later showed great talent in painting. He was appreciated and supported by the great Tang dynasty poet and painter Wang Wei (701?–761). During the reign of Tang Emperor Xuanzong, he was called into the imperial palace and made a professional painter. He paid great attention to sketching, using real horses in stables as models which he copied. He excelled at painting horses with harness, figures, and supernatural beings, but he was particularly known for his horses.

## Fig. 1  Eyes and Mane

The painter depicts Night-Shining White's eyes in great detail, first using smudges of heavy ink around the rims of the eyes, then using ochre to touch up the eyeballs. In this way, the frightened, uneasy eyes of the horse are expressed.

The horse's mane is drawn with threads of ink. These lines are powerful and vigorous enough to reflect the hardness of the horse's mane and the way its hair stands erect when it is frightened.

## Details

Dayuan State in the west (the modern day Ferghana region of Kyrgyzstan). In return, the king specially presented two Ferghana horses to Xuanzong. Being a great horse-lover, Xuanzong was especially fond of these two fine horses, which he named "Jade Flower" and "Night-Shining White." Of the two, the latter not only accompanied Xuanzong on his trips to scenic spots throughout the glory days of the Tang dynasty, but was also by his side in his most desolate period during the Anshi Rebellion, and it was deeply loved by the emperor. It has been rumored that Han Gan made separate paintings of Jade Flower and Night-Shining White, but the painting of Jade Flower has been lost.

From the extant painting *Night-Shinning White*, we see a fine horse tied to a post. It looks ferocious and has a flowing mane, with ears perked up, head raised and whinnying, and its four hooves moving furiously, making it appear frightened, as if it wants to break free of its bonds. The horse is the only focal point of the image, so its scale is small, while the short comments that follows the painting is quite long. From the red seals covering the painting and the inscription on the reverse side of the scroll, it is evident that the painting had been in the hands of more than 20 collectors between the Tang and Qing (1644–1911) dynasties, including the Qing dynasty Emperor Qianlong (1711–1799, reigned 1736–1796). He stamped 26 seals on the painting and made 10 inscriptions, indicating his fondness for it.

## Fig. 2  Horse's Body and Fading Tail

The artist depicts the horse's body in extremely simple lines. The length from its back to its rump is drawn with a thin, smooth line, and only a few lines are used to depict the muscles on its chest, with colors lightly added. Using only a few brushstrokes, the artist is able to depict the healthy and hypertrophic characteristic of the horse, demonstrating superb artistry. However, peculiarly, the horse's tail is not visible in the painting. Some experts speculate that this part of the painting may have worn off over time, making the tail fade. It is also possible that the part of the horse from the neck to its left torso was added by a later artist.

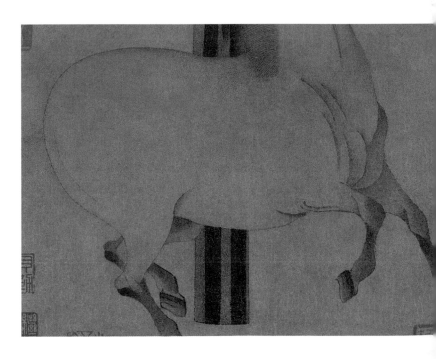

# GENTLEMEN IN RETIREMENT

Sun Wei (Tang dynasty, dates unknown)
Ink and color on silk
Height 45.2 cm × Width 168.7 cm
Shanghai Museum

According to scholarly research, the figures in *Gentlemen in Retirement* are the Seven Sages of the Bamboo Grove, but only four (Shan Tao, Wang Rong, Liu Ling, and Ruan Ji) are pictured in the surviving painting. They sit on the ground, legs crossed and holding fans or cups. A servant stands prepared to serve. Though the bamboo forest is not painted, with the rockery and plants, the feeling we get from the characters in the painting is that they are seated in a mountainside forest. The skillful painting carries a detailed depiction of the temperament of scholars of the Wei and Jin dynasties pursuing a spiritual life of moral loftiness, carefree tranquility, generosity, and detachment.

## The Seven Sages of the Bamboo Grove

The Seven Sages of the Bamboo Grove, Ruan Ji (210–263), Ji Kang (224–263), Shan Tao (205–283), Liu Ling (dates unknown), Ruan Xian (c. 222–278), Xiang Xiu (c. 227–272), and Wang Rong (234–305), lived in the Three

**Fig. 1   Shan Tao**

This sturdy, bare-chested man of renown is most likely Shan Tao. He wears a brown gauze hat, a long beard, and a crimson gown, and has his hands on his knees as he gazes forward. There is a bronze, patterned tripod beside him, and a serving boy on the other side holds a *qin* (a plucked seven-string Chinese musical instrument of the zither family).

Kingdom period (220–280). They were highly regarded for their literary achievements and unique artistic views, and were known to gather frequently in the bamboo grove to compose poetry, drink wine, and sing. It was later generations that dubbed them the Seven Sages of the Bamboo Grove.

**Sun Wei**, born in Shaoxing, Zhejiang Province, and later resident of Xi'an, Shaanxi Province, was proficient in painting figures, spirits, rocks and pines, ink bamboos, and religious figures. He was especially skilled at painting water. *Gentlemen in Retirement* is his only surviving work.

## Fig. 2 Wang Rong

This celebrated figure holds a *ruyi*[1] in hand, which is how Wang Rong is consistently depicted in classical texts. There is a fully opened scroll in front of him, and the boy beside him holds several more scrolls. Wang Rong has an exposed left foot, and his garments are red. The outer shawl seems to be made of gauze, with a translucent texture.

1 Translator's note: an S-shaped ornamental object, usually made of jade, formerly a symbol of good luck.

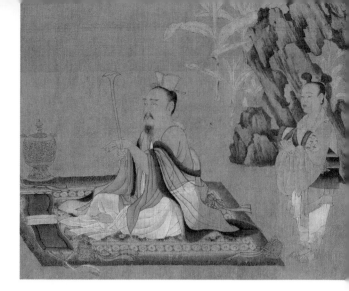

## Composition

*Gentlemen in Retirement* embodies an early form of composition in Chinese painting. The characters in the painting are sitting on carpets, forming a group in the painting, even as each remains an independent unit from the others. The trees and stones separate the painting into individual units, but there is still echo between these units. The two celebrities pictured on the right face the left, while the third faces left, but turns back to respond to someone behind him, speaking over his shoulder. The person furthest to the left faces the front, with his gaze turned to the right side. These details link the figures in the painting to one another.

The rockeries and tress in the background are painted with light ink and are smaller, in proportion to the figures in the foreground. The trees on the left and right are placed in a more prominent position, but are only partially drawn. The servants are relatively small, and they are painted in light colors to allow emphasis to remain on the main characters. In this, its composition is typical of early Chinese paintings.

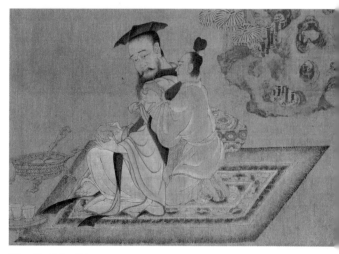

## Fig. 3 Liu Ling

Unlike the first two figures and their servants, this celebrated figure interacts with the boy behind him. The serving boy kneels on the carpet, holding a cup with both hands, and the celebrated figure holds his own square cup with both hands as he turns back, seeming to spit into the cup. The scene is very much in line with Liu Ling's well-known love of drinking.

### Fig. 4 Ruan Ji

The final figure is Ruan Ji. He faces Liu Ling, a faint smile on his face. He wears a pointed silk hat. The item in his hands is shaped like a fan. In ancient times, similar items made of deer tails were called *zhuwei*, and they were used to keep dust and mosquitoes away while one chatted.

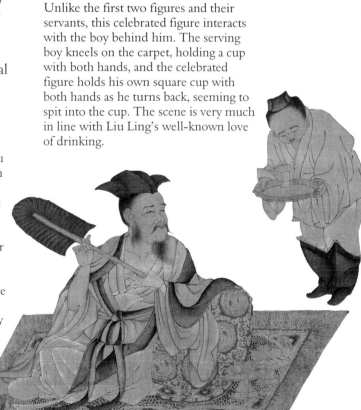

# MOUNT KUANGLU

Jing Hao (born c. 850)
Ink on silk
Height 185.8 cm × Width 106.8 cm
Palace Museum, Taibei

*M*ount Kuanglu set a new precedent for panoramic landscapes in Chinese art history. Its composition allows the viewer to feel as if he or she is observing, walking through, touring, and even living in the painting.

## Scenery

On the right edge and the foreground of the painting, vast waters are depicted. There are boatmen on the water, and villages and buildings are scattered across the slopes beside the water. A path leads across the mountain to another slope, suggesting a secluded place for a painter to live and work. On the right side of the painting, one person drives a pair of mules, preparing to cross a bridge. A simple shack sits beneath the trees in the lower right hand corner of the painting, and a person stoops to enter the house. Looming pavilions sit between the two peaks, suggesting a sort of fairyland that inspires longing in the viewer. Several waterfalls run down the mountain, flowing into the river. The waterfront is dotted with houses, bamboo fences, bridges, and boats, a depiction of a typical day in village life.

**Jing Hao**, a native of Qinshui, in Henan Province, retreated to a life in the Taihang Mountains to avoid war during the Five dynasties period (907–960). He is remembered in history as a Confucian scholar who, because of the ravages of war, was unable to make a name for himself in the world, so instead retired to paint in seclusion. He is also known as a leading art theorist. He was the first person in Chinese history to put forward a complete theory of Chinese landscape painting, which is recorded in his *Brush Techniques (Bifa Ji)*.

## Not Mount Kuanglu

The name Kuanglu refers to the Lu Mountains, in Jiangxi Province. However, it is evident from the painting that the landscape features depicted here are closer to the natural scenery of the northern region. It is possible that it is the Taihang Mountains where Jing Hao lived in seclusion. The alias Jing Hao

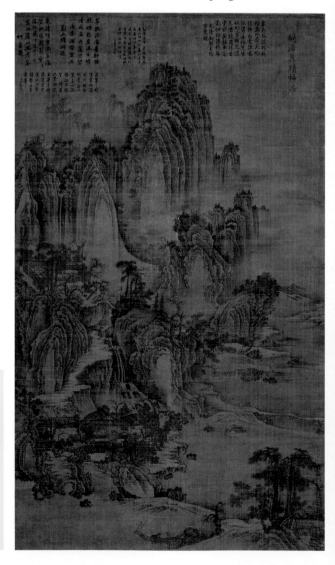

## Fig. 1  Kuanglu

Kuanglu was another name for the Lu Mountains. For this reason, some scholars believe that *Mount Kuanglu* depicts the scenery of the Lu Mountains, though others believe it was the site of Jing Hao's seclusion. The painting does not seem to merely present a natural landscape. More importantly, it reveals an ideal environment for an artist to live in seclusion. There is a hidden courtyard built on the pine-covered slopes, looking like a painter's retreat.

assigned to himself was Hong Guzi. Based on the common practice of scholars at the time, such an alias would indicate things such as place of residence, place of origin, specialization, or interests. An alias was often a reflection of the painter himself. In Jing Hao's chosen alias, we note that he once lived on Mount Honggu in the Taihang Mountains. Visiting the mountain today, one can detect traces of *Mount Kuanglu*.

## Fig. 2  The Symbolic Significance of the Pines

Since ancient times, pine trees were thought to represent noble character. They were often used to depict the virtue of those who retreated from official life to live in seclusion. The pine is the main tree seen in *Mount Kuanglu*.

## Fig. 3  The Vertical Texture Strokes

In the painting, the rock is created with the vertical texture strokes, which uses short, strong, dense strokes. Following the changes of the structure of the rock, the lines alternate between horizontal, vertical, and oblique strokes, highlighting the visual effects of the cliffs and crags.

# PLAYING CHESS BEFORE REPEATING SCREEN

Zhou Wenju (Five dynasties period, Southern Tang, dates unknown)
Ink and color on silk
Height 40.3 cm × Width 70.5 cm
Palace Museum, Beijing

During the Five dynasties period, the Southern Tang (937–975) was situated in Jiangnan, the area south of the Yangtze River, amidst beautiful landscapes. It only lasted for a total of 38 years, but saw three rulers, Li Bian (889–943, reigned 937–943), Li Jing (916–961, reigned 943–961), and Li Yu (937–978, reigned 961–975). The latter two loved both literature and art. With their support and encouragement, painting flourished in the Southern Tang, developing the art in general. The use of a picture within a picture was an ingenious innovation at this time.

## Chess

In the foreground, there are four people playing chess on a board with clearly defined latitude and longitude lines. It is obvious at first glance that it is Chinese chess, which is played by two opponents, one playing the black pieces and the other white. The two people sitting in front have their hands raised, the one on the left thinking about his move and the one on the right, with chess piece in the hand, observing his opponent. The two people on the daybed behind the table are watching. These four figures are Li Jing (in the middle, wearing the high hat) and his three brothers, the third brother Li Jingsui (920–958, sitting next to Li Jing), the fourth brother Li Jingda (924–971, the player on the right), and the fifth brother, Li Jingti (937–967, the player on the left).

Art historians think there is almost certainly a political meaning behind the painting, because in the historical records, Li Jing and his younger brothers had a very nuanced relationship. Although he was

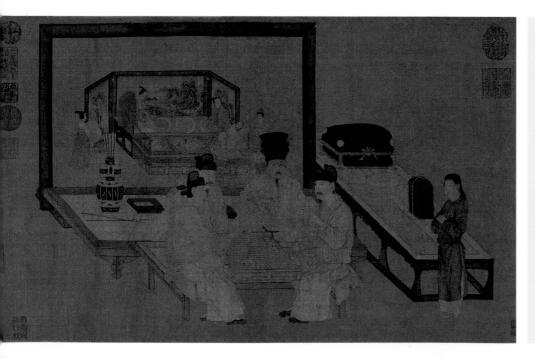

**Zhou Wenju**, a native of present-day Jiangsu Province, was renowned for his figure paintings. His unique brushwork is simple and fluid, which gives the lines a sense of powerful movement. This brush technique is called "rippling with wavy fluidity" or "tremolo brushwork."

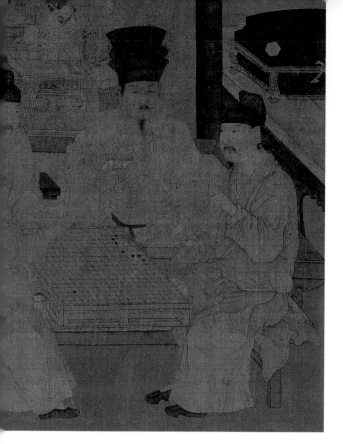

## Fig. 1 Figure Painting Technique

In the center of the painting are four figures, Li Jing and his brothers. The painter draws them with a powerful, twisting line. This is consistent with Zhou Wenju's brushwork of "thin, hard battle" (a slim, strong stroke that wavers as it is dragged).

## Repeating Screen

According to scholars, this painting itself may have originally been installed on a screen. If so, then combined with the image in the painting, there would have been a total of three screens. The first is the painting itself, the second is the screen behind the chess players, and the third is the foldable screen painted on the screen in the painting, on which is a Chinese landscape painting.

This sort of repeating screen is rare in the history of Chinese painting, creating a distinctive picture space in the composition. The landscape painting on the screen painted on the in-painting screen is the most distant object in the entire composition. This sense of depth pushes the boundaries of the interior space, reaching as far as the mountains and the sky, and on to infinity.

an emperor, he was by nature timid and weak. While he was in office, he faced many challenges both internally and externally, and his heirs had not yet grown up. Very worried that his younger brothers would usurp his throne, he implemented numerous policies meant to appease them.

## Fig. 3 Poetic Meaning in *A Nap after Drinking*

The material on the second screen recreates the Tang dynasty poet Bai Juyi's (772–846) work *A Nap after Drinking*. A glass of wine is on the desk, and an old man lies on the daybed, immersed in sleep, most likely Bai Juyi himself. His wife helps him take off his hat, and the maids are making the bed. Bai Juyi wrote this poem to ridicule his own comfortable life, and it could be completely transformed into the subject matter of the screen, so the later painter fulfilled the dream in this picture.

### Fig. 2 Servant and *Humen*-Style Bed

On the right side of the painting stands a servant dressed in green, with his hands crossed. In ancient China, servants and younger generations had to stand with their hands crossed when they were idle, as a show of respect to their masters or elders. Beside this servant is a *humen*-style bed or hollowed-out bed (a bed with decorative door-shaped hollowed-out between the legs, called *humen*), a common decorative feature for Chinese furniture and architecture.

# A LITERARY GARDEN

Zhou Wenju
Ink and color on silk
Height 37.4 cm × Width 58.5 cm
Palace Museum, Beijing

"Elegant gatherings" were a common activity of the Chinese literati in ancient times, where members of the literati class would gather to recite poetry and other literary works and hold learned discussions. *A Literary Garden* depicts such a scene.

## Literati

There are four main characters in the painting. Their dressing suggests a certain identity and learning. A further look at the rolled scrolls and writing brushes in their hands and the boy preparing the ink for writing beside the stone on the right side further makes clear that they are members of the literati class.

In addition to the dress and accoutrements that indicate their identity, the painting also includes a pine tree and rockeries, beloved items of the literati. Pine trees can stand the severe winter, featuring the nobility the Chinese literati pursue, while appreciating stones was a hobby of the Chinese literati throughout ancient times, and remains so today. Through different types of stones, they are led to appreciate nature and life.

## Elegant Gatherings

Scholars speculate that *A Literary Garden* is a depiction of the story told of the Tang dynasty poet Wang Changling's (698–757) elegant gathering with friends at Liuli Hall (Colored-Glaze Hall), the innermost court of Wang Changling when he was stationed in Jiangning (modern day Nanjing, Jiangsu Province). Such speculation is based on the

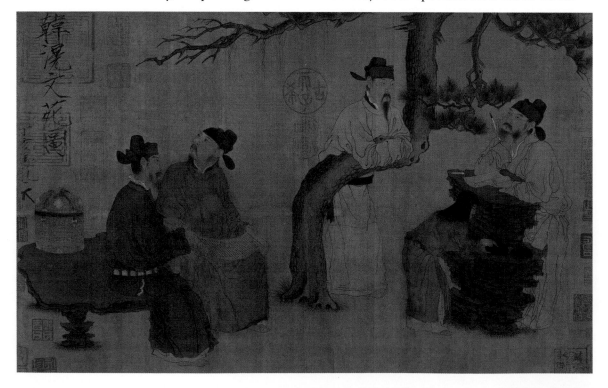

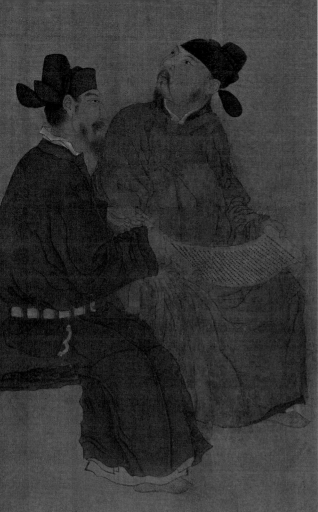

### Fig. 1   Clothing
The Chinese scholars are dressed in gowns. One of them wears dark colors, with red belts around the waist. This was the uniform of Song dynasty (960–1279) officials, leading some to speculate that the painting was composed in the early years of the Northern Song dynasty.

the renowned Tang dynasty poet Li Bai (701–762).

In the painting, Li Bai seems to be contemplating, perhaps conceiving a new work. What is the topic that so engrosses the two people sitting on the stone bench on the left side, deep in conversation over a scroll? Perhaps one has just written some poetry and is asking the other's advice. On the right side, one person holds a brush in one hand, propped under his chin, and a scroll in the other. His eyebrows are bunched together, as if absorbed in thought.

Although there is no strong interaction among the four figures, through the connections of their physical movements, we gain a vivid sense of the serene, peaceful setting of a gathering where the literati learn from one another.

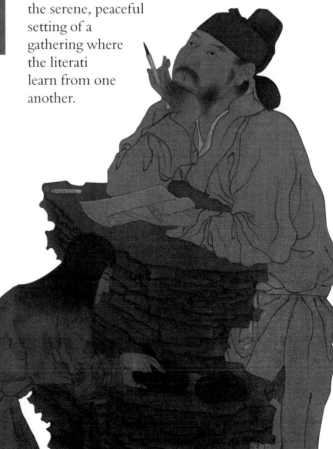

painting *Scholars of the Liuli Hall*, now housed in the Metropolitan Museum of Art in the U.S. The subjects of the two paintings are very similar, but *A Literary Garden* seems to show only a portion of the material depicted in *Scholars of the Liuli Hall*. If these theories are accurate, it is possible to determine the identities of the four figures depicted here. The one leaning on the pine tree would be

### Fig. 2   Four Treasures of the Study
The four treasures of the study include ink, brush, paper, and inkstone, which are depicted in this painting. The brush one scholar holds has a white body with a short brush, while the brush cap lying beside his elbow, and the paper he holds seems to have grid lines. The ink the boy holds in his hand and the inkstone below can find their physical counterparts of the same era in the museum.

# SKETCH OF RARE BIRDS

Huang Quan (d. 965)
Ink and color on silk
Height 41.5 cm × Width 70.8 cm
Palace Museum, Beijing

*S*ketch of Rare Birds includes a total of 24 birds, insects, and tortoises. These animals are accurately and rigorously rendered, each distinct from the others. Their demeanor is vivid, interesting, and captivating, and the work shows great breadth, accuracy, and detail.

## A Model for a Son

This is a unique work in the history of Chinese painting. In most bird-and-flower paintings, animals are accompanied by plants, often perched on branches, hidden among grass, or flitting between leaves, but *Sketch of Rare Birds* does not include any background detail. The animals are simply arranged in the painting. The reason for this approach is hinted at in the text in the lower left-hand corner of the painting. The painting was originally made as a model for the artist's son, Huang Jubao (dates unknown) so that he could study painting.

This type of painting is rarely preserved. Paintings like this, passed down from father to son, are rare and hence precious.

**Fig. 1**

## Realistic Depictions

Even someone who has little knowledge of the names and appearances of animals can

> **Huang Quan** was a native of modern-day Chengdu, Sichuan Province. He was a court painter in the Xishu reign of the Five dynasties period. His bird-and-flower paintings are detailed and meticulous, with accurate, vivid shapes and noble, elegant colors. He was a very influential painter during that period.

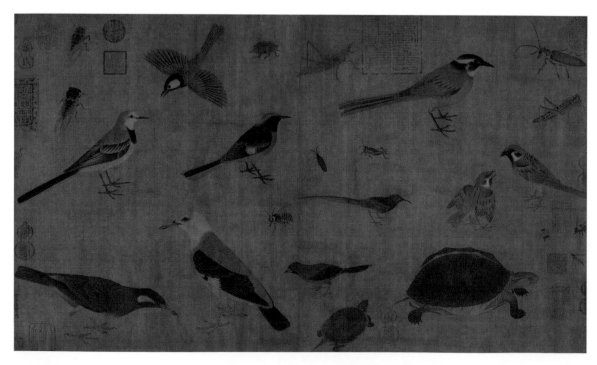

**Fig. 2**

## Figs. 1–2 Turtles

The larger of the turtles depicted here is the Chinese box turtle (see fig. 2), while the smaller is the Chinese pond turtle (see fig. 1). The Chinese box turtle is now very rare, but it was once a common species of turtle. It is evident from the feet that the two turtles are crawling, but they are drawn at different angles. One is sideways, displaying only half the figure, while the other offers an oblique view of the body. It is conceivable that the artist's intention was to use this arrangement to allow his son to gain a better understanding of the importance of angles of painting.

## Fig. 3 Light-Vented Bulbul (*Pyconotus sinensis*)

The light-vented bulbul has a white band of feathers behind its eyes, which the painter clearly captures here. This white-vented bulbul stands sideways, revealing a blue-gray back. The painter first smudged ink, then painted over it with very fine strokes to create the feathers.

name all the creatures in this painting. They are very common animals, such as cicadas, sparrows, long-horned beetles, bees, and turtles. According to literary sources, Huang Quan kept poultry at home for observation, so he understood the morphological structure of these animals very well. For this reason, the artist relies on the one hand on his general sketching experience, creating vivid animals in his painting. On the other hand, his painting skills are superb, the lines delicate, the colors light, and the animals' features realistic.

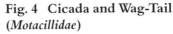

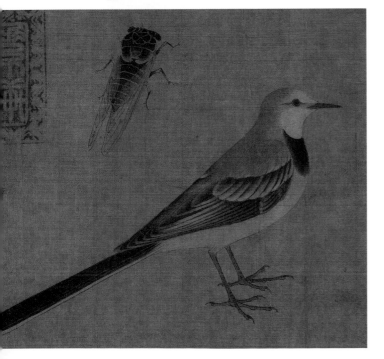

## Fig. 4 Cicada and Wag-Tail (*Motacillidae*)

At the top of the picture is a cicada (top) which, because it lives in high trees and drinks only dew, is seen as a symbol of nobleness. The hum of the cicada often leads to nostalgia, so it is often praised by poets and painted by artists. In this painting, the artist uses light ink lines to depict the transparent wings, creating a very realistic effect.

The wag-tail (bottom) is a bird that lives near the water. In the *Book of Songs* (*Shi Jing*), it is used to express a brotherly friendship. The one painted here has a beautiful bearing, the black fluff on its chest making it look noble and elegant.

# TRAVELERS IN A WINTRY FOREST

Li Cheng (919–967)
Light ink and color on silk
Height 162 cm × Width 100.3 cm
Metropolitan Museum of Art, New York

Li Cheng's paintings had a profound influence on later generations. Guo Xi (c.1000–c.1090), Xu Daoning (dates unknown), Wang Shen (1048–earliest 1104), and others took him as a master to imitate. He, Guo Xi, and their successors later became known as the Li-Guo School of painting. Alongside Fan Kuan (before c. 967–after c. 1027) and Guan Tong (907–960), he was known as one of the Three Great Painters of the Early Northern Song Dynasty.

*Travelers in a Wintry Forest* depicts a gentleman riding a mule in the countryside, with servants in front of and behind him. In addition, there is an old pine high up, looking like it stands above the clouds and withered trees by the cold stream, creating an engaging image. Zhang Daqian considered this Li Cheng's best work.

## Looking for Plum Blossoms in the Snow

The gentleman in the painting is dressed in casual clothing and a hat, and his hands are clasped in front of his chest, suggesting that the road is rough and the weather cold. Two boys accompany him. The one in front carries a staff, leading the way, and the other walks a little behind. In the Tang and Song dynasties, the theme of riding a donkey was often closely related to the life of the literati, and many poets had anecdotes about riding a donkey. The most representative one was the Tang dynasty poet Meng Haoran (689–740), whose image of riding a mule through the snow to search for plum blossoms was the most classic. *Travelers in a Wintry Forest* is a scene after a winter snow. Is the rider Meng Haoran himself? Perhaps the painter felt Meng's unfortunate experiences coincided with his own, and Meng's talent was greatly respected by the painter. It is very possible that Li Cheng held Meng Haoran in high esteem, and for this reason, he painted Meng's story of riding through the snow in search of plum blossoms to depict his own interests.

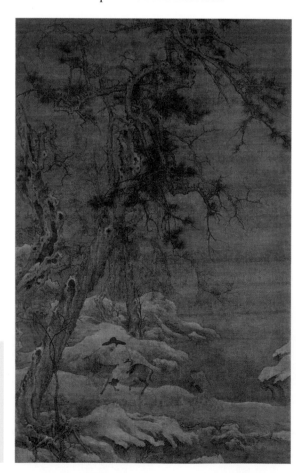

**Li Cheng** was a native of today's Xi'an, Shaanxi Province, and later moved to Qingzhou, Shandong Province. He was not engaged in official life, and always remained an unrestrained character. He loved to drink and was a skilled player of the *qin*. He was an avid poet, and has always been particularly praised for his landscape painting.

## Fig. 1  Technique for Drawing Pine Trees

The outer edges of the tree's branches are depicted in strong, powerful inky brushstrokes, and the bark on the loose branches is stained with a dry brush. More unique is the knot in the tree. Most painters use a circle to depict knots, but Li Cheng colors his with ink, leaving the outer ring of the cluster white.

## Pine and Rock in Level Distance

A tall pine stands upright in the painting, a straight vertical line across the picture, while the sloping ground occupies only a small portion of it, highlighting the towering height of the tree. The figure beneath the tree is very small. This method of composition is common in the Li-Guo School. The combination of the pine and rocks in level distance is another technique commonly employed by Li-Guo School painters. In his book *Forest and Spring* (*Linquan Gaozhi*), which records Guo Xi's theory of painting, pines and rocks in level distance is listed as a theme in the small scenes genre. This style requires that the painting "use level distance to depict pines and rocks, with the pines and rocks drawn larger and objects in the level distance drawn smaller." For instance, in *Travelers in a Wintry Forest*, the pine is located

in the picture's foreground, and the tip of the stone is small, only clustered around the roots of the tree. However, the proportion of the stone is large, while the blank space beyond the pine and rock is left level and distant. Although this blank space is relatively small, it still generates a feeling of the openness of the surrounding area in the distance.

## Fig. 2  Snow Scene

The artist employs two methods to depict the snowy scene. One is the snow on the rock, for which he first outlines the rock with brush and ink, then uses light ink to smudge the shades and cracks in the rock, leaving blank spaces to depict snow. The other method is seen on the tiny withered twigs, where the artist uses the method of "sprinkling white powder" to depict the snow.

## Fig. 3  Technique for Painting the Figure

The technique for painting the character in the picture is quite unique. The painter sketches with simple ink, creating vivid, interesting lines. The character has three spots where the ink is focused, the hat, belt, and boots. The clothes, on the other hand, are fleshed out with a tremolo brushwork. They are without color. The painter outlines the garments, then leaves them blank to depict white fabrics.

# A SOLITARY TEMPLE AMID CLEARING PEAKS

Li Cheng
Light ink and color on silk
Height 111.4 cm × Width 56 cm
Nelson-Atkins Museum of Art, Kansas City

*A Solitary Temple amid Clearing Peaks* depicts a scene of a valley in winter. The peaks tower to the top of the picture, as if beyond the human gaze. In the village below, people walk about. The critical point of the picture is the Buddhist temple, which stands between the uninhabited heights and the human environment.

## A Buddhist Temple amid Landscapes

In this painting, the Buddhist temple is central, and it is drawn in meticulous detail, a departure from the custom seen in other paintings, in which temples are only given rudimentary representation. Buddhism has been one of the most important religions in China since ancient times, particularly during the Tang and Song dynasties, when the royal families and scholar-aristocrats practiced Buddhism. As a result, Buddhist temples are often represented in traditional Chinese culture. Because most Buddhist temples were situated among mountains and rivers, they became spots where emperors and scholars enjoyed leisure outings. In literature and art, Buddhist temples are often depicted amid such landscapes.

## Unique Style

*A Solitary Temple amid Clearing Peaks* is painted in a style unique to Li Cheng's works, similar to the monumental landscape style of Fan Kuan and Guan Tong. The picture consists of three parts: near, middle, and distant scenes. The main peak stands in the distance, occupying most of the space in the painting. It towers over the image like a huge wall, with waterfalls suspended from it. The Buddhist temple stands in the middle distance, on the

hills in the center of the painting. It is located in the most central part of the painting, showing the solemnity of the temple. By contrast, there is a strong sense of life at the foot of the mountain, shown in the near distance.

Most of Li Cheng's extant works render a far-reaching feeling, as seen in *Travelers in a*

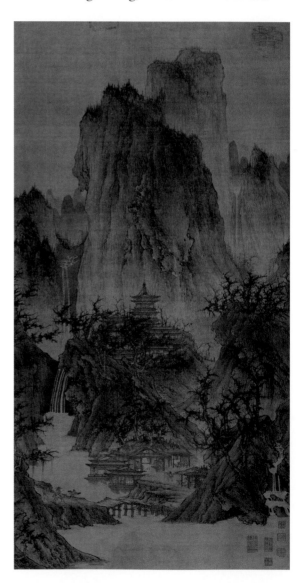

## Fig. 1  Buddhist Temple

The Buddhist temple is composed of monasteries and
stupas. The painter draws the outline of the image
with the technique of *jiehua* (line painting, using a
ruler to draw the lines), and the structure is very
accurately rendered. The temple tower is a loft-style
building, which is the earliest style of Chinese stupa.
A Liao dynasty (907–1125) wooden tower in today's
Yingxian County, Shanxi Province, is similar to the
tower pictured here. It stands in front of the mountains,
making the viewer feel she or he is in the scene, looking
at the mountains in awe.

## Fig. 2  Technique for Painting Trees

The trees in the painting are withered and the
branches are twisting. It was drawn with rapid, fluid
brushstrokes. The trunk is painted with outlines, and
the branches are painted with thick ink. The branch
tips are painted with the crab claw branch technique.

*Wintry Forest.* His style has been confusing to
scholars since ancient times. Mi Fu (1051–1107),
who lived many years after Li Cheng, wrote of
the latter's works, "There are two originals, and
three hundred copies," which he proposed as
the "Non-Existent Li Theory" (i.e., "there is
no such thing as Li Cheng's original painting").
What, then, is Li Cheng's style? *A Solitary
Temple Amid Clearing Peaks* may provide a
starting point for future research into this issue.

## Fig. 3  Huts at the Foot of the Mountain

At the foot of the mountain is an open-sided hut where
people relax and laugh, while others busy themselves
about it. One of the people on the left waterside gazebo
stands next to a column looking at the water, while
two men roll up a curtain behind them in the pavilion,
revealing a second curtain, which contains a calligraphy.

## Fig. 4  Technique for Painting Stones

The strokes outlining the rocks are not very coherent,
and the tremolo brushwork is evident in their
intermittent placement. The texture strokes are short
and powerful, like a raindrop, showing the firmness of
the rock.

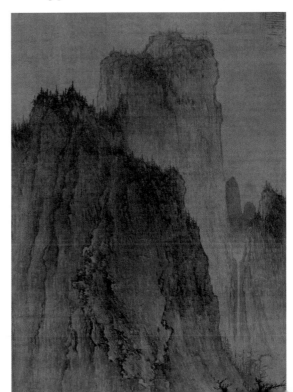

# BAMBOO IN THE SNOW

Xu Xi (Five dynasties period, Southern Tang, dates unknown)
Ink on silk
Height 151.1 cm × Width 99.2 cm
Shanghai Museum

*B*amboo in the Snow depicts bamboo in a snowy landscape. Three stalks of bamboo stand behind a stone, with others bent and broken stalks standing alongside them. The leaves on the upper reaches of these stalks are dense, but tidy. Between the bamboo and stone are several vines and weeds. The overall composition is novel, and the perspective in the work is richly layered.

## Painting in a Natural Style

*Bamboo in the Snow* has long been regarded as an anonymous work, until the 20th century art appraiser Xie Zhiliu (1910–1997) determined through documentation and related research that Xu Xi was its author. In his book *The Painter's Practice*, art historian James Cahill (1926–2014) evaluated the painting, saying, "I have introduced before an anonymous picture of bamboo, old trees, and rocks in winter, probably late tenth or early eleventh century in date, as a supreme exemplification of the ideal of concealing the painter's hand in order to concentrate the viewer's attention on the image, which appears to have come into being without the intervention of human art, like a creation of nature. And that is exactly how the works of great masters of this period,

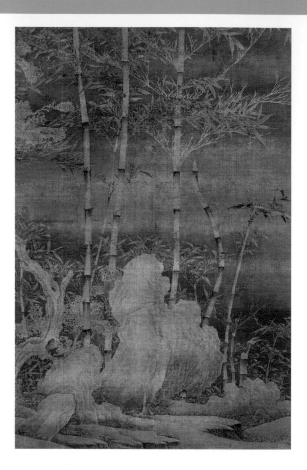

such as Li Cheng and Fan Kuan, are praised by their contemporaries: they create as nature does, without willfulness or any assertion of the self."

## Technique of Borrowing Background to Make Snow

To create this work in a natural style, the artist employed a complex rendering method. There are many ways to represent snow in Chinese painting, but this is the only painting in which the snowy landscapes is drawn by "borrowing background to make snow," leaving people to speculate today about how

**Xu Xi**, a native of today's Nanjing, Jiangsu Province, was born to a prominent Jiangnan family, but had no professional ambitions, living as an ordinary person with no official titles. He often visited and sketched gardens and flower nurseries. Besides the flowers and insects, which were the frequent subjects of ancient painters, he also depicted the vegetables, stems, leaves, and sprouts. He was especially good at depicting colors in natural ways. One of the most prominent bird-and-flower painters of his day, he had a profound impact on later generations.

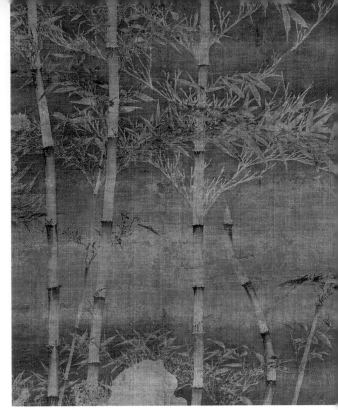

## Fig. 1 The Artist's Inscription

The practice of placing inscriptions on Chinese paintings became increasingly popular from the Song dynasty onward, demonstrating the growth of the value of the artist's identity. In *Bamboo in the Snow*, the artist is not identified, but on the stalk of bamboo behind the stone, he left a row of words, reading, "The price of this bamboo is 100 *liang* (roughly 3730 g) gold pieces," indicating how precious the image is.

## Fig. 2 Bamboo Stalk

There are three straight stalks of bamboo in the painting, reaching from top to bottom, along with several small or broken stalks. The bamboo here is not painted with ink, but is formed by rendering the background, with only thick bands of ink added to form the bamboo's joints. Here, there is evidence of the fineness of the artist's sketching, as he even drew the threads left on the broken parts of the bamboo.

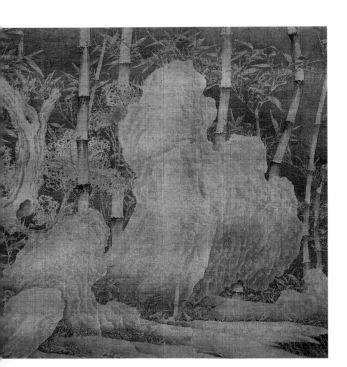

it was done. The painter first outlined the bamboo, stone, the dead tree and leaves in light ink. He then filled the space around these outlines with heavier colored ink to create a change in color. Then, in the part that needs to be emphasized, he uses outlines, texture strokes, dots, dye, and so forth, making the bamboo more prominent. This causes the surface of the bamboo, stones, and slopes to be lighter than the background, creating the illusion of snow. This technique is known as "borrowing background to make snow."

## Fig. 3 Stone

There are a few stones in the lower part of the painting, forming its center of gravity. The outline of the stone is formed by rendering the background, but in the stone's grain, crevices, and shadows, ink is used to create a three-dimensional effect.

# THE NIGHT REVELS OF HAN XIZAI

Gu Hongzhong (910–980)
Ink and color on silk
Height 28.7 cm × Width 335.5 cm
Palace Museum, Beijing

*The Night Revels of Han Xizai* depicts a historical event, a banquet at which Han Xizai (902–970) hosted guests during Li Yu's reign in the Southern Tang dynasty. There are five scenes recorded in the painting. Han Xizai appears in all five scenes, but he is always detached, unrestrained, and at times sullen or distressed. The complex characteristics of the people involved are clearly displayed, and we get a glimpse of the conflicts between the classes within the court in that turbulent context.

## Han Xizai

The main character in this painting, Han Xizai, was originally from Henan Province and later moved to Weifang in Shandong Province. His family served as officials for several generations, but his father was later beheaded at court due to his involvement in an uprising. As a result, Han's family had to flee to Nanjing, living in the Wu Kingdom during the Five dynasties period and Ten Kingdoms period (902–979). Later, the prime

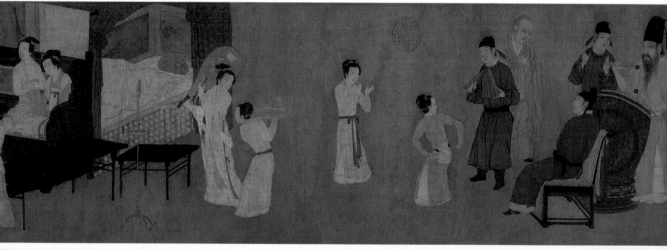

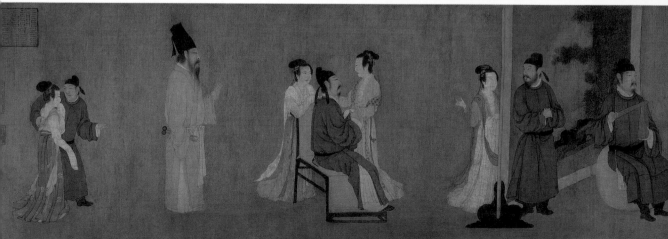

minister of the Wu Kingdom, Xu Zhigao (889–943), established the Southern Tang dynasty and became its emperor. Han Xizai served in his court and continued to advance. Later, he served in the court of Li Yu.

Han Xizai was multi-talented, skilled at painting and calligraphy, and music. He was a skilled politician, but because he had witnessed troubling trends at court, and because the emperor's power was diminishing, he indulged in song and revels throughout the night as a way to vent his frustration. He spent every night singing, cavorting, and generally ignoring his family's teaching, spending his fortune on entertainers while leaving nothing for himself and his family. During the Southern Song dynasty (1127–1279), Lu You (1125–1210)

In the history of Chinese painting, there are very few records concerning **Gu Hongzhong**. It is only known that he, who was skilled at figure painting, was a minister during Li Yu's reign in the Southern Tang dynasty. *The Night Revels of Han Xizai* is his only surviving work.

commented in *The Record of the Southern Tang* (*Nantang Shu*) that Han Xizai's behavior was a form of "self-contamination" to avoid being appointed prime minister of a conquered nation, since Li Yu had intended to appoint him prime minister.

## Motive for Producing the Painting

It is possible that *The Night Revels of Han Xizai* was drawn under the instruction of Li Yu to Gu Hongzhong. However, there are two possible motives for Li's behavior. First, it is possible he meant to appoint Han as

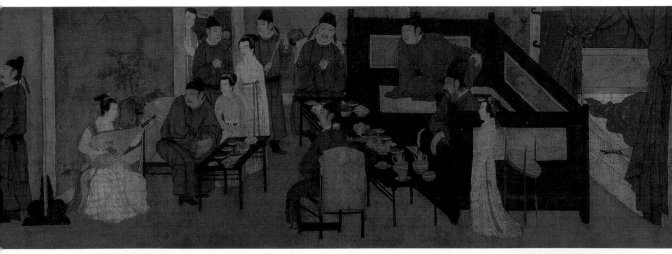

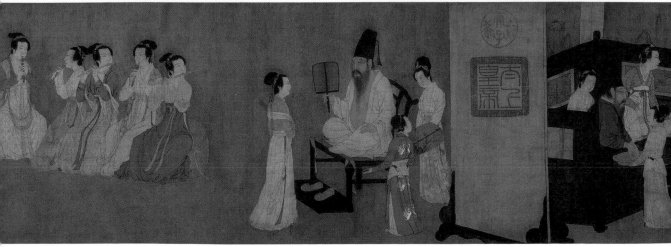

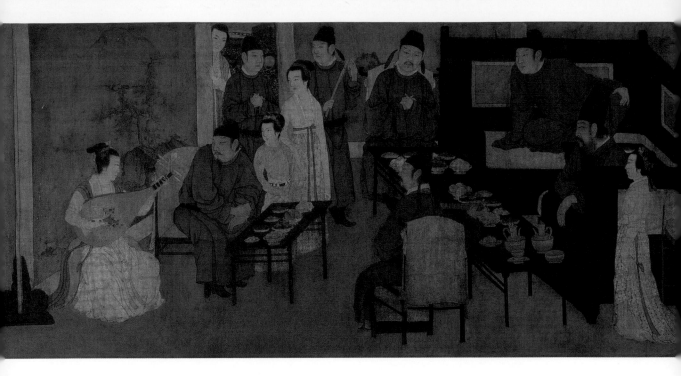

the prime minister, but when he heard how incredibly indulgent Han's lifestyle was, he thought of producing a picture of it as an admonition and had it sent to Han in hopes it would lead to self-reflection and correction of such habits. Of course, Han deliberately led an indulgent life and hence turned a deaf ear. Another possibility is that the painting was meant to be the confirmation of Han's behavior. When news of the revels had reached Li Yu's ear, he grew suspicious, and so commissioned a court painter to sneak into Han's residence and drew the scenes he saw as he spied there, allowing the emperor to have a better idea of what the situation really was.

## Scenes of Night Revels

For the above reasons, the painter depicts each scene in great detail, recording even the layout of the interior furnishings, dining utensils, and the characters' movements and interactions. The picture is segmented into frames to produce a narrative, much in the same way a comic strip unfolds. Each image is self-contained, and they are separated by screens or couches. At the banquet, there are scenes of musical instruments playing,

### Fig. 1  Listening to Music

In the first section of the scroll, Han and the rest of the figures are listening to music. In the image, Han and a top scholar Lang Can, in the red robe, sit on a day bed listening to a woman's music. The surrounding guests either sit or stand, and all the figures are recorded in history. For instance, Zhu Xian, an official, situated furthest from the viewer on the left side of the screen, stands holding a *bili*, a wind instrument, while Chen Zhiyong, in the center of the picture, sits facing away from the viewer.

Here, Han is wearing a green robe and a high hat, and he looks calm and content. He seems to be immersed in indulgence. There is a huge screen behind the musician playing *pipa* (a plucked four-stringed instrument), and a landscape is painted on the screen. The area from the screen on the left to the day bed on the right contains the scene "Listening to Music."

singing, and dancing, and the host and his guests are mingling boisterously, their joy and laughter carefully recorded. A total of 46 people are painted in the scroll, but it is evident from the faces and clothing that some appear in multiple scenes. One Yuan dynasty (1279–1368) scholar determined the identity of some of the figures by noting the political path of Han and his associates. The painting includes Han's official companions, his students, and well-known female singers of that time.

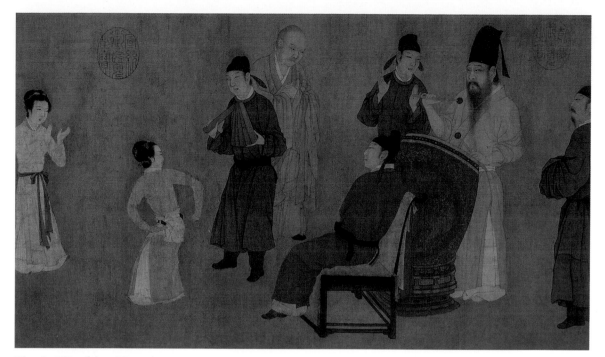

## Fig. 2  Watching Dancing

In this scene, Han and the rest watch his favorite dancer, Wang Wushan, dancing the "Six Little Dances." It is a dance characterized by allowing the sleeves to form the visual part while the footsteps sway in time with the rhythm of the music.

In this section, Han wears light-colored clothes with his sleeves pulled up as he plays a drum. The one sitting on the chair beside the drum is the top scholar Lang Can, who appears also in the first section. What is even more unique is that there is a monk depicted in this section too. He is a friend of Han, Monk Deming, and he, perhaps according to certain regulations, claps his hands together, standing in embarrassment with his back to the dancer.

## Fig. 3  Resting

After listening to music and watching the dance, Han rests on the day bed. The layout of the furniture is identical here to that of the first frame. It should be the same space, but viewed from a different angle. The household servants serve Han on both left and right. One of them holds a basin, in which Han washes his hands. On the other side, another servant holds a *pipa*, and another bends over a wine tray. The two seem to be talking.

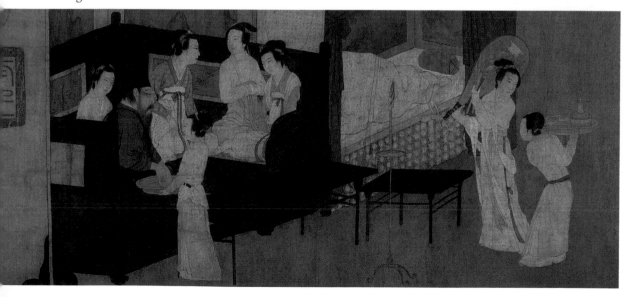

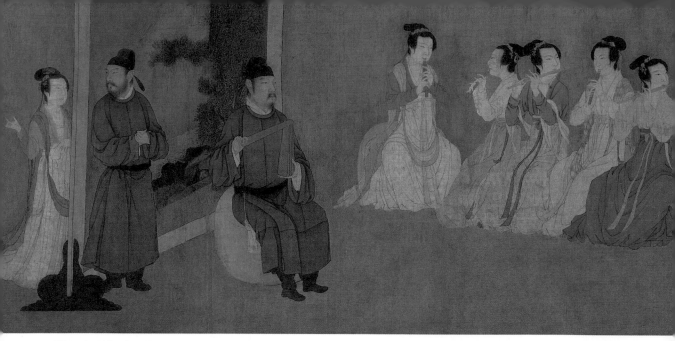

## Fig. 4   Playing Instruments

In this section, Han sits on a chair, enjoying the performance of a quintet. His chest is bare, and he holds a fan in one hand and seems to be keeping time to the music as he taps the other hand on his knee. The musicians sit side by side in the center of this image. Some play the flute while others plays the *xiao*, a vertical bamboo flute, each apparently independent of, but echoing the others. The man seated next to them beats the clappers to accompany them, and behind him, a bearded man stands talking to a woman behind the screen.

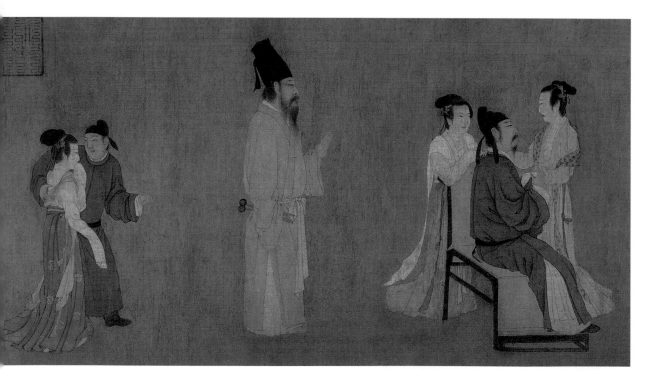

## Fig. 5   End of Banquet

In the final frame, Han Xizai waves farewell with drumsticks in his hands. On his left and right, his guests laugh with the women. Sitting on the chair on the right is Chen Zhiyong, who appeared in the first section. A close friend of Han's, Chen holds a woman's hands, looking into her eyes, reluctant to part, and she has a hand on his shoulder, as if comforting him. A woman stands beside them, listening to their conversation. Behind Han is Zhu Xian, who appears drunk. He has an arm around a woman and appears to be saying goodbye to her as they walk. She covers her face, apparently out of shyness.

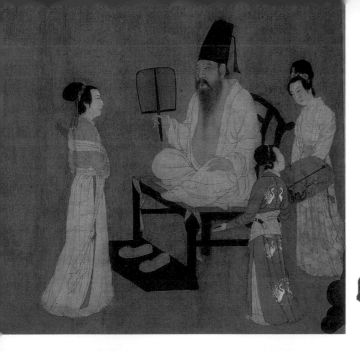

**Figs. 6–9
Ancient
Chinese
Musical
Instruments**

There are numerous ancient Chinese musical instruments in this painting, including drums, flutes, *xiao*, clappers, and *pipa*, offering insight into the appearance and playing style of these instruments. From fig. 6, we see that the picture painted on the surface of the *pipa* is very beautiful. In the Shosoin in Nara, Japan, we still see ties to China's Tang and Song dynasties' *pipa*, but the playing style is completely different. In the picture, the woman plays with a pick, but today, it is played with the fingers.

**Fig. 6   *Pipa***

**Fig. 7   Drum**

**Fig. 8   Clappers**

**Fig. 9   Flute and *Xiao***

**Fig. 10   Lang Can**

**Fig. 11   Monk Deming**

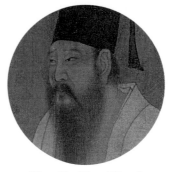

**Fig. 12   Han Xizai**

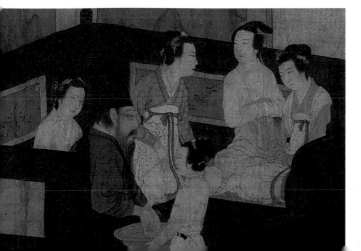

**Fig. 13   Figure Painting Technique**

The characters in the painting are portrayed accurately and subtly. The lines are smooth and the colors beautiful and elegant. The ladies' simple makeup and gorgeous clothing forms a perfect contrast to the black and gray clothing of the men.

**Figs. 10–12
Demeanor**

The characters in the painting are vividly portrayed, as seen in the movement of Lang Can, the top scholar, who seems to lean forward and listen attentively, and the deliberate avoidance of Monk Deming, as well as the carefree attitude of Han Xizai.

# ALONG THE RIVERBANK

Dong Yuan (Five dynasties period, Southern Tang, dates unknown)
Ink on silk
Height 221 cm × Width 109 cm
Metropolitan Museum of Art, New York

In his summary of the history of Chinese painting, the Ming dynasty (1368–1644) painter and critic Dong Qichang (1555–1636) divided Chinese painting into Northern and Southern Schools. The Southern School was represented by the Tang dynasty painter Wang Wei, and the Northern School by Tang dynasty painter Li Sixun and his son

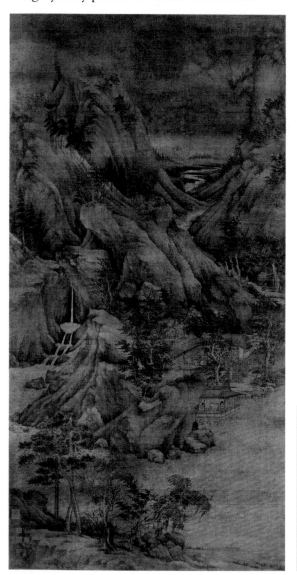

Li Zhaodao. Dong Yuan was the Southern School painter most admired by Dong Qichang. Because several of Dong Yuan's works are still extant, he provides excellent insight to the Southern School for later generations. However, *Along the Riverbank* presents a valley, stream, and village scene in a unique painting method, and it is quite different from Dong's three major works, *Waiting at the Crossing in Summer*, *Scenes of Xiao and Xiang Rivers*, and *Mountains in Summer*, which are collectively known as Xiaoxiang Scrolls. This distinction highlights the importance of the *Along the Riverbank* scroll, which has led to much debate in academic circles because of its distinctiveness, making it a classic example of the problems involved in identifying ancient Chinese paintings.

## Scenes of the Mountain Stream

There is a pavilion in the lower right hand corner of the painting. A literati leans against the pavilion. On one side of him, his wife, carries a child, while another child stands on his other side. Behind the pavilion is a village, with several buildings arranged around a courtyard. One woman prepares food in the courtyard, while another runs along a covered corridor carrying food. There is a mountain trail behind

**Dong Yuan** was a native of Zhongling, which today is understood to be either modern-day Nanjing, Jiangsu Province, or Jinxian, Jiangxi Province. He was a court painter who excelled in landscapes. In the Northern Song dynasty text *Seeing the Mind in Painting* (*Tuhua Jianwen Zhi*), Guo Ruoxu (dates unknown) states that Dong Yuan's style of ink and wash painting was similar to Wang Wei's and his coloring similar to Li Sixun's. Dong was also skilled at depicting oxen, tigers, and other animals.

**Fig. 1 Technique for Painting Trees**
At the bottom of the scroll is a row of trees, among which are three tall, straight pines that have been painted with extreme care. The bark on the trunks is drawn with fine, round strokes. The pine needles are painted first by outlining each needle, then lightly dyeing them. Near these three pines are several smaller trees depicted in less detail, with simple branches and randomly placed leaves.

**Fig. 2 Technique for Painting Rocks**
The method used for painting the rocks in this picture is different from the hemp fiber texture strokes found in Dong Yuan's other work. It has been shaped like a stretch of cloth, then scattered, which is an excellent technique for depicting the terrain in Jiangnan. It is also different from the texture strokes seen in works from the Five dynasties period. The painter depicts light and shadow only through color, then uses the brush and ink to rub the outline and overlaps in the rock.

the village, extending into the mountains that fill the upper portion of the painting. The two slopes are very steep, and a stream flows from the distant reaches, making the image more dynamic. The other scene is on the left side of the village. A waterfall cascades down from the mountain, falling into the stream.

## International Debate

As mentioned earlier, because the style of the *Along the Riverbank* scroll is so different from that of Dong Yuan's three Xiaoxiang Scrolls, and because its history of circulation and collection is so murky, the question of its authenticity has incited much controversy. In December 1999, at the Metropolitan Museum of Art's symposium "Issues of Authenticity in Chinese Painting," many Chinese and foreign scholars held a heated discussion regarding the *Along the Riverbank* scroll, which mainly included three competing views. The first saw it as a copy by Zhang Daqian (1899–1983), the second viewed it as originating in the Five dynasties period, possibly painted by Dong Yuan himself, and the third that it dated from no later than the Northern Song dynasty.

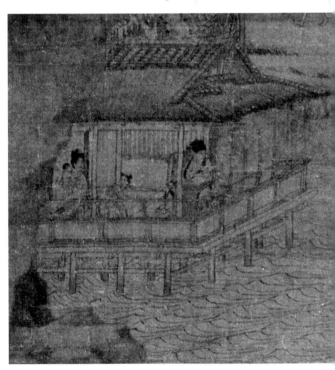

**Fig. 3 Water Pavilion**
On the banks of the stream is a water pavilion, painted with great delicacy. Its roof is tiled and thatched, its railings clear, and its structure sturdy. The four figures in the pavilion are vividly depicted. The literati leaning at ease on the balustrade wear hoods, wide robes, and large sleeves. There is a calligraphy hanging behind the female figure.

# EARLY SNOW ON THE RIVER

Zhao Gan (Five dynasties period, Southern Tang, dates unknown)
Ink and color on silk
Height 25.9 cm × Width 376.5 cm
Palace Museum, Taibei

*Early Snow on the River* depicts a cold scene after the snow, with a layer of snow covering the reeds along the riverbank. The fishermen fish on cold waters, and travelers struggle in the cold wind. The figures in the scroll are vivid and precise, and the ripples on the water are painted with sharp, fluid, meticulous lines.

## Early Winter Fishing Scene

Fishing is the main theme of the *Early Snow on the River* scroll, with figures who look like children fishing on the shore or in a hut. There are also fishing boats, and some fishermen even stand with bare feet in the cold waters where they fish.

Opening the scroll, there is a view of reeds blown in the wind. On the small road where the reeds sway, two travelers pull the boat and press ahead against the cold wind. One person on the boat holds a barge pole, presumably because the weather is bad and the fishing boat is difficult to control.

There are four children on the riverbank. One is hiding in the bamboo forest, peeking at the four people on the opposite side of the river. The other three hold a net, waiting to catch fish. At the end of the picture is a place perhaps set aside for the fishermen to rest. Two fishing boats are docked by the tree and a bearded man cooks for the children, with smoke rising above the fire. The hint of green visible on the stones near the boat indicated that winter has just arrived.

## Interpreting the Painting

One cannot help but wonder why a court painter like Zhao Gan created a painting depicting such hardship. Some experts believe that besides recording the affairs of the royal family or national-level political events as a form of praise to their patrons, court painters

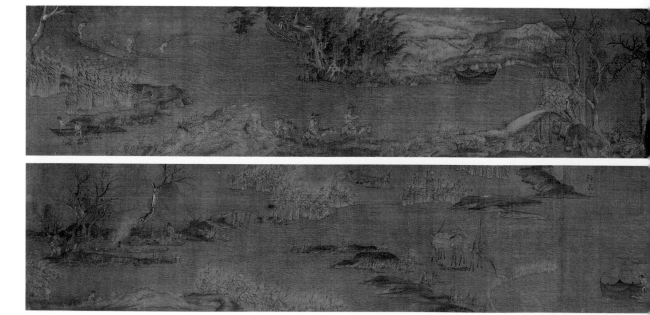

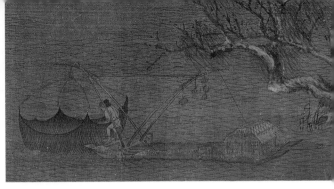

## Fig. 1 Sprinkled Powder for Snow

The snow in the picture was painted as powdered snow. Even today, an irregular sprinkling of powder is evident on the scroll, a method of depicting snow that is unique in the history of Chinese painting.

## Fig. 2 Fisherman and *Zeng*, a Square Fishing Net Supported by Sticks

The fishing method depicted in the painting is called *zeng*, an ancient method used as early as the Warring States period (475–221 BC). This method uses a bamboo stick as a frame to pull the four corners of the net, catching any fish that swim into it. Fishermen often appear in Chinese literary texts and paintings, representing the basic way of life of ancient Chinese people.

at the time were also tasked to act as the emperor's eyes and ears, creating images of life outside the palace and officials' private life as paintings that played the official function of allowing the emperor to understand the world outside the royal court. It is possible that *Early Snow on the River* was produced when Zhao traveled among the people, then reproduced the situation he found there.

On the other hand, some experts have noted that the scroll is very similar to the poem *A Fishing Legend* by Tang dynasty poet Wang Wei, particularly in two of the figures towing a boat depicted in *Early Snow on the River*. For this reason, the scroll is seen as a response to the poem.

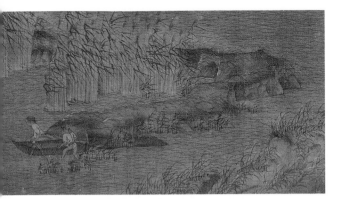

## Fig. 3 Technique for Painting Rocks

According to historical records, Zhao Gan once took Dong Yuan as a teacher. It is evident that the style of painting employed in this painting is that of Dong Yuan. The stones in the painting are painted with simple, slightly blurred hemp fiber texture strokes, and dyed with color.

**Zhao Gan**, a native of modern-day Nanjing, Jiangsu Province, was a student of the painting academy during Li Yu's reign in the Southern Tang dynasty period. He excelled at landscapes, and was particularly skilled in composition and layout, focusing on Jiangnan scenes in his work. He painted beautiful, soaring landscapes, which he decorated with buildings, boats, and people.

# STORIED MOUNTAINS AND DENSE FORESTS

Ju Ran (active in the second half of 10<sup>th</sup> and early 11<sup>th</sup> century)
Ink on silk
Height 144.1 cm × Width 55.4 cm
Palace Museum, Taibei

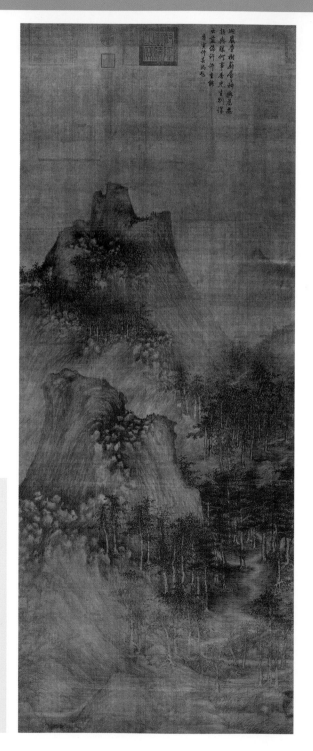

In Dong Qichang's theory of distinguishing the Northern and Southern Schools, Wang Wei is credited with creating the Southern style of shading light ink, which was later inherited by Zhang Zao (Tang dynasty artist, 8<sup>th</sup> century), Jing Hao, Guan Tong, Dong Yuan, Ju Ran, and others. *Storied Mountains and Dense Forests* is a masterpiece of this shading light ink style, and Ju Ran is one of the prime examples of the Southern School style of painting.

## Shading

It is often said in Chinese painting that ink can be divided into five colors, meaning that by altering the ratio of ink and water, different colors of ink are produced. Shading means that pigment (or ink) is applied lightly to the paper. This sort of light ink has a saturated moisture content. It is a completely different style of painting from that of Li Sixun, which is rich in colors, and is more suited to creating Jiangnan landscapes. In his early years, Ju Ran lived in Nanjing, where there was plenty

**Ju Ran**, a native of modern-day Nanjing, Jiangsu Province, was a monk. He was proficient at landscape painting. He lived through the fall of the Southern Tang dynasty and the establishment of the Northern Song dynasty. He was employed in the Kaiyuan Temple in Nanjing, capital of the Southern Tang, and with Li Yu, he was later relocated to Bianjing (now Kaifeng, Henan Province), which became the capital of the Northern Song. There, he stayed in the Kaibao Temple. Ju Ran may have been a student of Dong Yuan in Nanjing. He was already a renowned painter during the Southern Tang. After entering the Song court, he painted murals on the northern wall of the most prestigious cultural institution of his time, which was praised by many of his contemporaries.

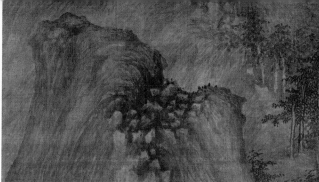

## Fig. 1 *Fantou*

*Fantou* is a term for a technique in Chinese landscape painting, indicating that the stone on the top of the mountain resembles the shape of the crystal aluminite. In *History of Painting (Hua Shi)*, the Northern Song dynasty calligrapher, painter and art theorist Mi Fu suggested that *fantou* was a technique Ju Ran employed early in his career. If such a statement is correct, then *Storied Mountains and Dense Forests* can be dated to his early years, when he was in Nanjing.

## Fig. 2 Long Hemp Fiber Texture Strokes

Hemp fiber texture stroke is a technique of texture method commonly used by Dong Yuan and Ju Ran. Dong Yuan often uses short hemp fiber texture strokes, while Ju Ran prefers long hemp fiber texture strokes to depict the texture of stone.

of humidity and fog frequently appeared, concealing the shape of the mountains and making them appear rippled. Wet ink created just such a light, uncertain style.

## Haze

Haze (or mist that drifts through the mountains) has no specific form, erratic and difficult to render. However, in many painting theories of successive dynasties, Ju Ran is often associated with mist, demonstrating that he was a true master of painting it. In this painting, there are two conical hills, with a gap between them leaving blank. This is the mist and it continues to the hills in the distance, hiding the mountains, save for their blurred outline.

There is also mist in the lowest mountain pictures. Some grass and trees are painted very lightly on the ground. The painter uses this technique to show the plants beneath the mist.

## Space

The relationship between the three hills constitutes the picture's notion of space. Chinese painting does not use perspective in the way Western painting does, so its sense of space comes from the mode of viewing. The great Song dynasty painter Guo Xi once summed up three aspects of painting

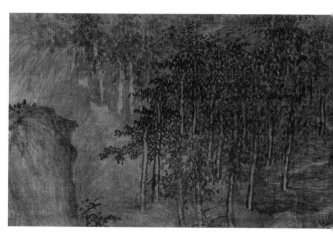

## Fig. 3 Technique for Painting Trees

Ju Ran's painting employs a very freehand style. He paints the trunk of the tree with two strokes, then paints the leaves with brush in an upright position. The color of the ink is suitably varied, and the brush uses a quick stroke, making for clean, tidy lines.

as "upper distance," "deep distance," and "level distance." From the word "distance," we can understand the artist's expansion of the space plane, which is realized through the relationship between the mountains. For instance, "upper distance" is "from the foothills to the peaks," while "deep distance" is from "before the mountain to behind it," and "level distance" is "from the near mountain to the distant mountain." From *Storied Mountains and Dense Forests*, we see that the viewer's visual point is the top of the near mountain, while the length of mist stretches from the near mountain to the distant mountain. This is what is meant by level distance.

# TRAVELERS AMONG MOUNTAINS AND STREAMS

Fan Kuan
Ink on silk
Height 206.3 cm × Width 103.3 cm
Palace Museum, Taibei

This painting is representative of Fan Kuan's work. It is two meters tall, which makes the mountains seem like walls, creating an imposing feel. This painting typifies Northern Song dynasty landscape paintings.

## Majestic Northern Landscapes

A thin spring flows down from the mountains in a stream, recalling the artistic conception of "flying down three thousand feet as if the Milky Way were falling down from the Nine Clouds." A big stone sits at the edge of the stream, and between the dense forest, a group of people with horses loaded with cargos enters the picture, walking on a rugged trail through the mountains. These are either merchants on a journey to conduct business, or wanderers returning home. This group of travelers appears to be extremely small against the backdrop of the majestic mountains. The towering mountain above them is almost

at the center of the painting, and it pushes against the top. The tall peaks touch the sky, and the rounded highest peak is surrounded by lower mountains. The forest cascades down the slopes, adding to the stability and monumental effect of the painting.

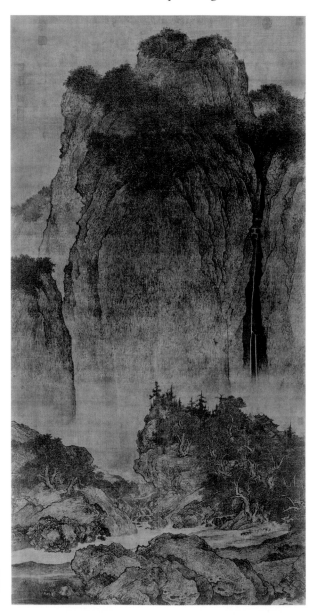

**Fan Kuan**, a native of modern-day Tongchuan, Shaanxi Province, first studied painting under Li Cheng, then under Jing Hao. When he later traveled in Zhongnanshan Mountain, after observing the changes in the natural world, he realized that the ancients were not as suitable as nature to serve as instructors for examining the artist's inner world, thus moving from learning from the masters to learning from nature, and ultimately to following one's own heart. The latter is seen as the highest level of painting in traditional Chinese aesthetics. He put this idea into practice in his own artistic work, drawing inspiration from nature and expressing his own inner world through his painting. As a result, the spirit of the mountains is most evident in his paintings. In his landscapes, raindrop texture strokes and dense forests are common. The trees tend to lean to one side, and the water often flows around large stones, creating a unique style.

**Fig. 1 Technique for Painting Trees**
As noted by the Song dynasty painting and calligraphy connoisseur and art history critic Guo Ruoxu in *Seeing the Mind in Painting* (*Tuhua Jianwen Zhi*), Fan Kuan's trees tended to lean, almost seeming to fall over. He used simple, short brushstrokes to paint the trunks and leaves.

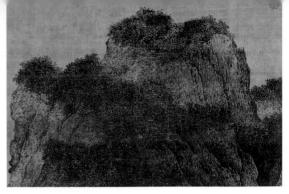

**Fig. 2 Dense Forests**
In *History of Painting*, Mi Fu said that Fan Kuan was particularly skilled at painting dense forests on mountains. These forests, which densely cover the slopes, along with the shrubs, create greater texture in the rocks.

## The Theme of Traveling

Huge mountains are often contrasted with figures to set off the hardship of a journey. Travel is a common theme in the writings of ancient poets, and it eventually evolved into a genre of poetry. The Chinese literati often left home for the sake of their careers or due to wars. When they went to battlefields or to take up a new post, they often felt homesick or confused about their future. This led many poets to rely on the scenery encountered along their journey to commemorate their feelings. Painters refined the imagery of poetry into concrete physical objects, such as mountains, rivers, sparse forests, bridges, rustic hotels, temples, pavilions and other buildings, teams of horses, or groups of travelers. The bitterness and tribulations of the travelers is demonstrated in paintings that take travel as their theme, which over time became a common theme in Chinese art.

**Fig. 3 Raindrop Texture Strokes**
Fan Kuan creates greater texture in the rocks by using the raindrop texture strokes, which involves placing force on the center of the brush in drawing, along with the occasional use of the side of the brush. These raindrop-shaped strokes are drawn rapidly, with a quick movement of the brush. Because it is also shaped like a sesame seed, "sesame texture strokes" is another name commonly used for this technique. It is a very suitable method for use when depicting Northern landscapes, as it more fully captures the hard, heavy feeling of the northern rocks.

## The Author's Hidden Signature

The author of this work was not recorded in earlier records, but in 1958, the former vice president of the Palace Museum in Taibei, Li Lincan, found the characters "Fan Kuan" among the trees in the right corner of the frame, revealing the long-hidden identity of the painter. Such covert signatures were common practice among Song dynasty painters. In order to avoid altering the overall effect of the work, the painter would sign his name between leaves or trees, integrating the signature into the painting, thereby achieving the dual goals of fixing his name to his work and not affecting the overall coordination of the painting.

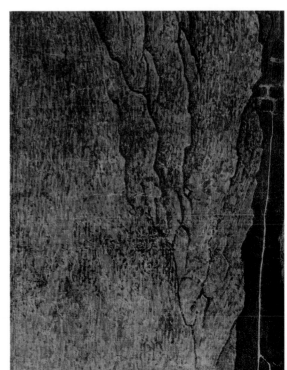

# PAVILIONS ALONG THE YANGTZE RIVER

Yan Wengui (Northern Song dynasty, dates unknown)
Ink and color on paper
Height 31.9 cm × Width 161.2 cm
Osaka City Museum of Fine Arts

Yan Wengui was skilled at integrating mountains, waters, boats, paddle boats, pavilions, and other similar structures, which led to an ingenious, independent style in his paintings. As a result, his landscapes were called "Yan style scenes." *Pavilions along the Yangtze River* is an example of a small river scene. It is not large, but exquisitely arranged and extremely open.

## Pavilions, Mountains and Waters

Unrolling the scroll, a long range of mountains and lush trees comes into view.

**Yan Wengui**, a native of modern-day Huzhou, Zhejiang Province, was a renowned painter of the Northern Song dynasty. He was mainly active during the reigns of Song Emperor Taizong (939–997, reigned 976–997) and Song Emperor Zhenzong (968–1022, reigned 997–1022). It has been said that during the Taizong period, Yan Wengui took a boat to the capital, where he made a living by selling his paintings. He was recommended to the court by Gao Yi (dates unknown), a painter who was amazed by Yan's work when he happened to pass by and see it. As a result, Yan Wengui became a court painter. He excelled at landscapes and figure paintings.

The marshes in the distance extend to the middle of the river, and a row of trees sweeps to the right, showing the force of the wind. The view of the structure in the center of the painting is shrouded in looming clouds and magnificent rocks, creating a cool wonderland. At the end of the range is a towering peak, the highest in the painting, surrounded by lower mountains. The residence is nestled in the foothills, and several woodcutters returning from a journey of collecting wood are entering the courtyard, while another group crosses the bridge. The waterfall plunging from the mountain merges with the river below, and the water flows rapidly, rushing to the edge of the picture.

## Yan Style Scenes

The term "Yan style scenes" was coined by Yan Wengui's contemporary Liu Daochun (dates unknown). Liu said, "Paintings of flowing waters will be known as 'Yan style scenes' from now on." In his *Successful Paintings (Hua Ji)*, the painter Deng Chun (dates unknown) in the end of Northern Song dynasty called Yan Wengui's "work in landscapes elegant and charming … a style

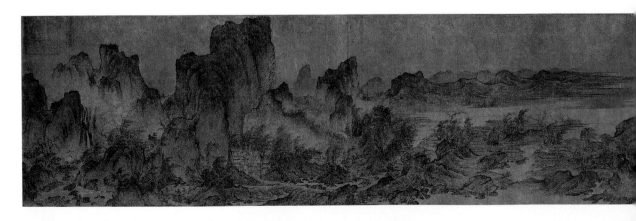

## Fig. 1  Buildings

A group of buildings is situated in the center of the image of the river, built on the waterfront. The painter did not use a ruler to draw the buildings, and applied light color to the columns.

called in the painting academy the 'Yan style.'" It is evident that this elegant, charming style was typical of Yan's scenery. According to records of Yan's work, his scenes were in stark contrast to Fan Kuan's style. Yan and his disciples spread the peaks out with sharp, delicate brushwork, and the riverside halls and pavilions are clouded with the line painting technique. Hazy clouds surround the river, the trees are lush, the mountains are expansive and overlapping, and the landscape is drawn with a lively atmosphere, meeting the viewer's need for a living scene to appreciate.

As a recipient of the "Yan style scenes" tradition, Song dynasty painter Qu Ding (dates unknown) can be called Yan Wengui's most distinguished disciple. Because of his use of the style in *Summer Mountains*, now housed in the Metropolitan Museum of Art in New York, the work was once attributed to

## Fig. 2  Village

Depicting views of life is one of the characteristics of "Yan style scenes." In this painting, there is a village nestled in the foothills in the back part of the painting. The people in the village are busy at work. Three people are returning to the village, with one already inside the gate and the other picking up firewood, entering behind him. The figure holding the umbrella may be resisting a wind blowing from the left.

Yan Wengui. According to research conducted by Fang Wen (1930–2018), Yan's work was more open and free and the brushwork includes repeated texture strokes and smudges, while *Summer Mountains* is more in line with descriptions of Qu Ding's work as recorded in the history of Chinese painting.

## Fig. 3  Technique for Painting Stones

The contours of the rocks in this painting are powerful, and varied in thickness and spacing. The stone surface is dyed with smaller dabs of the brush. This painting is very similar to *Travelers among Mountains and Streams* (see page 58).

# BIRDS AND THORNY SHRUBS

Huang Jucai (933–993)
Ink and color on silk
Height 97 cm × Width 53.6 cm
Palace Museum, Taibei

During their own time, the paintings of both Huang Jucai and his father were great favorites of the royal family, and they were collectively known as "treasures of the Huang household." Huang Quan's style was gorgeous, suited to the rich atmosphere and decorative tastes of the court, making his system well loved by the royal family. It eventually became the main basis for paintings in the early Northern Song dynasty, and it holds an important place in the

**Fig. 1   Partridge**
In this painting, there is a blue, red-beaked partridge, which belongs to the crow family. Its body grows up to 54 to 65 cm long. Both male and female have similar feather markings. The body is bluish purple and the tail feathers long, with the two in the center being especially prominent. The tail is white, and the beak and feet are red. It has a solemn, elegant appearance.

tradition of bird-and-flower painting. *Birds and Thorny Shrubs* depicts a small scene in late autumn, with streams, stones, thorns, clumps of bamboo, and various birds. This sort of work in which vitality is highlighted in bleakness is unique to the "treasures of the Huang household."

## A Small Scene in Late Autumn

On the right side of the center of the painting, there is a huge rock. Several withered trees stand behind it, with only a few bare branches remaining. It is easy to imagine that it is winter or late autumn. A few tufts of bamboo leaves have yellowed under the withered tree,

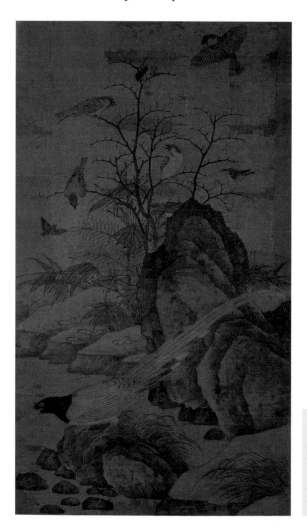

**Huang Jucai**, a native of Chengdu, Sichuan Province, and was the youngest son of Huang Quan. He inherited the traditional family teaching from his father, and was skilled at painting flowers, bamboo, and birds. He was especially known for his sketching and was more highly praised than his father.

**Fig. 2  Lake Stone**
The lake stone in this painting has been only vaguely formed by rubbing, with an outline in ink line. Only a small amount of ink is used to emphasize the grain of the stone.

and fallen leaves are scattered on the ground. The stream is dry, leaving the rocks exposed. A partridge perches on the rock, with red beak and black head. It has white, flowing feathers, and it stretches its neck, as if it wants to eat or drink something it cannot quite reach. There were six tits perched on the branches among the thorns, all in different postures. Each minor movement creates a vivid, dynamic image, with a feeling of immediacy.

## Unique Composition

Compared with paintings from the same period, *Birds and Thorny Shrubs* is unique and has a decorative purpose. Primarily, the painter gives attention to the relationships and transitions in the composition. The partridge

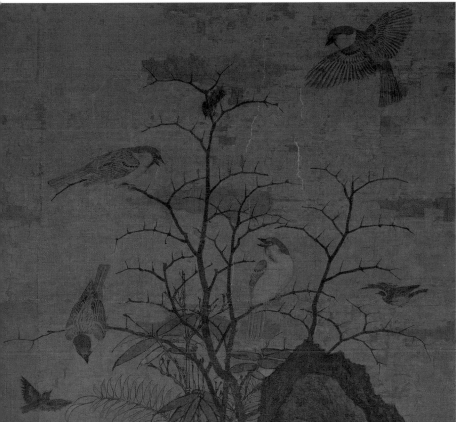

is close up, the rock and slope in middle distance, and the birds in the far distance, creating a feeling of movement, density, and size. Further, the painter has arranged the position of each object along a central axis, a compositional method often seen in Tang dynasty tomb murals.

**Fig. 3  Tit**
The painter has included six tits, creating a sense of distance by drawing the three nearer birds larger than those flying in the distance. Each is in a different posture, either perched or looking around it.

# BIRD ON A SNOWY BRANCH

Li Di (Northern Song dynasty, dates unknown)
Ink and color on silk
Height 115.2 cm × Width 52.8 cm
Shanghai Museum

*B*ird on a Snowy Branch depicts a small scene after snow, with bamboo leaves lightly touched with fine snow, upon which a shrike is perched.

## Bird on a Snowy Branch

In the painting, a Chinese grey shrike (*Lanius sphenocercus*) perches on a twig, surrounded by a cluster of bamboo. Bamboo leaves and dead wood are covered with a layer of snow, and there is almost nothing on the slope below, aside from a bunch of straw. The clear intent is to depict the chill of winter. The shape of the shrike is accurate, and the feathers on the body are drawn in vivid details. It perches in solitude on the branch, creating a solemn, austere feel.

## Panoramic Composition

The painter adopts a closely knit panoramic composition, arranging the objects from the bottom to the top of the picture. It is evident that the trunk is drawn vertically across the painting, curving in an S-shape to prop the overall image. The left side is densely laid out,

while the right side is sparser. Similarly, the lower portion is dense, and the upper sparse. The layout of the bamboo likewise follows the dense-sparse pattern, which is commonly seen in Chinese painting.

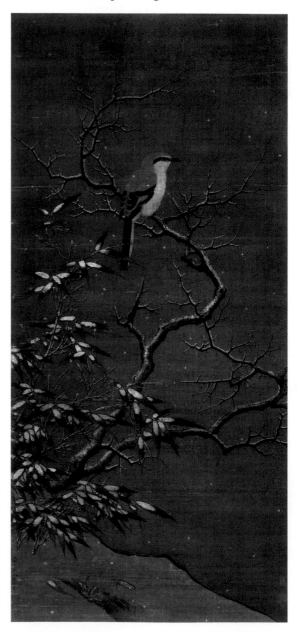

**Li Di**, a native of today's Mengzhou, Henan Province, worked in the Northern Song dynasty imperial painting academy. He was a key figure in painting circles of his time, and many painters took him as a teacher. Chinese historical records note that Li Di's bird-and-flower albums were often subtle, and the birds were presented in different forms. He excelled at the use of ink, often employing techniques of rendering rather than portraying, which was often disregarded by scholar-officials, who found his style mundane, but his works are vivid and natural, with a touch of exquisite elegance.

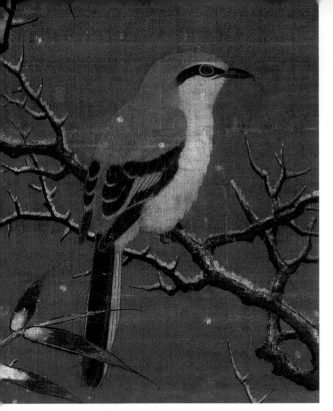

## Fig. 1 Chinese Grey Shrike

The Chinese grey shrike in the painting is characterized by its strong beak and the black pattern running from front to back around the eye. This sort of bird is one of the larger shrikes. Its tail and flying feathers are black, and the tail is long and curves downward.

The painter's depiction is consistent with that of an actual shrike, but the bird is not depicted with a single layer of plain coloring. The feathers are finely portrayed, layered, then re-outlined with fine lines. Even the white down on the breast is drawn in great detail.

## Fig. 2 Three-Dimensional Presentation of the Branches

Most Chinese paintings are flat objects, but the branches in this painting look three-dimensional, as seen in the play of light and shadow on the branches, alternating between bright and dark. In fact, this is the result of the painter's treatment of the snowy scene. On one side of the branch, a layer of white is painted in a method of spreading snow (i.e., sprinkling white powder), which not only depicts the snowy scene, but also forms a contrast of dark and light on the branches, resulting in a three-dimensional effect.

## Fig. 3 Technique for Painting Snowy Bamboo

The method for painting bamboo was very popular during the Northern Song dynasty. First, the shape of the bamboo is drawn with an ink line, then the interior space is filled with color and layers rendered to change the color. At the joint of the bamboo leaves and branches, the artistic effect of white snow is achieved, and finally, veins are drawn in the bamboo leaves, starting from the tip. The painter excels in the use of calligraphic strokes, displaying the state of bamboo leaves in the cold of winter, even adding ochre color to the tips of some leaves.

In contrast to this painting, Xu Xi's *Bamboo in the Snow*, in which the background is more evident, with the method of alternating ink and leaving blank space on the bamboo leaves, uses a unique approach.

# WINTERY SPARROWS

Cui Bai (1004–1088)
Ink and color on silk
Height 25.5 cm × Width 101.4 cm
Palace Museum, Beijing

Cui Bai's bird-and-flower paintings differ from Huang Quan's rich, noble painting, having a lighter, livelier style that was revolutionary at that time. It is said that he once tutored Song Emperor Huizong (1082–1135) and that his own work was highly valued by the emperor, resulting in him to become an influential figure at the painting academy in that time. This picture depicts a withered branch with nine sparrows flying around or perching on it in winter. The composition of the painting is ingenious and well-arranged, with both divisions and connections between the moving and static parts.

## Composition

The objects in the painting are arranged on a horizontal scroll. The withered tree and its branches run across the entire picture. The nine sparrows are arranged in three groups around the withered tree. The density of the arrangement is appropriate, with the two groups on the left side being situated more closely together, while the one on the right is more sparsely arranged. In each group, the

**Fig. 1  Sparrow**

The painter drew the outline of the sparrow with a dry stroke and delicate, powerful lines, particularly on the flying sparrow and its beautiful, vivid outspread wings. Each feather is carefully depicted, its contours first outlined in ink, then rendered in light ink. And finally the dark ink is used to emphasize light and shadow. The sparrow's expression is also vivid, its eyes intense, and its beak strong and short, demonstrating the artist's skill.

sparrows assure different postures, echoing one another as they combine movement and stillness, forming a rhythmic series.

This aspect of the layout benefits from the painter's capability in overall design. Because of their length, most of the paintings on

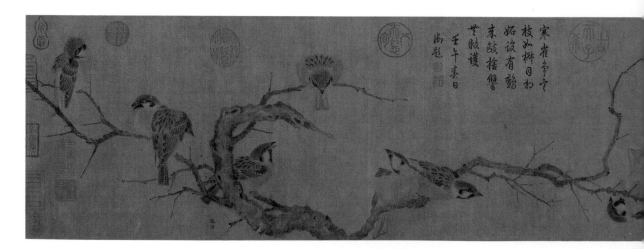

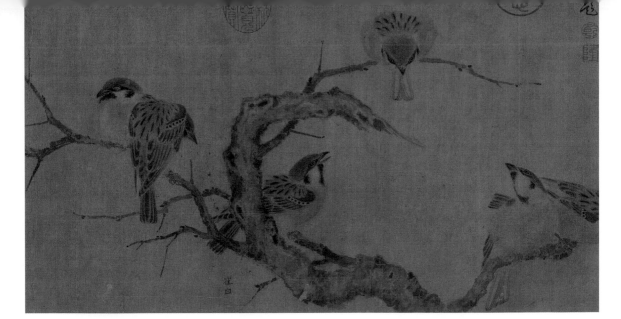

## Fig. 2  Technique for Drawing the Withered Branch

In the painting, the withered branch is mainly produced with smudged ink using a brush dipped in ink without any water. This chafing or scraping method is a Chinese painting technique to create the texture and shadow of stones. Here, the artist deliberately avoids depicting the object, but instead produces the image entirely in ink with brushwork of rare quality. This technique, aiming at an elegant and effortless effect, is unique to Cui Bai.

handscrolls begin from the right, so that, with each new part that is revealed as the viewer opens the scroll, the overall painting comes more fully into view, including the plurality employed in the composition of the piece. The full view of the painting generates a feeling of an endless view. However, because this painting is small, the artist abandoned the right-to-left order of drawing, beginning

instead with the withered tree in the center of the scroll. The branch is thicker on the left, with the upper part twisting toward the right side. On the right, the long and thin branch twists, extending all the way to the top of the scroll. At the beginning of the scroll, another twig reaches toward the top, breaking the empty space on the upper portion of the scroll, which renders it an ingenious design.

## Three Groups of Sparrows

The three groups of the nine sparrows are arranged with the first group, consisting of five sparrows, situated on the left side, along with two twigs protruding from the trunk. The one on the far left turns to peck its feather, and the one on the right looks back at it. The next sparrow, with its back facing the viewer, looks down and to the right at something behind the branch. Another bird, facing the upper right, seems to be screeching, and in the direction of its gaze is another bird, this one looking at the ground.

The second group consists of two sparrows in the center of the scroll. These two birds serve a connecting function. One looks to the left, echoing the first group of birds, while the other stretches straight toward the next group, which it is facing.

The final pair of sparrows is very lively, with one hanging upside down from a branch while the other flies through the air.

**Cui Bai**, a native of today's Fengyang, Anhui Province, was an extraordinarily talented person who was also known for his good temperament. He was skilled at painting flowers, birds, fish, and insects, especially sketches. He also painted landscapes, figures, and Taoist and Buddhist paintings.

# MAGPIES AND HARE

Cui Bai
Ink and color on silk
Height 193.7 cm × Width 103.4 cm
Palace Museum, Taibei

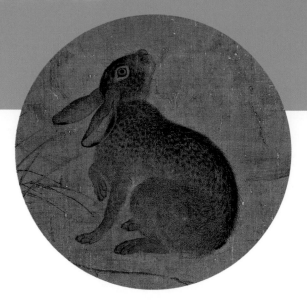

According to the historical records of Chinese art, the composition of Cui Bai's paintings is unique, with *Wintery Sparrows* often cited as a prime example. *Magpies and Hare*, a huge vertical scroll, however, is in no way inferior by comparison. This painting depicts the late autumn season when the leaves are falling and the grass is barren. The magpies are landing on a dead, thorny branch, and their fluttering wings have captured the

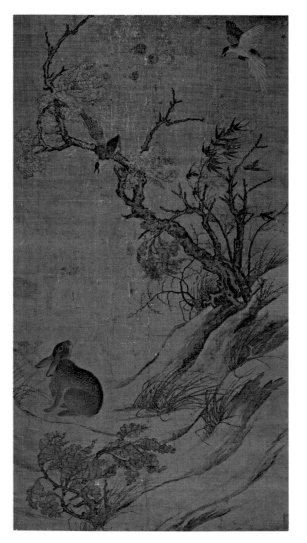

### Fig. 1  Technique for Painting the Hare

The hare in the painting is depicted meticulously and accurately. Its fur is brown and black, and the black spots on the head and back are very realistic. Using smudges, the fur is drawn with a fine brushstroke. These brushstrokes change with the shape of the body, like the long, fluffy fur on the back, the short, curly fur on the legs, and the dark inner fur and brown outer fur on the ears. The hare's eyes are captivating. They are drawn first with ink circles, then filled with gamboge, and finally touched with thick ink. This forms the spirit of the rabbit's eyes.

attention of a hare on the ground below. The hare sits gazing up over its shoulder at the pair of magpies.

## Identifying the Artist

The artist did not name the painting himself. It has become known as "Double Happiness" in Chinese, perhaps because of the pair of magpies in the painting. In the Qing dynasty, it has collected in the *Shiqu Treasure Book* (*Shiqu Baoji*), an anthology of calligraphies and paintings of the Qing dynasty royal family, and since then it often been referred to as the "Song Double Happiness Scroll." It was not until the 1960s that someone discovered the painter's signature on a small branch on the right side of the picture, identifying the Northern Song dynasty painter Cui Bai as the artist.

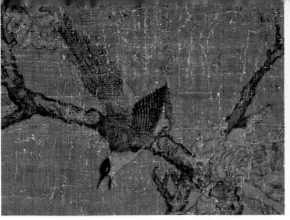
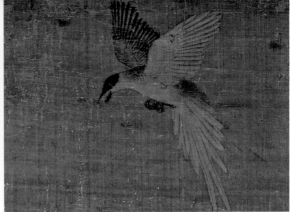

**Figs. 2–3 Magpies**

In the painting, one of the magpies is settled on the branch and cawing at the hare. The other shakes its wings and opens its mouth. The painter's portrayal of the magpie is also very detailed. The feathers on the back and abdomen are filled with white powder, and the outline of the feathers and the fine fluff on it are drawn with very light ink lines.

## Unrest in the Song Court

"Double happiness" is far from the painter's original intention. The sorrowful image in the painting conveys no enthusiasm. It is natural to ask why the artist painted this image and to wonder at the meaning of the magpies and the hare. The most dramatic of the numerous theories speculating on this question is that it depicts the story of the struggle between Princess Fukang (1038–1070) and her husband Li Wei (dates unknown). Legend has it that after Emperor Renzong of Song (1010–1063, reigned 1022–1063) ascended the throne, in an effort to make up for the death of his biological mother, he promoted her bother Li Yonghe (988–1050) and gave his own eldest daughter, Princess Fukang, to Li Yonghe's son, Li Wei, in marriage.

**Fig. 4 Slope and Vegetation**

Compared with the detail of the hare, Cui Bai is less precise when painting the sloping ground and the vegetation that covers it. It is only painted with simple, random ink, and it is not deliberately shaped.

The difference in their upbringings and the disparity in their status caused great discord in the couple's marriage. Princess Fukang talked extensively of her problems with a well-informed court official (a eunuch) named Liang Huaiji, which led the Li family to be greatly dissatisfied with the princess. After learning of this situation, Emperor Renzong sent Liang Huaiji to guard the imperial mausoleum. Liang's departure deeply affected Princess Fukang, ultimately driving her insane. She died at the age of thirty-three. When the princess died, her nephew Emperor Shenzong of Song (1048–1085) was on the throne (reigned 1067–1085) and he demoted the late princess's husband, Li Wei. The frightened hare in Cui Bai's painting may be Li Wei, on the verge of breaking out a fight against the magpies on the branches. It is a show of the painter's sympathy for Liang Huaiji and the princess, since they could not be together.

## Ingenious Composition

The composition of this painting is like that of the *taiji* image, which is often called "China's premier image." It is a perfect circle divided by an S-shaped curve into black and white halves, with a black dot in the white half and a white dot in the black half. Looking at this painting, the branches and slope create an S-shaped division. The hare and magpies are arranged in opposite corners of the painting, like the two dots in their opposite colors in the *taiji* image.

# EARLY SPRING

Guo Xi (see the painter's introduction on next spread)
Light ink and color on silk
Height 158.3 cm × Width 108.1 cm
Palace Museum, Taibei

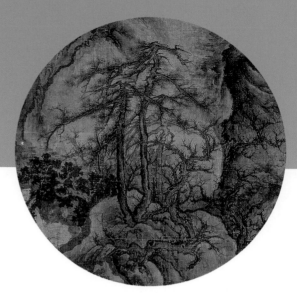

The works of early painters are generally difficult to explore, due mainly to a lack of historical materials, but this is not the case with Guo Xi. Not only are many of his works extant, but the text *Forest and Spring*, which records his ideas on painting, also survives. The work was written by his son Guo Si (dates unknown), recording Guo Xi's own oral and written descriptions. It offers insights into why he chose to paint landscapes, which he claims originate from the forests and springs that reside in a gentleman's mind. The paintings of the masters were often hung in their own grand halls, allowing those who

**Fig. 1  Pine Beneath the Mountain**

There are several high pines growing at the base of the mountain, a typical scene in which pines form the most prominent scenes, with vines surrounding it. Here, the painter uses the metaphor of pine to represent a general. He is a great man, and the soldiers around him are there to serve him, but they are obedient in the shelter of the mountain, knowing their places well and harboring no thought of rebellion. These pine trees are painted with the crab claw branch technique that the Li-Guo School often used to express winter forests.

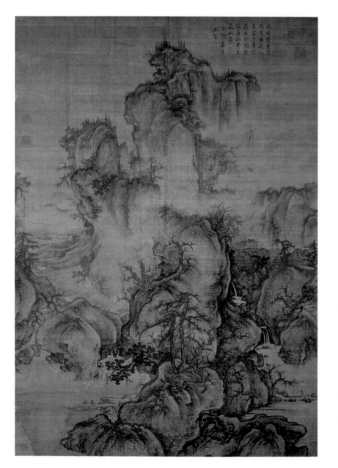

sat there to enjoy the scenes of mountains and rivers, faintly hearing the echo of birdsong as they observe the vast landscape of the painting.

## Scenes of Early Spring

This picture vividly depicts, in subtle brushstrokes, a mountain scene in spring after a cold winter. The painter does not express a spring scene of pink peach blossoms and green willows or long, verdant grass, but a scene of renewal everywhere. For instance, on the huge rock in front of the hill, dead wood is entrenched, but new shoots spurt out from some branches. The spring waters surge down from the mountain, slamming into the valley, where they merge. The rivers have thawed, and the fishermen have begun to fish with their nets. The figures walking in the mountains are on the path, and their clothing is lighter than winter clothes, and they are less constrained than figures in a winter scene.

## Figs. 2–4 People Walking

In the painting, there are several people walking, hidden among the rocks. According to Guo Xi's theory, where there are people walking, it is not necessary to draw the path.

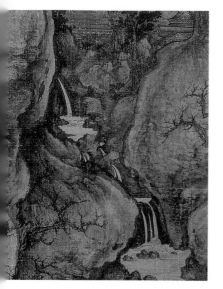

### Fig. 5 Flowing Water

In Guo Xi's landscapes, water is the lifeblood of the mountains, so water is essential in a landscape painting. In this painting, the waterfall flows from top to bottom into the valley and, like lifeblood, it gives vitality to the rocks.

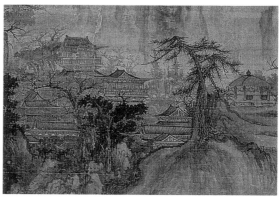

### Fig. 6 Buildings and Structures

Guo Xi holds that buildings included in the scene make for good landscape paintings. In *Early Spring*, there is a view of buildings surrounded by mountains. What is unique is that, on the right side of the buildings, there is a humble hut that seems quite at odds with the more magnificent structures.

## Three Distances

In *Forest and Spring*, Guo Xi proposed the important theory of "three distances," referring to three angles in landscape painting. He says, "From the bottom of the mountains to the top is upper distance, from the front of the mountain to the back is deep distance, and the view from one mountain to another is level distance." Viewing *Early Spring* with this theory in mind, we can see that Chinese landscapes are not meant to depict real scenes, but a way of viewing scenes. In this painting, from the huge rock in front of the mountain, looking up at the mountain, we see "upper distance." Looking out from the cliff on the right side, the scene is layered, with the palace hidden in the layers. This is "deep distance." Looking at the distant mountains from the left, they are empty and endless. This is "level distance."

### Fig. 7 Peak

Just as the pine growing at the base of the mountain is symbolic of a general, the peak represents the supremacy of imperial power. The peak stands among the mountains, and the surrounding hills are like ministers.

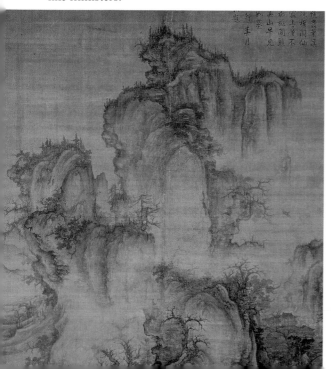

# OLD TREES, LEVEL DISTANCE

Guo Xi
Ink and color on silk
Height 37.5 cm × Width 853.8 cm
Metropolitan Museum of Art, New York

*O*ld Trees, Level Distance is an open scene depicting the rejuvenation of the earth and the resurgence of the people in spring. It is a masterpiece of level distance, painted by Guo Xi.

## Level Distance

Level distance is a technique admired by many painters. Alongside Li Cheng's masterful work in level distance, Wang Wei is the most revered painter of level distance scenes. In *Old Trees, Level Distance*, the foreground contains a clear, identifiable view of mountains and rocks. By contrast, the distant mountains have an illusory appearance. Further, the rocks on the nearer mountain are relatively small, providing almost no blockage of the distant mountains, which gives the viewer a sense of looking at mountains some distance away.

Another characteristic of level distance painting is the juxtaposition of clear and blurred images. *Old Trees, Level Distance* is an excellent depiction of the contrasts between

Guo Xi, a native of today's Meng County, Henan Province, was undoubtedly a painter who had a long life and career, though his exact dates are unknown. In the early years, he worked in relative obscurity and his works were of a general nature. Later, under the tutelage of Su Shunyuan (1006–1054), he made great progress by copying Li Cheng's painting *Sudden Rain*. In terms of technique, he also chose to study Li Cheng as a master. Because the Emperor Shenzong of Song loved Li Cheng most, he invited Guo Xi to the palace. After that, Guo Xi developed a resounding reputation, and he composed most of the court paintings during that period. However, when the Emperor Zhezong of Song (1077–1100, reigned 1085–1100) came to power, Guo Xi was subjected to such a cold reception that the palace servants even cleaned the tables with a scroll he had painted.

virtual and real scenery, the light distribution of ink, and the priority of the brush. The near mountains and trees are heavier and more detailed, and the distant landscape is painted with fewer strokes. This method of using ink and color has created a unique artistic conception.

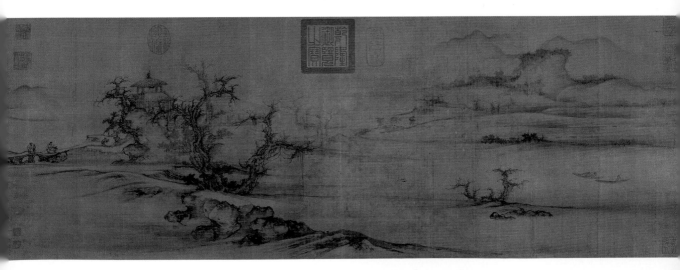

## Fig. 1   Distant Mountains in Ink

The distant mountains in the painting are rendered in light ink, producing a sense of faintness in the clouds. The peak of the mountain is depicted as a block of stones, painted with wet ink using texture strokes, with the trees later added using short freehand brushstrokes.

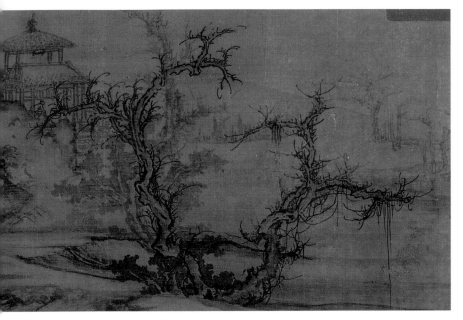

## Fig. 2   Technique for Painting Trees

The two withered trees on the left of the scroll are very conspicuous. They tilt slightly left and right, creating a visual sense of tension. The painting includes crab claw branch technique inherited from Li Cheng, and the branches are painted in simple form.

## Fig. 3   Technique of Rolling Clouds Texture Strokes

Art historian Fang Wen states, "In the 1070s, Guo Xi developed Li Cheng's painting technique into a style of full, mysterious mist." Guo Xi also inherited and developed Li Cheng's methods for painting rock. This painting method was later named "rolling clouds texture strokes." His brush is like a chaos of clouds, round and dynamic.

## Distant Mountains and Near Trees

In the foreground of the scroll, an outstanding pine tree is on display, rooted in a flat part of the slope. There are two boats on the water beyond the first hill, with a figure onboard one vessel. On the other side of the river is a plain, which expands to the far side. The foot and top of the distant mountain is rendered in thick, fresh ink. Compared to the simplicity and elegance at the beginning of the scroll, its left side depicts undulating slopes with swelling rocks, withered trees, and a looming view of a solitary pavilion. The entire scroll is fascinating, its mood bleak. In its use of depth and clarity, it makes the viewer feel she or he is actually in the scene depicted there.

# BAMBOO IN MONOCHROME INK

Wen Tong (1018–1079)
Ink on silk
Height 131.6 cm × Width 105.4 cm
Palace Museum, Taibei

It was common practice for the literati to use objects to express their feelings or their inner worlds. In the history of Chinese art, beginning with Su Shi and Wen Tong, it became the practice for literati paintings to borrow an object to express a feeling. Over time, this became an important school of thought in literati paintings. *Bamboo in Monochrome Ink* depicts a bamboo dangling downward from the left side of the picture. Though the bamboo is bent and its branches twisted, it is pliable, and its leaves are draped and spread out.

## Bent Bamboo

The bamboo in this painting is very unique. While most bamboo is depicted as rising from the ground (i.e., the bottom of the scroll), this bamboo protrudes into the picture from the left. Scholars hold that the bamboo painted by Wen Tong came from Lingzhou, which bends as it grows. This branch was trapped by its environment as soon as it came up from the ground, preventing it from developing normally, and when Wen Tong discovered it, it had bent so far that it touched the ground. It was barely supported by this time, and would not last much longer.

Lingzhou is the area now known as Renshou, in Sichuan Province, where Wen Tong once served as head of Lingzhou. He rigorously rectified the security situation of the people of Lingzhou, reformed its old legal system, and developed its economy, which resulted in him receiving great support from the local people. Even as he engaged in this work, he did not neglect his artistic creation. He once wrote a work entitled *Bent Bamboo Chronicle*, which records the development

**Wen Tong**, a native of modern-day Mianyang, Sichuan Province, was made an important official after passing the Imperial Palace Examination in 1049. In 1078, he was given orders to work in Huzhou (in today's Zhejiang Province), but he died during the journey to fill the post. He was renowned for his bamboo paintings, which were depicted so realistically it seemed the wind would rustle them. He was a cousin of the great Song dynasty poet and painter Su Shi (1037–1101), and he was very close to both Su Shi and his brother Su Zhe (1039–1112). Su Shi once said that Wen Tong had poetry, the *Songs of Chu*, calligraphy (cursive script), and painting all to the highest degree. His painting style had a great influence on later generations, including Li Kan (1245–1320), Ke Jiusi (1290–1343), Gu An (b. 1289), and even Zhao Mengfu (1254–1322) and Wu Zhen (1280–1354). These and other painters followed Wen Tong's method of painting bamboo, forming what was later called the Huzhou Bamboo School.

process of bamboo from beginning to end, according to his own observations.

## Bamboo as an Expression of the Literati's Sentiments

It was just this sort of bamboo that moved Wen Tong. He praised it for its knots and its slender leaves, which could withstand wind, rain, and frost. It seemed to break the laws of nature, moderating everything around it. From his fascination with this amazing plant, it is evident that Wen Tong admired these qualities of this unique stalk of bamboo. He not only wrote in praise of it, but also depicted it in this *Bamboo in Monochrome Ink*.

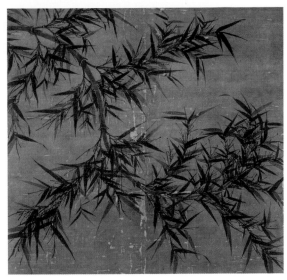

**Fig. 1   S-Shaped Stalk of Bamboo**

In this painting, the bamboo is S-shaped. From the perspective of natural growth, this form might be the result of the constraints of its environment. From the perspective of the composition of the painting, the odd shape makes the picture fuller and more dynamic.

**Fig. 2   Technique**

*Bamboo in Monochrome Ink* is painted purely in ink. When drawing the bamboo leaves, thick and light ink are varied to create the effect of light and shadow. The painter uses brushwork borrowed from calligraphy. In drawing the stalk of the bamboo, he holds the brush horizontally, as if writing a horizontal stroke in calligraphy, with the beginning and end touching. When drawing the leaves, he holds the brush at the center, then drops the pen at the junction of leaf and stalk, following the shape of the leaves to create sharp ends at both front and back, with a wide middle. The center of the brush always remains on the paper, slowly drawing the leaves. This method of using calligraphic strokes is an important feature of literati paintings.

# PLUCKING LEGUME

Li Tang (1066–1150)
Ink and color on silk
Height 27.2 cm × Width 90.5 cm
Palace Museum, Beijing

The era in which Li Tang lived was a critical period for the survival of the nation. When Jin (1115–1234) soldiers invaded the Song court, putting it in jeopardy, Li used the story of Boyi and Shuqi refusing to serve in the Zhou court, to indirectly express his dissatisfaction with the Southern Song's decision to surrender.

**Li Tang**, a native of modern day Mengzhou, Henan Province, was a painter during the transition period between the Northern Song and Southern Song dynasties. He made a living as a painter in his early years and was later recommended as a court painter. He excelled at landscape paintings, drawing mountains and rocks with the ax-cut texture strokes, and creating drastic twists and turns, as if with a blade, giving his paintings a vigorous, magnificent momentum. He also painted scenes of historical events as a way of exposing social ills. He is known as the first of the Four Masters of the Southern Song Dynasty, the other three being Liu Songnian (c. 1131–1218), Ma Yuan (1140–1227), and Xia Gui (dates unknown).

## Plucking Legume for Food

The figures depicted in *Plucking Legume* are the two sons of the Shang dynasty Guzhu monarch (located in present day Lulongnan, Hebei Province), Boyi and Shuqi, who renounced their inheritance and fled the country, relying on Ji Chang, King Wen of Zhou (1152–1056 BC). Shortly after King Wen's death, his son Ji Fa (d. 1043 BC) launched a war against the current emperor King Zhou of Shang (c. 1105–1045 BC). Boyi and Shuqi, believing this was a major act of rebellion, offered stern advice to Ji Fa. Ji Fa ignored the advice and continued his war against the emperor of the Shang dynasty, ultimately gaining victory and overthrowing the Shang dynasty to establish the Zhou dynasty. He is known in history as King Wu of Zhou.

After this, Boyi and Shuqi refused to eat the food of the Zhou court. They fled to the Shouyang Mountains (in modern day

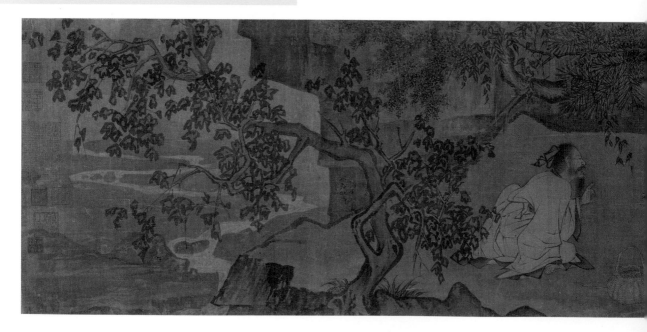

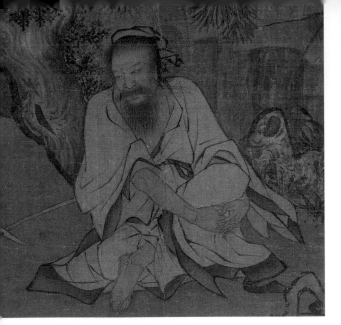

**Fig. 1 Outlines**
The lines on the garments of Boyi are worth noting. The folds have square corners, like bent reeds, giving them the name "bent-reeds outlining."

Yongji County, Shanxi Province), where they plucked legume for sustenance. Ultimately, they starved to death.

## Expressing Ambitions through Painting

In the painting, two people sit on a rock, talking. From the surrounding trees, plants, and water, it is evident they are in the mountains, most likely the Shouyang

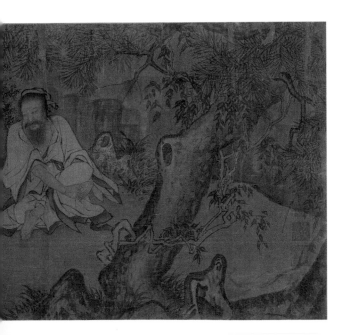

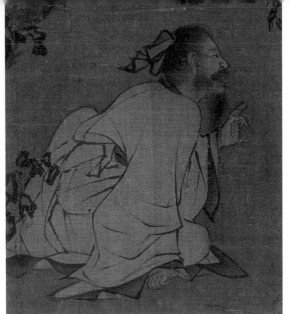

**Fig. 2 Buddhist Gestures**
Interestingly, Shuqi makes a Buddhist gesture with his left hand, but Buddhism had not been introduced into China in the Shang dynasty. This suggests that it was the artist's independent creation.

Mountains. The one facing forward with his hands on his knees is Boyi. Though he is unkempt, his eyes are bright. The one facing the side is his younger brother, Shuqi. There are a sickle and a bamboo basket beside him, with a bit of grass in the basket, making it appear the brothers have just returned after plucking the legume.

This sort of image is very common in Chinese painting, with implicit, restrained expressions of emotion. It is a very subtle way for the Chinese artists to express his own mind, drawing on historical incidents to persuade an emperor, admonish the public, and express their ideal of retreat through landscape paintings.

**Fig. 3 Legume**
There is *wei* or legume in the basket beside Boyi and Shuqi. *Wei* is a sort of bean that grows in the mountains, the leaves and stems of which can satisfy hunger when they are tender.

# WIND IN THE PINES AMONG MYRIAD VALLEYS

Li Tang
Ink and color on silk
Height 188.7 cm × Width 139.8 cm
Palace Museum, Taibei

*Wind in the Pines among Myriad Valleys* is a three-piece scroll, meaning three pages are pieced together to create a single painting. With its intense dyes and ancient color scheme, it is a prime example of a Northern Song dynasty monumental landscape.

## The Last Masterpiece of the Northern Song Monumental Landscape Style

Li Tang, the leading figure of the Four Great Masters of the Southern Song Dynasty, was a full-time painter in Song Emperor Huizong's imperial painting academy during the Song dynasty. Huizong was particularly fond of him, and when the Song court later moved to the south, Li Tang likewise went to Lin'an (modern day Hangzhou, Zhejiang Province), where he again entered the imperial painting academy as an old master, serving as a model for the rest to learn from. Li Tang brought the influence of Northern Song dynasty painting to the Southern Song dynasty, but the strong northern landscapes were not so well received in Jiangnan. Li Tang and his disciples implemented a change that ultimately formed a unique Southern Song style, paying particular attention to ink variation and the use of corner views. According to the title hidden in the distant rock in the upper corner of this painting, it was made in 1124, just three years before the Northern Song period ended. It is evident that this painting is not only in the style of Li Tang's early years, but more generally, it is also the latest example of the monumental landscape style of the Northern Song dynasty.

## Wind in the Pines among Myriad Valleys

In the painting, there are several layers of fine springs entering the valley on the left side of the main peak. There is another waterfall on the right side as well. The two waterfalls converge in the lower left side of the picture, forming a stretch of rapids in the river, which rushes forward, creating a dynamic effect.

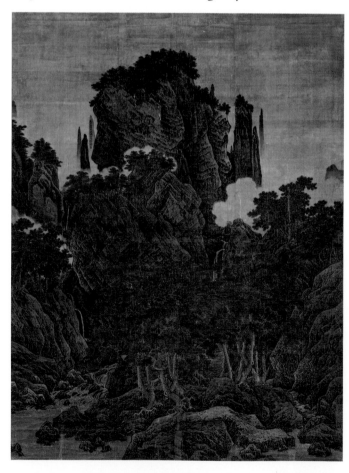

## Fig. 2  The Rocks on the Mountain's Face

The blocks of rock forming the face of the mountain are roughly outlined in ink, while the unevenness of the stone's surface is drawn with small brushstrokes. The treatment of the rock is determined according to the environment in which the rocks are located. For instance, the stones on the edge of the water are small and broken. Because these rocks are wet, they are painted in thick and wet ink (see fig. 1). The stones higher on the slopes are dry, so they are painted with light color and less smudging (see fig. 2). This indicates the high level of realism the painter employed for this work.

The soft sounds of the water and of the wind in the pines echo each other, and murmuring water is in contrast with the towering rock. The rock's ochre hue is like cast iron, but the mountainside is split by a layer of clouds, giving the painting a dense, layered effect that breaks up the denseness of the image and prevents the viewer from feeling oppressed.

## Fig. 1  Waterfall

A sense of the water's flow is created by the use of blank space, and the small waterfalls in the area show the curvature of the water's flow and the spray through ink lines. In the parts where the water's flow is slower, the entire surface of the water is painted with color, while fine ink lines are used to depict the water's line.

## Fig. 4  Pine Forest

Li Tang's method of painting pines is unique, unlike Li Cheng, Guo Xi, and others, whose work in pines is characterized by techniques of crab claw branch and antler branch (i.e., branches shaped like antlers). His pine trees are generally formed in groups of six or seven, with the needles and branches intertwining to form a single unit. They are not random or chaotic, but rather made of straight, upright trunks, with small circles of lines representing the barks of the pine trees.

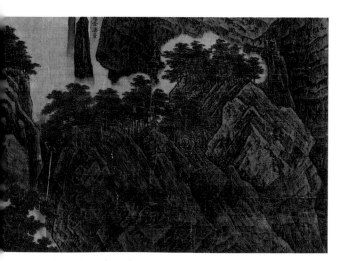

## Fig. 3  Clouds and Mist

Chinese painters often depicted mist by leaving blank space. What is unique about *Wind in the Pines among Myriad Valleys* is that the three clouds on the mountainside are located behind the pine forest, and the one in the center even traces along the outline of the pine trees. This method of using blank space not only indicates the front and rear levels between the peaks, but also highlights the position and shape of the pine trees.

# COPY OF *COURT LADIES PREPARING NEWLY WOVEN SILK* (SONG DYNASTY)

Attributed to Song Emperor Huizong
Ink and color on silk
Height 37 cm × Width 145.3 cm
Museum of Fine Arts, Boston

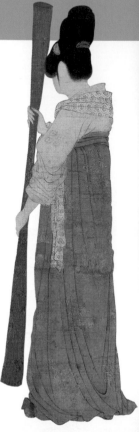

*Courtly Ladies Preparing Newly Woven Silk* depicts a scene of the main activities of courtly women. The women in the painting are divided into three groups, depicting activities including pounding the silk, weaving, and ironing.

## Pounding Perfecting

According to archaeological findings, 5,000–6,000 years ago, in the middle of the Neolithic period, China began to raise silkworms, using their threads to weave silk. From that time on, the silk manufacturing industry continued to develop, reaching its peak in the Tang dynasty, when the silk trade began its development along the Silk Road.

Pounding, or perfecting, the silk is an important process in the production of Chinese silk. The *lian*, is a fabric made of raw silk with sericin, becoming hard and yellow when it is woven. It has to be boiled and bleached with boiling water, then rubbed repeatedly with wooden stick, which dissolves the sericin on the thread, making it soft and white and ripening it from its raw state. This process is known as *daolian*, or perfecting the silk. Once

### Fig. 1   Clothing

The garments worn by women in the Tang dynasty included mainly skirts, shirts, short shirts, and so on. The lower part of the blouse is folded into the long skirt, and the skirt is long and wide. The long skirts in the painting stretch down from the chest, completely covering the body and legs.

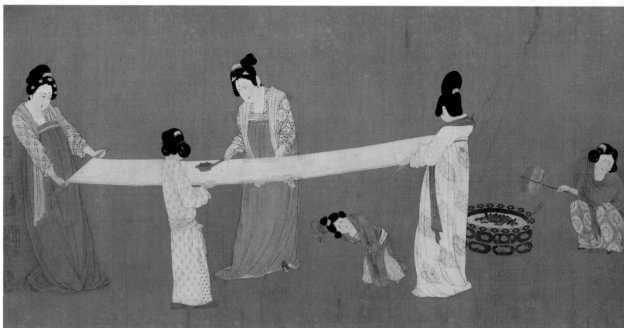

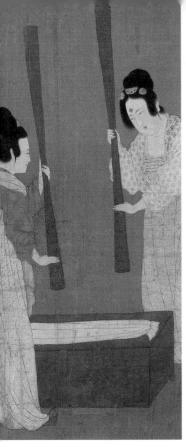

**Fig. 2 The Perfecting while Standing**

According to the ancient Chinese agriculturalist Wang Zhen's (1271–1368) *Agricultural Book* (*Nong Shu*), ancient methods of preparing or perfecting silk were categorized into two types, "standing-position" and "sitting-position." What is depicted in this painting is the "standing-position" method.

*Court Ladies Preparing Newly Woven Silk* is a Song dynasty copy. At the very first of the scroll, the sixth emperor of the Jin dynasty, Jin Emperor Zhangzong (Wanyan Jing, 1168–1208, reigned 1189–1208), inscribed in Huizong's thin golden script style with the title "after Tianshui." Here, the phrase "Tianshui" refers to the ruler of Tianshui County, or the **Song Emperor Huizong**. It is evident that this painting was closely related to Zhao Ji, i.e., the Song Emperor Huizong. If it was not composed by him, it is most likely the work of one of the Xuanhe (Song Huizong's reign, 1119–1125) Painting Academy masters.

The original painting on which this one is based was painted by Zhang Xuan, a native of Chang'an (modern day Xi'an, Shaanxi Province) and a court painter during the reign of the Tang Emperor Xuanzong. He was skilled at painting figures, particularly reflecting themes of courtly aristocratic life.

the silk has been pounded, it is ironed flat, then finally cut so that it may be sewn into clothing.

During the Tang dynasty, there were agencies such as the Shaofu which supervises the craftsmen and their work, the Weaving and Dyeing Department, and Yeting Bureau which is in charge of women's work in the palace and the official silk workshops. In the late part of the Xuanzong reign, thousands of workers were employed in the work of embroidery and treasure-making for Yang Guifei (aka Yang Yuhuan, c. 719–756), the most beloved concubine of Tang Emperor Xuanzong. There were also numerous slaves in the government workshops, and many who had outstanding talent were assigned to the court. The scene depicted in *Court Ladies Preparing Newly Woven Silk* is an accurate reproduction of the life of the women at court.

Society was relatively stable and unified during the Tang dynasty, and the economy prospered. The measure of women's beauty

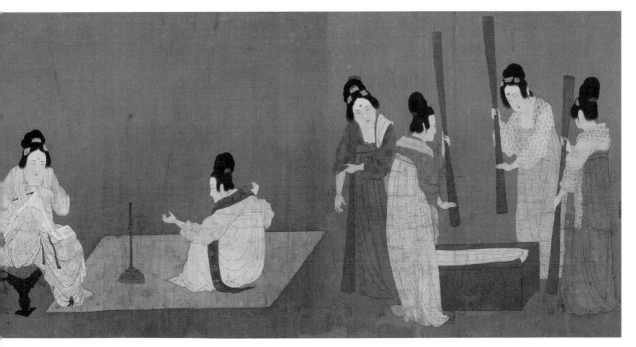

## Fig. 4  Delicate Brushstrokes

The strokes in the painting are fine and delicate, like the threads of a silkworm, particularly in the depiction of the patterns on the clothing. All is drawn in one rigorous, accurate stroke. Though the lines are thin, they are not floating, but have a round, raw, brisk texture. With the flow of these lines, the viewer seems to observe the movements of the artist's brush, modeling his superb skills and his ability to control the brushstrokes. The fine lines are matched by the graceful postures, sweet faces, and elegant costumes of the figures, achieving a high level of unity between form and content.

## Fig. 3  Female Faces

Female faces in this painting are outlined in fine lines. Their eyes are long and raised like a phoenix's, the eyebrows smooth like a willow, and the lips small and bright like a cherry. In this figure, the women's eyebrows are slender and the ends sharp, and they are slightly curved in the middle, like a crescent moon, forming the shape called "the moon eyebrow."

during this period mostly focused on their plumpness, grace and dignity. The women depicted in *Court Ladies Preparing Newly Woven Silk* are full-bodied, well-rounded, and dressed in long skirts, a feature characteristic of Tang dynasty paintings.

Because of the work of "perfecting" was mainly done by women, when the weather turned cold, they began to pound and sew the silk, preparing to give their husbands guard frontier regions warm clothing made by their own hands. For this reason, pounding silk was often associated with autumn reminisces in Chinese literature.

## Color and Composition

The entire scroll is elegant and colorful, and the arrangement of main and auxiliary colors is ingenious, as it tends to adjust the weight of the image.

Throughout the painting, it is evident that the artist's approach to composition is particularly creative. The first figure's head leans back and to the left, guiding the viewer's line of sight toward the left as the scroll is opened. As the line of sight moves, each group of characters appears in turn before the viewer, whether the figure is stationary or moving, standing or sitting. Some face the viewer, while others face away, and some look up, while others look forward. The overall composition of the image has a raised head and tail, and is lower in the middle.

## Fig. 5  Weaving

In the painting, the woman sitting on the green mat is pulling thread with her hand, seemingly from the spool placed in the center. She concentrates on her fingertips, and her body leans slightly back, as if she is using a bit of force. Another woman sits on a bench facing her. Because of the requirements of her sewing task, she has one foot on the bench, holding the silk against her leg. The left hand holds the silk, while the right hand calmly pulls the thread. She is focused on the thread in her hand. Though the thread of the silk is not clearly visible, it can be detected from the actions of these two figures.

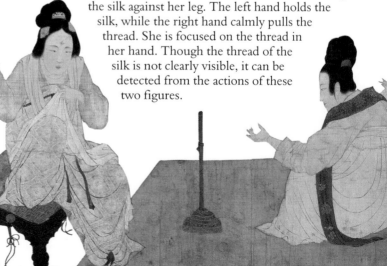

## Fig. 6   Hair Buns

Many of the women's hair buns are high, with floral patterns cut out and stuck to the forehead. This was a common hairstyle for women in the Sui and Tang dynasties.

## Fig. 8   Charcoal Stove and Fan

The depiction of the objects in this painting are vivid and detailed. For instance, the charcoal fire in the stove is half red, half black, making it obvious that it is burning. The patterns and rims of the charcoal stove are painted a golden color, highlighting its texture of real metal. There is a wild duck and reed bank painted on the fan in the girl's hand.

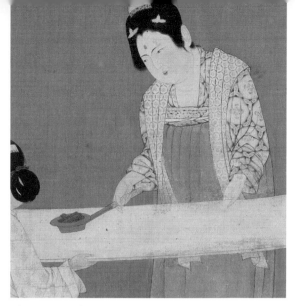

## Fig. 7   Ironing

The woman in an orange dress holds a copper iron, showing us the style of iron used in the Tang dynasty. It is shaped like a small basin, with a hot charcoal fire in it. The high temperature of the charcoal fire is transmitted to the bottom of the copper bowl, creating the heating effect. The iron has a long handle, the end of which is secured to a piece of wood that can be held in the hand.

## Fig. 9   Weaving Patterns

During the Tang dynasty, aristocratic women's clothes were bright and luxurious, with brilliant colors and varied patterns. In this painting, the court ladies' clothing is not only brightly colored, but the artist also employs fine brushstrokes to ingeniously create patterns on the dress that are complex and exquisite, varying with the pleats of the dresses.

# COPY OF *THE PAINTING OF LADY OF GUO STATE ON A SPRING OUTING* (SONG DYNASTY)

Attributed to Song Emperor Huizong
Ink and color on silk
Height 52 cm × Width 148 cm
Liaoning Provincial Museum

The painting depicts the Lady of Guo State and a group of ladies on horseback taking a tour in spring. Lady of Guo State is the third sisters of Yang Yuhuan. The painting reflects the life of leisure enjoyed by higher ranking aristocrats during the Tang dynasty. Yang Yuhuan and her sisters, the Lady of Han State, the Lady of Guo State, and the Lady of Qin State, are all outstanding figures. Of them, the elegant Lady of Guo State is the most legendary. She relied on her beauty to win the emperor's favor through her relationship with Yang Yuhuan. History remembers her as "luxurious and sensuous." After the outbreak of the Anshi Rebellion, Emperor Xuanzong fled Xi'an and the Lady

There is no artist named in the scroll. The beginning of the scroll says "Tianshui's copy of Zhang Xuan's *The Painting of Lady of Guo State on a Spring Outing*," inscribed by Jin Emperor Zhangzong, Wanyan Jing. "Tianshui" here refers to Song Emperor Huizong, Zhao Ji. It is evident that the painting is Emperor Huizong's copy of a work by Tang dynasty court painter Zhang Xuan, entitled *The Painting of Lady of Guo State on a Spring Outing*.

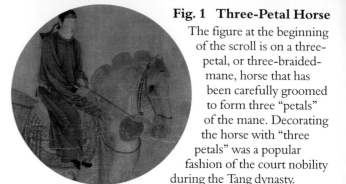

**Fig. 1   Three-Petal Horse**
The figure at the beginning of the scroll is on a three-petal, or three-braided-mane, horse that has been carefully groomed to form three "petals" of the mane. Decorating the horse with "three petals" was a popular fashion of the court nobility during the Tang dynasty.

of Guo State fled to the west. When she learned that the prime minister, her brother Yang Guozhong (d. 756), had been killed and Yang Yuhuan had died, she fled to Chencang (now Baoji, Shaanxi Province), where she committed suicide.

## Identifying the Lady of Guo State in the Picture

There are a total of nine people on horseback in the painting, including three men, five women, and a girl. Which of these people is the Lady of Guo State has always been

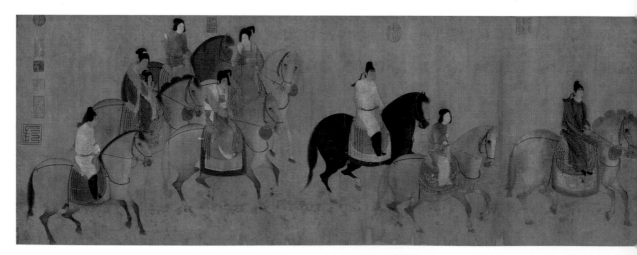

**Fig. 2  Maid**

The second rider is a maid. Her hair is combed in plaits and she is dressed in a round-necked shirt, which was the common image of a maid in the Tang dynasty.

**Fig. 3  Boots**

The third rider is dressed in white and wears black boots. Boots originated with nomads. The Tang dynasty was an open, tolerant era, and fashions shared across cultures were trendy at that time.

**Fig. 4  Hair Bun**

The hair bun two of the women wear were called *duoma* (lit. "falling off the horse") bun. Its name is derived from its look, which resembles a person falling from a horse.

a controversial question. There are three views. Some believe the woman who holds the girl in her arms is the Lady of Guo State. Others believe she is one of the six people in the group at the rear, most likely one of the two in front who looks back over her shoulder talking to those behind her, while the one beside her is the Lady of Qin State. The third view is that she is one of the three riders in the front of the scroll, dressed in men's attire. This is a unique view, but not without merits. During the Tang dynasty, it was fashionable for women to wear men's garments, and the figures in men's clothing is on a three-petal horse, which only the nobility could ride.

## Spring Tour

Although there is no green grass, flowers, or spring waters in the painting, it is evident from the leisurely state of the figures and

**Fig. 5  Techniques**

The lines in the picture are slim and round. The color use is elegant and rich, intended for decoration. The painting is in a lively, bright style.

the slow pace of the horses that they are on a spring tour.

In the Tang dynasty, both courtly aristocrats and common folk loved outings, and these became highly systematized. Every year in spring, the emperor would tour Liyuan (the name of a place in Chang'an, now Xi'an) with his courtiers to offer sacrifices by the river. Most spring tours were made on the third day of the third lunar month. Tang dynasty poet Du Fu (712–770) once composed poems about the Yang siblings on a spring tour of Qujiang.

# RIVERSIDE SCENE AT QINGMING FESTIVAL

Zhang Zeduan (Northern Song dynasty, dates unknown)
Ink and color on silk
Height 24.8 cm × Width 528.7 cm
Palace Museum, Beijing

*Riverside Scene at Qingming Festival* is of the historical painting genre, depicting the Northern Song dynasty capital of Bianjing (now Kaifeng, Henan Province), displaying the natural scenery, the customs, and the look of the city along the banks of the Bianhe River during the Qingming Festival. The figures in the painting come from all walks of life, and there are various buildings with different characteristics. Statistics collected by scholars indicate that there are 815 people, 95 animals, 255 trees, 114 buildings, 300 tables and chairs, 35 bamboos, 24 boats, 38 umbrellas, 30 pergolas, 8 sedan chairs, 6

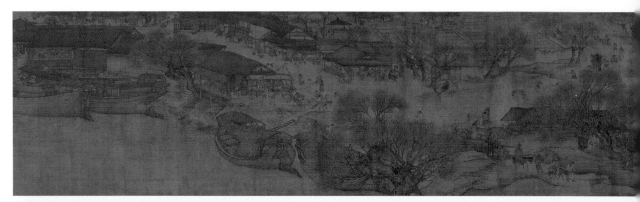

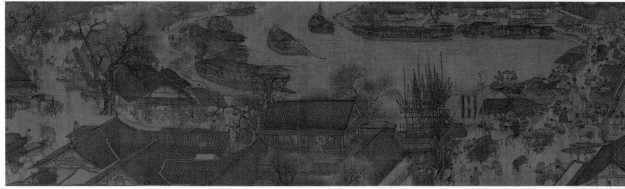

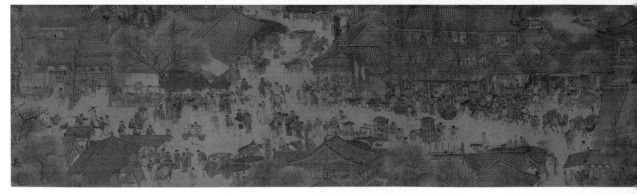

bridges, and 16 wooden carts in the scroll. It is filled with rich, overwhelming images, reproducing daily urban life in China 900 years ago.

*Riverside Scene at Qingming Festival* has been revered as a masterpiece since ancient times, and it has been widely favored. Many copies have been made of the scroll, so many versions of it have been handed down. According to a survey conducted by art historian Kohara Hironobu, there are lots of copies of *Riverside Scene at Qingming Festival* in art galleries worldwide alone,

**Zhang Zeduan**, a native of today's Shandong Province, was a court painter of the Hanlin Academy during Xuanhe period. He excelled at line painting as well as painting urban bridges, walkways and city walls, sailing boats, and carts on bridges. The *Riverside Scene at Qingming Festival* scroll, his only extant work, is one of the most representative and significant masterpieces of Chinese painting.

including 18 in Japan, 13 in Taibei, 6 in New York, 4 in London, and 1 each in Beijing, Liaoning, Chicago, Los Angeles, and Prague. Of those, the one that contains the largest number of figures is the copy made by Qiu Ying (c. 1498–1552), located in the Liaoning Provincial Museum, which depicts over

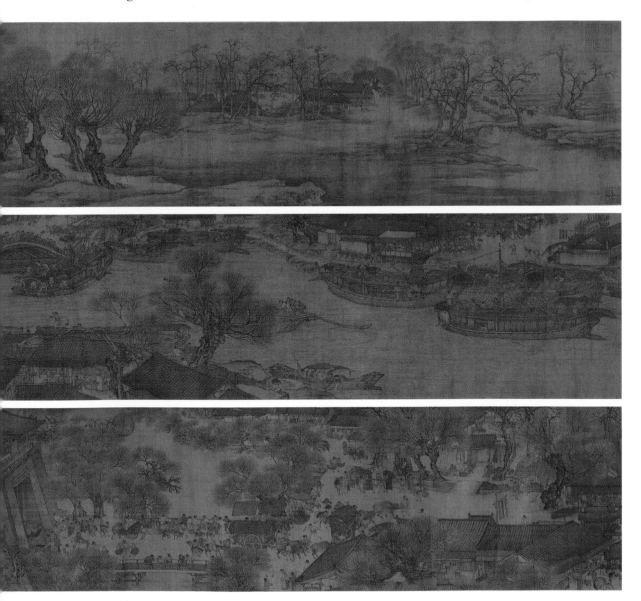

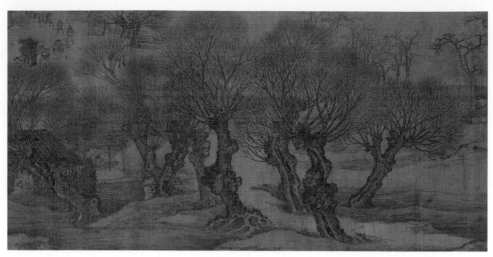

**Fig. 1  Dryland Willows (*Salix matsudana*)**

This sort of willow is not similar to the weeping willows common to Jiangnan landscapes. The willows in the north are more tolerant of cold, and their branches grow upward. They have thick trunks, numerous knots, and slender branches.

**Fig. 2  Wang Paper-Horse Shop**

On the bank of the Bianhe River, a sign containing the words "Wang Paper Horse Shop" is visible. It is clear that the shop specializes in people, horses, and towers made of paper and money for the dead, which were all used as sacrifices. Since ancient times, it had been customary during the Qingming Festival to burn people, vehicles, and horses made of paper as a form of sacrifice. This shop is a further indicator that the painting does indeed intend to depict the Qingming Festival.

2,000 figures. Zhang Zeduan's *Riverside Scene at Qingming Festival*, housed in the Palace Museum collection in Beijing is rich in content and vivid in story, with its characters and architecture presented in great detail and with great technical acumen. Its composition is the most distinct, sophisticated, and well-arranged, making it superior to any other version.

**Fig. 3  Rainbow Bridge**

An arched wooden bridge spans the Bianhe River. It is an exquisite structure, finely formed into the shape of a rainbow. It is commonly called a *hongqiao*—or rainbow bridge—but its proper name is "Shangtu Bridge." What makes this bridge special is that there are no piers or columns at its center. On the four ends of the bridge stand wind vanes, indicating wind direction for passing ships.

A big boat is passing on the surface of the water beneath the bridge, some of its boatmen using bamboo poles for support, some using long poles to hook the vessel to the bridge, others securing it with hemp rope, and still others lowering the mast. The scene is so intense that it attracts the attention of onlookers standing on the bridge, some of whom eagerly attempt to reach out to help. The scenes above and below the bridge echo one another, magnifying the dramatic effect of the painting.

The scene on top of the bridge is even more lively. Alongside the people on either side of the railing, there are numerous vendors interspersed in the crowd, leaving only a narrow path in the center upon which people and horses may pass. Those who fail to pay attention are sure to block the flow of traffic.

## Suburban Scenery

On the far right side of the painting are a field and a village, lying on the outskirts of Bianjing. Several huts are hidden in the misty forest, and hints of green have appeared on the willows in the north, suggesting that spring has arrived. A group of horse-drawn carts is entering the scene from the willow

forest, along with a sedan chair decorated with branches with red blooming flowers. At the junction of city and farmland is a scene of rural paths intersecting between fields and densely populated areas.

The depiction of the landscape unveils certain seasonal characteristics. Later generations have produced many theories regarding the title of the painting, with some suggesting that it refers to peace and prosperity, while others hold that it literally points to the Qingming Festival, but from the hints of green on the willows, we are able to

### Fig. 4 Shiqian Wine Shop and the Scaffold-Like Structure

One of the buildings under the bridge looks very strange, like scaffolding on a modern building site. In fact, the scaffolding, which consists of square wooden planks and wooden rods bound together, is a type of decorative archway, with colorful ribbons and posters hung on it to attract customers, giving it the name the *cailou huanmen*.

Below the *cailou huanmen*, there is a sign that reads *Shiqian jiaodian* (wine shop). The phrase *Shiqian* is the name of the shop, while *jiaodian* indicates a secondary wholesale retailer selling wine. Connected to this shop is the official shop, which was an official store directly subordinate to the Song court liquor monopoly.

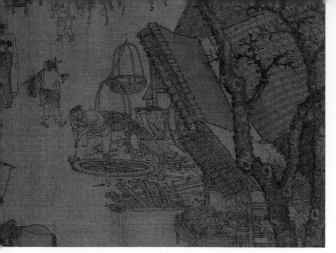

## Fig. 5 Cart Repair Shop

There is a cart repair shop from that period depicted in the painting. At the shop, a figure carrying a hammer for repairing a wheel is visible, while another is sawing a piece of wood. Varied pieces of wood scattered on the ground around the shop.

## Fig. 6 Fortuneteller's Stall

Fortunetelling has been a part of Chinese life since before the Qin dynasty. Most fortunetellers predicted the future details of their customers' lives and their fates based on their time and date of birth, or by reading their palms or faces. There is a fortuneteller's stall in *Riverside Scene at Qingming Festival*. A fortuneteller sits there, and one customer talks to him as three or four wait in line for their turn.

## Figs. 7–8 Fan

On the street in the painting, one person holds an item in hand that seems to be a fan. Some scholars think this means that the scene depicted is a summer scene, when a fan would be more likely to be needed. In fact, though, there were several uses for a fan at that time besides cooling off, such as covering the face when one did not wish to be seen.

confirm that it depicts spring days before or after the festival, which also confirms the title.

## Scenes of the Bianhe River

During the Northern Song dynasty, the Bianhe River was the most important transportation hub and commercial artery in the country. The Bianhe River entered the city of Bianjing from the western gate and flowed across the city, exiting at the eastern gate. In *Riverside Scene at Qingming Festival*, the Bianhe River slants into the image, running through the middle of the scroll. Many ships are moored on the Bianhe River, including several passenger vessels. Most of the ships are for transporting grain from the Yangtze River, Huaihe River, Jinghu Lake, and the southern and northern parts of Qiantang River. A cluster of shops sit on the bank of the Bianhe River, including mainly restaurants and taverns, as well as some small vendors selling various goods.

## Fig. 9 Camel Caravan

A team of camels is entering the gate in the painting. Most camels belonged to merchants from the western region during this period, demonstrating the trade commerce that was common in the Northern Song capital Bianjing.

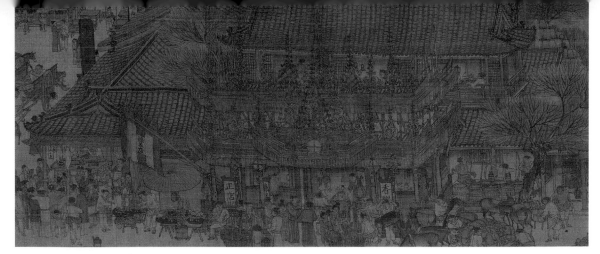

**Fig. 10  Sunyang Shop**

This is the largest tavern in the painting. The words "official shop" on the sign above the door indicate its status as a shop directly under the official administration. The *cailou huanmen* is more luxurious than that of "Shiqian Wine Shop," hanging not only a cloth sign, but also a decorative flowery fringe. The open windows on the upper floor show many customers, and there are also jugs on the table. There are several tile cylinders on the right side of the shop, from which we can see that the shop was allowed to brew its own wine.

## Urban Markets and Streets

Bianjing was extremely prosperous during the Northern Song dynasty. The city was surrounded by four rivers, and roads stretched out in every direction. It was the hub of the country's land and water transportation network, putting its commercial development top in the country. At the time, more than 1 million residents lived in Bianjing, and the lively business scene and dense population made it a very busy city. There were numerous shops in the streets, and there were even night markets.

In the city depicted in this painting, the shops are relatively large, though there are other smaller shops consisting of a single shed. There are also many temples and other official buildings. The pedestrians are shoulder to shoulder in the streets, and the horse-carriages and loaded carts make their way through the busy thoroughfares. Among the pedestrians are nobles, bureaucrats, servants, pedlars, attendants, cart drivers, workshop laborers, storytellers, barbers, doctors, fortunetellers, aristocratic ladies, wandering monks, playful children, and even beggars. The tall city gate, called Dongjiaozi Gate, is located in the southeast section of the inner part of Bianjing.

**Fig. 11  Inn**

In an inn depicted in the scroll, a person who looks like a scholar can be seen in the second floor window, where he sits reading. The sign outside says "Long-Term Stay at the Wang Yuanwai," indicating that it was an old, reputable establishment.

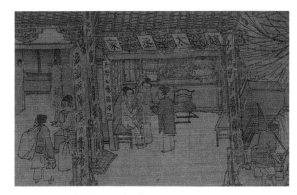

**Fig. 12  Clinic and Pharmacy**

From the signboard, it is evident that this is a pharmacy. Two women sit outside the door, carrying a baby to be diagnosed. It is likely a clinic that specializes in gynaecology and pediatrics, as well as a pharmacy.

# A VAST LAND

Wang Ximeng (b. 1096)
Ink and color on silk
Height 51.5 cm × Width 1191.5 cm
Palace Museum, Beijing

Throughout the length of the scroll, the viewer is greeted by a continuous range of mountains and a vast river. The green hills are luxuriant and the blue currents ripple. The painting is dominated by a bluish-green, giving it a clean, bright feel. According to the research, because Wang was young and did not have great traveling experience, the scenery in *A Vast Land* were most likely not sketched, but were condensed from several scenic mountainous locales. When seen

together with Wang's identity as a court painter, it is possible the piece was painted according to the wish of the Song Emperor Huizong, playing a role in propagating the beautiful mountains and rivers of the Northern Song dynasty.

## Grand Scenes of the Song Dynasty

According to textual evidence, the scene depicted in this painting may have come from

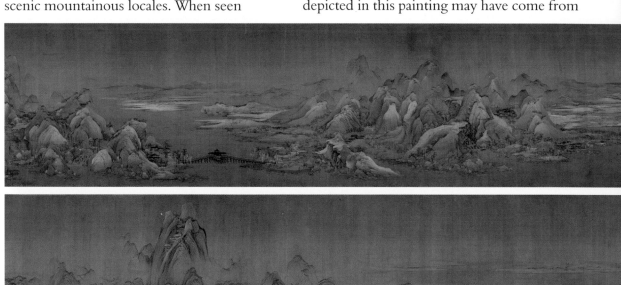

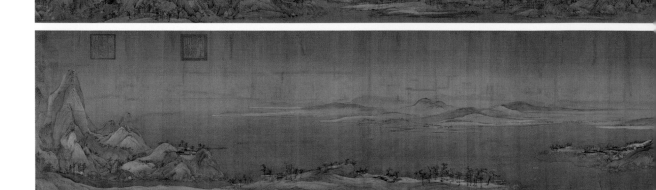

The process of confirming **Wang Ximeng** as the painter of *A Vast Land* was an arduous, circuitous journey. Throughout the scroll, aside from a Qing dynasty inscription, there were only those of the Song dynasty high-ranking official Cai Jing (1047–1126) and Yuan dynasty figure Pu Guang (dates unknown), and in Cai Jing's inscription, only "Ximeng" was mentioned as the author of the piece. In the Qing dynasty, when some research was conducted by various collectors, it was confirmed that the artist's surname was Wang and his given name was Ximeng. Throughout history, very little is recorded concerning Wang Ximeng. The earliest is Cai Jing's inscription on *A Vast Land*. From that time on, it was inferred that Wang was born in 1096, and he was trained as a student in the painting academy established by the Song court. He painted *A Vast Land* under imperial commission when he was just 18 years old. According to the later collector Song Luo (1634–1714), Wang passed away just two years after he painted this picture.

the Poyang Lake area (now the northern part of Jiangxi Province), a scene viewed from a peak over a bay in Poyang Lake, which looks out onto the peaks of Lu Mountains (modern-day Jiujiang City, Jiangxi Province). Because these imposing peaks stood on the banks within the territory under the rule of the Northern Song court, only Lu Mountains has this characteristic, which also resonates with Meng Haoran's poem *Looking at Lu Mountain on Pengli Lake*. Furthermore, the open waters depicted in the painting, with the waterside reeds and the distant expansive mist, look like an elongated marshy lake, similar to the swamps and wetlands in the Poyang Lake area. Moreover, the vegetation, the bamboo fence in front of the building,

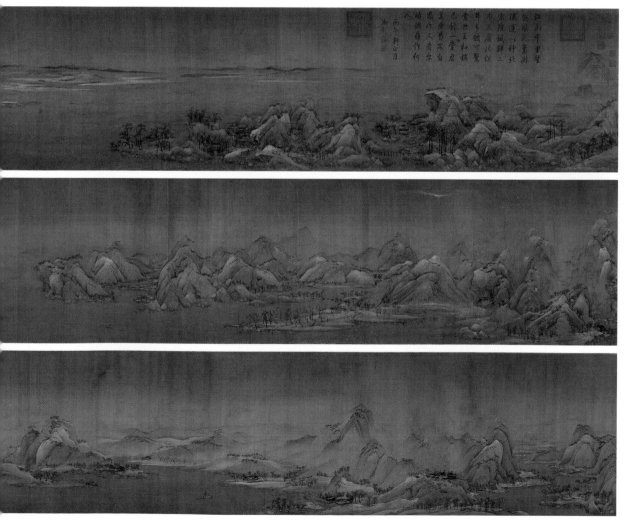

## Fig. 1　Cross-Shaped Building

Nestled among the mountains is a cluster of buildings with a cross-shaped structure at its center. There are two pavilions in front of the building, and corridors to the left, right, and rear. There are cypress trees planted among the pavilions, making it unlikely residential buildings.

## Fig. 3　Grass Hut

This structure seems to be built in a gap in the cliffs. Two people sit in front of the hall, and there is a grass hut behind it and a pavilion to the left of the grass hut. It is possibly an abode of hermits.

## Fig. 4　Temple and Monasteries

Here, the artist paints temples and monasteries hidden among mountains and clouds with light brushwork.

## Fig. 2　I-Shaped Housing

The painting depicts a number of buildings, especially residential buildings. The detail shows I-shaped housing, which has a front hall and back room connected by a main gallery, shaped like the Chinese character 工 (*gong*), giving it its name. In addition, a fence wall can be seen enclosing the house into a courtyard. The place where the water stands in front of the house is a building on stilts standing on the water. Two people converse, leaning against the railings.

and the rain capes used by people depicted in the painting are all characteristic of that region.

However, at the beginning of the scroll, a long wooden bridge spans the river. The renowned architectural historian Fu Xinian (1933–) believes that the bridge is most likely the long bridge in Wujiang, Jiangsu Province, which was constructed in the eighth year of the Northern Song dynasty (1048). Because Wujiang and Poyang Lake are some distance from each other, it is evident that the painter is not merely copying a scene, but has pieced together a scene from Poyang Lake and Lu Mountains, combined with other locales.

In addition to mountains and lakes, the painting also depicts numerous villages and scattered courtyards. These villages and courtyards are mostly distributed among the mountains or on the banks near the water. The smallest courtyard is surrounded by three or four houses, while larger residences have more houses, pavilions, and ponds. The people in the painting enjoy the scenery from pavilions, work in houses, tend the fields, or fish on the lake. Throughout the scroll is a rich, peaceful scene of a prosperous world.

**Fig. 5  Long Wooden Bridge**
There are many bridges in *A Vast Land*. This simple unadorned long wooden bridge linking the two mountains is the only way to cross the water. The bridge deck is supported with wood, and its surface is covered with grass. At one end of the bridge, a figure carries a heavy object, driving a donkey as he prepares to cross the bridge.

**Fig. 6  Bridge with Pavilion**
This bridge, a Jiangnan style structure, is exquisitely crafted. Its deck is covered with neat timber and its pavilion is surrounded by a piece of woven fabric to decorate the low wall. Weeping willows are planted on both sides of the bridge. It is spring, and the willow branches hang over the pavilion. A person is crossing the bridge.

## A Masterpiece in the History of Art

Because it is a royal work painted in accordance with the holy wishes, *A Vast Land* uses the best court painting materials available at the time to create a giant blue and green landscape painting. It makes use of the entire silk surface, which stretches to 51.5 cm. Of extant paintings, not many reach half a meter.

In addition, this picture has been preserved this long, its colors still vibrant, indicating the use of good quality pigment in its production. In *A Vast Land*, two colors are used to depict the mountains, blue and green. The painter changes color by varying brush, ink, and the coloring process, creating different levels of mountains in the painting plane. The color of azurite blue is most remarkable. The main peaks and body of the mountain are mostly emphasized by azurite blue, and the shadowy distant mountains are usually covered with it. (This covering is mainly formed from

**Fig. 7  Long Bridge**
The most unique part, the long bridge situated in the front section of the scroll, is a real treasure of *A Vast Land*. It arches over the face of the river like a rainbow. In the middle of the bridge is a cross-shaped pavilion, with a beautiful shape and novel structure.

According to scholars, the prototype of this bridge is probably the long bridge in Wujiang, Jiangsu Province, called the Liwang Bridge. Because it is shaped like a rainbow, the Liwang Bridge is also called "Chuihong Bridge," meaning "rainbow bridge." The bridge, built during the Qingli Year (1041–1048) of Northern Song dynasty, was originally a wooden structure more than a thousand feet long. It was the first long bridge in Song dynasty China. The bridge demonstrated the superb architectural technology level of that time. Northern Song writers often wrote poems about this bridge, leaving behind an eternal legacy.

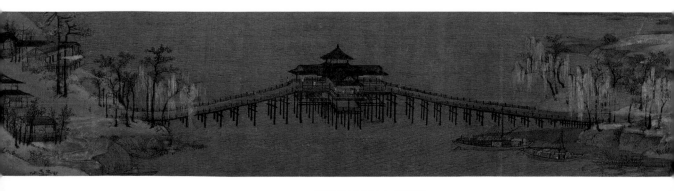

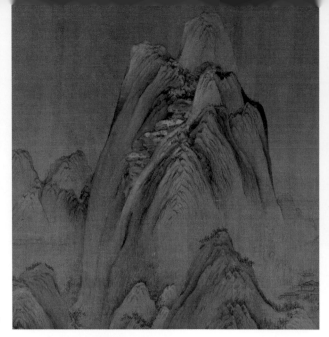

## Figs. 8–9   Techniques for Painting Rocks

The shape of the rock in the figures is very rich. The painter first outlined them with different shades, then added short lines using texture strokes. The peaks are most likely made using the lotus leaf texture strokes, which involves angling the brush downward from the peak to create shapes like the veins of lotus leaves. After that, the stones' surface is rendered with light ink and ochre, then covered with ochre. The tops of the stones are stained with dark green (combining gamboge and indigo), then dyed with azurite blue and mineral green.

## Fig. 10   The Highest Peak

The highest peak towers into the sky. The artist paints it with refined brush and ink, highlighting the peak with bright colors.

## Figs. 11–13   Running Water

There is much flowing water in the painting, in many shapes and a variety of colors. The flowing water is often outlined, and waterfalls below the mountains are often represented by short lines (see figs. 11 and 12). The waterfalls on the mountains are mostly drawn with long, thin lines (see fig. 13). The waterfall in fig. 13 is the most unique, combining a fourfold and double waterfall, which is extremely rare.

**Fig. 11**

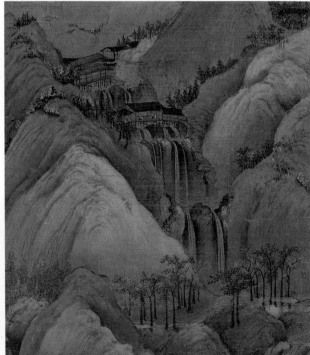

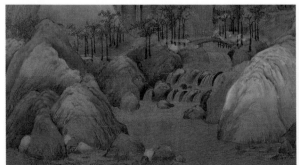

**Fig. 12**

**Fig. 13**

**Fig. 14 Twin-Body Pedal Boat**

This type of boat is unique, and appears to be two boats joined together. According to scholars, it may be an unusual twin-body pedal boat that employed the physics of rolling transmission power, similar to stepping on a waterwheel and constantly churning the water.

**Fig. 15 Passenger Boat**

The passenger boat is docked on the bank of the river. From the painting, we see that it has a main cabin, along with a hatch and a passenger pavilion.

**Fig. 16 Water Mill**

A water mill is depicted in the painting, straddling the mountain creek. According to studies, the principle of water mill operation is to build a structure on a dam and set up a water wheel, diverting the water to hit the wheel, driving the mill. Ancillary buildings, gates, and fences are built around the mill. There is a sluice on the stream behind the mill, which is used to store, direct, and flush water.

a flat coating, which is covered with water and translucent color to unify the colors.) In this way, there is a distinction between the primary and secondary coloring.

Responding to the "solidity" of the mountains is the "void" of the water's surface. In drawing the lake water, the painter uses method of leaving blank, then outlines the water's pattern with refined ink lines. After this, he paints with green to dye it. This gives the viewer a sense of "a breeze floating on the river without rippling it." When painting distant water, he uses a net pattern to depict the fading of the current, and his lines increase in length. This creates distant water and sky that are expansive and far away.

Although green and blue are the main colors in the painting, there is almost an equal number of ochre as a secondary color. In the Tang and Song dynasties, ochre was used in great blue and green landscape paintings, which employed more outlines, fewer texture strokes and thick coloring, to fix the foot of the mountain and to color the rocks. The status of the ochre gradually improved among later generations of painters, becoming the light ochre landscape style, which meant that the main color used in pastel landscape

paintings was ochre, with some ink painted or smudged. In addition, *A Vast Land* uses clam shell cake and rogue to paint other scenes. A look at the history of Chinese art shows that a piece like *A Vast Land*, with its use of such elegant materials, holds an important place and is of great value.

**Fig. 17 Water Surface**

The water's surface is painted with a net pattern, creating a sparkling visual effect. This pattern is a common technique used to depict water in Chinese painting. Generally, surfaces of the water with mild currents are depicted by a layer of net pattern, while larger surfaces are drawn with a fish scale pattern.

# CHILDREN AT PLAY IN AN AUTUMN COURTYARD

Su Hanchen (1094–1172)
Ink and color on silk
Height 197.5 cm × Width 108.7 cm
Palace Museum, Taibei

This painting is a large-scale image, nearly two meters in length, depicting an autumn courtyard where a pair of children play games. In ancient Chinese paintings, infants and young children appeared in paintings of court ladies at an early stage, mostly playing a supporting role. For instance, in *The Admonitions Scroll*, there are scenes in which women hold children or infants at play. After the Song dynasty, infants developed as an independent theme. Later, they gradually became an important theme in folk figure paintings. People were fond of paintings of infants mainly because the represented prayers for many descendants and great blessings.

## Children at Play in Autumn

The first thing that captures the eye in this painting is the large lake-worn stone in it, which fills about one quarter of the scroll, stretching even beyond its top edge. Behind the stone, hibiscus flowers bloom. The hibiscus mostly opens from August to November. Under the hibiscus are small daisies, indicating that it is late autumn. There is a stool beside the daisies, and some children's toys are placed on the stool, with a cymbal casually lying on the ground. The toys do not attract the attention of the children,

**Su Hanchen**, a native of modern-day Kaifeng, Henan Province, spent most of his life in modern-day Hangzhou, Zhejiang Province. During the Song dynasty Xuanhe period, he worked in the imperial painting academy, where he excelled at painting images of the Buddha and Taoist and of children. His descendants inherited the traditional family teaching and achieved much in the fields of Buddhist and Taoist paintings, figure paintings, and paintings of court ladies.

who stand on the left side of the painting playing a game on another stool.

## A Fine, Elegant Style

There is no title on the painting, nor any indication whether it dates from the Song, Yuan, or Ming period. The earliest mention of the painting is in official records of the Qing court. It cannot be stated with certainty that it is in fact the work of Su Hanchen, but from

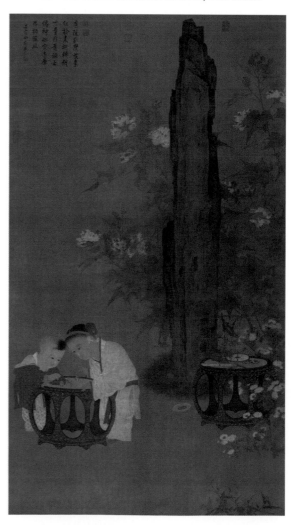

## Fig. 1   Stone from the Lake

Passed down from ancient times, the Chinese people have a tradition of appreciating stones. This is mostly a practice of the literati, who prefer to stay away from common crowds, and thus wish to return to the mountains and forests. As a microcosm of natural landscapes, the stone becomes an object of their admiration. The huge lake-worn stone in this painting suggests that the courtyard belongs to a bureaucrat.

the style of the painting, it is undoubtedly a Song dynasty piece. The scholar Chen Baozhen has praised the lines and colors in this piece in his book *On Ancient Paintings*, saying, "the width of the lines is fine, and they are wire lines (i.e., a technique of drawing the outline of the line as thin as wire, which is mainly used to draw clothing). The color is elegant, particularly in the clothing of the two children, which is decorated in red and white, making it bright. Su Hanchen's work with color has been highly praised … even to the point that it is said to surpass that of Yan Liben."

## Fig. 3   Technique for Painting Hibiscus Flowers

In the painting, the technique for painting hibiscus flowers first uses the brush to outline the shape, then adds color. The flowers are layered, with the front petals rendered in cinnabar, without any trace of counter-staining at the point of transition. The branches and leaves capture the play of light and shadow, and the layers are thus clearly depicted. The flowers are in different phases, including both buds and blooms.

## Fig. 2   Ancient Chinese Children's Toys

Much can be learned about the toys of Chinese children in ancient times from this painting. On the tortoise shell disc on the right side of the stool, there is a top, which is spun by hand. In the middle is another type of toy called *qianqian che*. It has an upright wheel that a rod inserted through the disc, upon which two figurines ride. Another rod is inserted through the middle for support. The things drawn on the wheel match those on the long strip of paper on the left. Behind the wheel is a stupa, which was used in children's games in ancient times. On the left behind the stupa are Chinese chess boxes, suggesting that chess was also a favorite game of children long ago.

## Fig. 4   Pushing the Jujube

The two children in the painting seem to be brother and sister. The game they are playing is called "pushing the jujube," a seasonal game played in autumn. The game was played with a fresh jujube, cut in half horizontally. The first half is laid out with the flesh of the jujube exposed upward. Three bamboo sticks are inserted into the other half and it is stood upright on the table. A thin piece of bamboo with a small jujube on either end is placed on the core of the halved jujube, adjusting its center of gravity to keep the ends balanced. The bamboo is then twisted by hand, attempting to spin it without letting it fall.

# WHILING AWAY THE SUMMER BY A LAKESIDE RETREAT

Zhao Lingrang (Northern Song dynasty, dates unknown)
Ink and color on silk
Height 25.9 cm × Width 694.5 cm
Museum of Fine Arts, Boston

Zhao Lingrang's style of painting was highly respected during the Ming and Qing dynasties. Dong Qichang made reference to *Whiling Away the Summer by a Lakeside Retreat* three times. The "Four Wangs" renowned in the Qing dynasty—Wang Shimin (1592–1680), Wang Jian (1598–1677), Wang Yuanqi (1642–1715), and Wang Hui (1632–1717)—along with their peer Yun Shouping (1633–1690) all followed Zhao Lingrang's style. *Whiling Away the Summer by a Lakeside Retreat* depicts a scene from a village in the suburbs during the summer. It is representative of a Song dynasty small painting of lakes and rivers.

**Zhao Lingrang**, a native of modern-day Kaifeng, Henan Province, was the fifth-generation descendant of the Song Emperor Taizu Zhao Kuangyin (927–976, reigned 960–976), and he grew up at court. Though he was constantly in contact with the descendants of wealthy families, he was not haughty, but remained always fascinated by ancient scriptures and histories, and also loved painting. Zhao Lingrang often drew scenes of the slopes and islets in streams on the outskirts of the capital, showing the geese frolicking amidst the clouds. He also visited the mountains and rivers of Jiangsu, Zhejiang, Hunan, and Hubei. He was friends with Mi Fu, Su Shi, and others. In evaluating Zhao's paintings, Mi Fu once said that his small paintings were beautiful, with snowy scenes similar to Wang Wei's and islets and waterfowl that captured the beauty of expansive waters.

## Small Scenes of Rivers and Lakes

The opening of the scroll depicts a section of a lake. The lotus pond has two areas, and the leaves that open on it create a summer feel. The willows on the shore hang so low they almost touch the surface of the water. Several birds are perched on high trees, and the woods in the distance are veiled in mist, with a small path cutting through the forest. Alongside the stream, running to the center of the painting, there is a village tucked beneath trees and clouds.

Unlike the landscapes painted by Fan Kuan and Guo Xi, there are no mountains in *Whiling Away the Summer by a Lakeside Retreat*. The scenery

**Fig. 1 Technique for Painting Trees**
The technique used to draw trees in this scroll is very simple and tidy. The shape of the trunk is drawn with an ink line, then filled with color. The branches are then added, creating a single form of the entire tree.

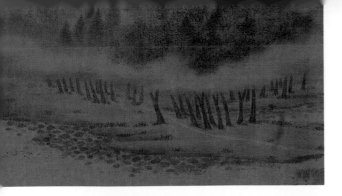

## Fig. 2　Mist and Tinting

The fog surrounding the forest and village is very unique, creating the feeling that one is surrounded by clouds. When drawing the mist, the artist uses the technique of leaving blank, then slightly dyeing the edges, creating the feeling of movement.

The whole scroll is light and elegant. Besides ink color, the leaves of trees and lotuses are outlined with indigo. The roofs and slopes are rendered lightly in ochre color.

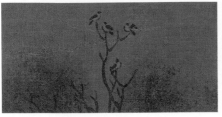

Fig. 3

Fig. 4

## Figs. 3–5　Birds

There are three spots in the painting where birds are depicted. One is at the beginning of the scroll, where several birds perch atop a tree. Another is located at the end of the scroll, where there are three trees, with several birds flying over them. A third spot is on the edge of the lotus pond, where a group of ducks is swimming to the shore.

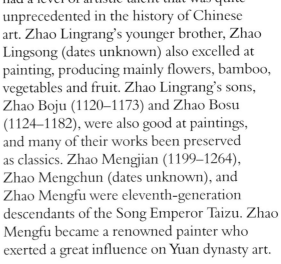

Fig. 5

depicted is an embellishment of the background in the work of Fan Kuan and others. Though it lacks the grandeur of towering mountains and vast waterways, it is a lovely, fresh image.

## Painters of the Song Dynasty Imperial Family

The Song court, of which Zhao Lingrang was a member, lacked political skill, but made considerable achievements in literature and art. The Song emperors, of whom Emperor Huizong was most representative, were endowed with great artistic talent, and even the paintings produced by the empress, and his concubines were not inferior. Among the painters in the royal Zhao family, quite a few had a level of artistic talent that was quite unprecedented in the history of Chinese art. Zhao Lingrang's younger brother, Zhao Lingsong (dates unknown) also excelled at painting, producing mainly flowers, bamboo, vegetables and fruit. Zhao Lingrang's sons, Zhao Boju (1120–1173) and Zhao Bosu (1124–1182), were also good at paintings, and many of their works been preserved as classics. Zhao Mengjian (1199–1264), Zhao Mengchun (dates unknown), and Zhao Mengfu were eleventh-generation descendants of the Song Emperor Taizu. Zhao Mengfu became a renowned painter who exerted a great influence on Yuan dynasty art.

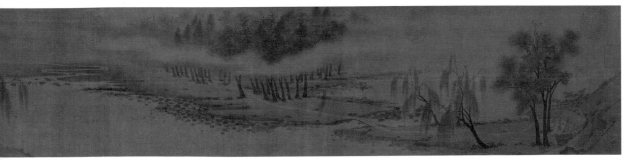

# AUTUMN COLORS AMONG RIVERS AND MOUNTAINS

Zhao Boju
Ink and color on silk
Height 55.6 cm × Width 323.2 cm
Palace Museum, Beijing

*A*utumn Colors among Rivers and Mountains adopts the traditional horizontal hand scroll form, showing a scene of rich, slim mountains, with layers of mountains and rivers stretching across the scene. The picture contains cliffs, deep shoals, and waterfalls, as well as pines, cypresses, and bamboos among the mountains and various wildflowers playing hide-and-seek on the slopes. A variety of Buddhist and Taoist temples, towers, shrines, solitary pavilions, and pagodas are integrated harmoniously into the natural scenery. Figures with nets catch fish or seek solitude, resting beside the river, while others stand looking over a fence. It is a mesmerizing image which one can examine tirelessly.

## The Subject of the Painting

The main peak in the painting is clearly depicted, and the other peaks distinct, and there is a sense of harmony in the scene of rolling mountains. At the far right side of the scroll is the main peak and several small peaks. Several complex buildings, such as Taoist temples, gates to monasteries, and pagodas and temples, stretch from the

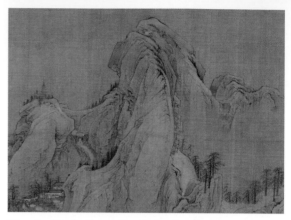

**Fig. 1  Technique for Painting Stones**
The steps involved in depicting the main stones in this painting are to first use lines in thick ink to outline the stone, then distinguish the veins in the same ink lines. Finally, small ax-cut texture strokes (i.e., short, broken, strokes shaped like the cut of an ax) are used to draw the contours of the landscape. Color is applied first with ochre as a base, then azurite blue and mineral green, according to the structure of the mountain. In this way, the color is light and even, and it does not cover the ink.

foot to the peak of the mountain. They are rigorously structured and properly laid out. The mountains are connected by bridges. There is a smooth path, with people walking leisurely along it. Pines grow on the slopes. In the distance, there are green peaks hidden

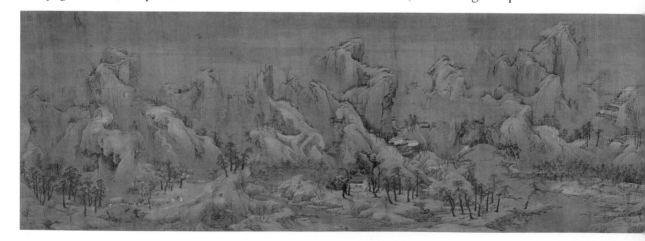

**Fig. 2 Unique Song Dynasty Technique for Painting Stone**

It is evident that the holes in these stones are shaped like a series of irregular bubbles. This technique for painting such stones was more common in the Song dynasty. For instance, in Song Emperor Huizong's painting *Xianglong Rockery*, the stones are depicted in this way.

**Zhao Boju**, a native of modern day Kaifeng, Henan Province, was a seventh-generation descendant of the Song Emperor Taizu Zhao Kuangyin. According to records of painting theories, because the state of Jin had conquered the north, the Northern Song imperial family fled south to Hangzhou, Zhejiang Province, establishing the Southern Song dynasty. Zhao Boju and his brother Zhao Bosu fled with the imperial family. The painted paper fans of Zhao Boju were greatly appreciated by Zhao Gou, the Song Emperor Gaozong (1107–1187, reigned 1127–1162), and he was later appointed to an official position. He excelled at depicting Taoist and Buddhist figures, landscapes, flowers and fruits, birds, buildings, and line painting, particularly blue and green landscapes. He took Tang dynasty painters Li Sixun and his son Li Zhaodao as masters from whom to study the blue and green landscape style. In his own work, he broke through the constraints of traditional Tang style blue and green landscapes, creating a blue and green style that sat comfortably between court and literati paintings, bringing about a renewal in the Southern Song art scene.

deep in the clouds, and mountains loom in the distance past the main peak.

The most magnificent, undulating peaks and trees, as well as the most sophisticated and exquisite buildings and people, appear in the center of the scroll. In this section, Taoist temples and monasteries, towers, pavilions, and a wooden corridor follow the rise and fall of the terrain, integrated into the natural scenery. The figures in the painting are accurate in shape and vividly presented. With careful attention to this section of the scroll, one can trace each step of their journey.

At the end of the scroll, the buildings on the hill, the wooden walkways on the mountain path and the groups traversing them, the creek flowing at the base of the mountain, and the scholars and monks gazing at the waterfall all contribute to this scene and its rich sense of secular life.

**Fig. 3 Technique for Painting Pines**

The shape of the pine trees in this painting is very detailed. Ink color is first used to outline the pine branches, making the posture evident. This is then combined with thin lines in a sparse fan shape, encircling the outer periphery of the pine needles, while the inside is painted with dark green as the foundation and then dyed with mineral green.

**Fig. 5**

**Fig. 6**

**Figs. 5–6   Buildings**

There are many buildings in the painting, including temples, cottages, covered bridges, and pavilions. One of the most unique is the covered corridor in fig. 5, which is built on a mountainside to allow people either to walk along it or to stop and rest there.

## A Title Rooted in the Season

The title of the painting, *Autumn Colors among Rivers and Mountains*, is recorded in the *Shiqu Treasure Book*. At that time, it was thus named because of the inscription at the end of the painting by Zhu Yuanzhang (1328–1398, reigned 1368–1398), the first emperor of the Ming dynasty. Born a civilian, Zhu Yuanzhang first made his living raising cattle. Later, he jointed a coup rebelling against the Yuan court. He was eventually named emperor, establishing Ming rule and becoming a legendary emperor in Chinese

**Fig. 7   A Gathering at a Pavilion amidst Pine Trees**

The pavilion amidst the pine trees, with a hall in front and pavilion in back, is rigorously depicted. The pine trees in front of the pavilion sway and dance, while the scholars and monks beneath the pines talk together in a gentle manner. On the right are the guests' horses and attendants, suggesting that the refined meeting is held as scheduled.

**Fig. 4   Taoist Imagery**

The Song dynasty royal family advocated the observance of Taoism. Besides receiving it as an inheritance from the Tang dynasty, it also served as a stabilizing force in the hearts of the people, forming a cultural confrontation with the Buddhism embraced by the northern tribes. For this reason, as one of the forms of court painting, the blue and green landscapes also expressed Taoist ideas, to varying degrees.

In Taoist culture, there is a doctrine of "earthly paradise" or "fairyland," referring to a special space where one could live as a recluse. It was a place inhabited by fairies and immortals, separate from the human world, but with entrances to it, mostly located in the mountains. Its essence was the renowned mountains for the meditation and self-improvement of the Taoist priests. The mountain range in *Autumn Colors among Rivers and Mountains* has the atmosphere of a blessed spot. There are also numerous buildings that serve as passages "directly to heaven and earth." Several figures at the foot of the mountain are making their way to these structures.

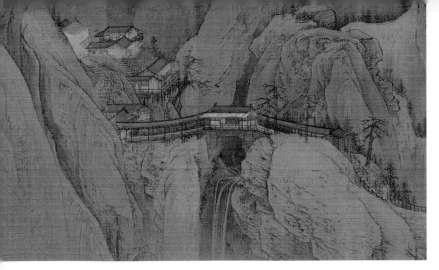

**Fig. 8  Covered Bridge**

There is a covered bridge in the painting, a bridge constructed with a roof, offering shelter from the rain and also a place for people to rest, gather, talk, and enjoy the scenery. Some of this sort of bridges even have rooms where people might stay temporarily. In the painting, the bridge spans two rocks. In the middle is a gallery, flanked by two wooden walkways. A variety of covered bridges can still be seen in southern Zhejiang and Fujian today.

history. Because he was not highly cultured and his writing was not good, it was rumored that many of his inscriptions were actually made by the prince. On this painting, the title *Autumn Colors among Rivers and Mountains* is followed by a record in the prince's handwriting, which seems to confirm the rumor.

Zhu Yuanzhang's inscription states that the painting is an autumn scene, which led to the mistake in naming the painting in the record of *Shiqu Treasure Book* in the Qing dynasty. In fact, there are many examples of peach blossoms and camellias growing beside the waters in the mountains. Peach blossoms are typical early spring plants, and the camellia is usually seen from the first lunar month until early spring, so the season depicted is evidently early spring. Further, the main boughs of the pine trees in the painting are painted with varying degrees of white powder, suggesting that there is still snow in the tops of the trees, further proving that it is late winter or early spring. Finally, there are numerous wild ducks in the distance. There is a Chinese verse saying "the duck is the first to plumb the spring river," adding weight to the idea that this is a spring landscape as wild ducks are frequently depicted in Chinese paintings as part of the spring scene.

**Figs. 9–11  Figures**

The figures that people this painting blend in with the scenery, making it an image full of humanity. As shown in fig. 11, at the edge of a deep pool, several scholars gaze at the waterfall, which flows down from the mountain in a perfect line. A pine grows in a downward direction from a crack in the rock immediately before the waterfall. On the water, a few people in a boat are admiring the waterfall.

Unlike other parts of the scene, in fig. 10, a group of travelers crosses the bridge. There are ten people in single file, driving donkeys or pulling carriages. Unlike the two groups in the previous image, in fig. 9, at the foot of the hill, a monk in a bamboo rain hat walks with the aid of a cane through a peach grove. His face is slightly turned, as if he is enjoying the flowers.

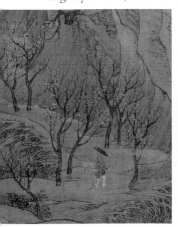

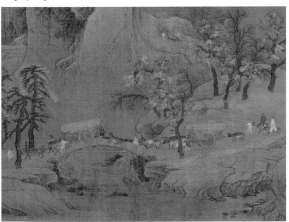

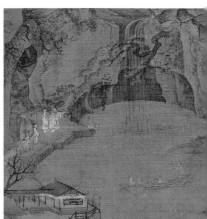

**Fig. 9**          **Fig. 10**                              **Fig. 11**

# AUTUMN COLORS ON THE QUE AND HUA MOUNTAINS

Zhao Mengfu
Ink and color on paper
Height 28.4 cm × Width 93.2 cm
Palace Museum, Taibei

*A*utumn Colors on the Que and Hua *Mountains* depicts the scenery of the Que, and Huafuzhu Mountains in the northern suburbs of Jinan, Shandong Province. It was not, however, painted during Zhao Mengfu's official service in Jinan, but in his hometown of Wuxing (today's Huzhou, Zhejiang Province).

This painting embodies the transformation seen in Zhao Mengfu's landscape painting. Though the painting style is similar to the small landscapes of Zhao Lingrang and Zhao Shilei (dates unknown), the mountain is put into the picture with a relatively simple

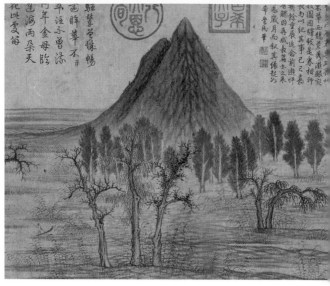

**Zhao Mengfu**, a native of Huzhou, Zhejiang Province, was the eleventh-generation descendant of the Song Emperor Taizu, Zhao Kuangyin. He achieved many great things in painting and calligraphy, and was a leading figure in the Yuan dynasty. He excelled at many types of subjects, which is rare in the history of Chinese art. As a representative figure of the literati painting style, he had a profound influence on later generations. In addition to painting and calligraphy, he was also proficient at poetry, music, antique appraisal, archeology, and other arts. He is aptly called the "crown of the Yuan dynasty" (i.e., the greatest figure of the Yuan dynasty).

**Fig. 1   The Huafuzhu Mountains**

The Huafuzhu Mountains were one of the eight scenic spots in Jinan, located north-east of Jinan City, south of the Yellow River, and north of the Xiaoqing River. The reason the Huafuzhu Mountains are famous is because they were the site of a battle in the Spring and Autumn period (770–476 BC). After the Han dynasty, flooding in the Yellow and Ji rivers formed a large lake. During the Tang and Song dynasties, the Huafuzhu and Que Mountains were surrounded by waterways. There were light, temperate, shallow creeks, swamps, and reeds, and these were surrounded by fishing villages and willows, like the landscape in Jiangnan. In the painting, the Huafuzhu Mountains are straight, and the peaks are painted with lotus leaf texture strokes.

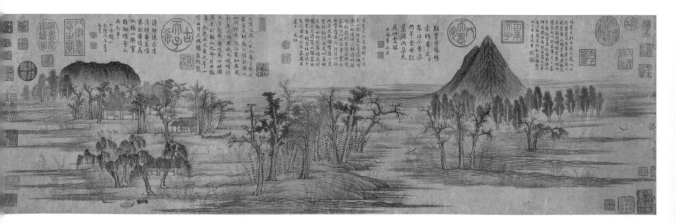

**Fig. 2   The Que Mountains**
The shape of the mountains to the left is like bread. It is named for the dense migration of birds that settle on the mountains each year in July and August. It is also said that a famous pre-Qin doctor Bian Que (407–310 BC) once practiced alchemy here, and that he was buried on the site, giving it its name.

aesthetic approach. There is no complex brushwork, with the mountain being painted only by coloring and sketching. The blues and greens of the Tang dynasty are abandoned, with the more elegant indigo providing the main color. The hills and trees are mostly indigo, while the other colors like ochre and cinnabar are used to decorate the buildings and trees. The overall combination is harmonious, creating a pleasing visual experience.

## Painting as a Means of Addressing a Friend's Homesickness

This picture depicts real locales in Jinan. So why was it painted in Zhao's hometown? The painter left a small inscription to address this question. He writes that the father of his friend, the Song dynasty writer Zhou Mi (1232–1298), is from Jinan, and he also happened to be an official in Jinan. When he returned to Huzhou after being dismissed from office, he talked of Jinan's landscapes. Of those, the Huafuzhu Mountains is the most famous, and there are records of it in *Commentary on the Spring and Autumn Annals (Zuo Zhuan)*. The image of the Huafuzhu Mountains is beautiful, and there are many

### Fig. 3   Trees on Hillock
From this painting, we see the influence of Dong Yuan and others on Zhao Mengfu. The sloping stone in the painting is drawn with hemp fiber texture strokes, with a clean brush and bright colors. The painting of the trees also inherits the traditions of earlier masters. The trunks are outlined by ink lines, and some of the leaves are drawn directly in color.

amazing scenes there. This prompted Zhao Mengfu to paint this image for Zhou Mi. To the east of the Huafuzhu Mountains is the Que Mountains, so he named the painting *Autumn Colors on the Que and Hua Mountains.*

A short line of words reveals the relationship between the painter and Zhou Mi, the painting's origin, the name of the painting, and the characteristics and position of the two "main characters" in it.

## The Distance between the Huafuzhu and Que Mountains

As Zhao Mengfu notes, the Que Mountains are to the east of the Huafuzhu Mountains. In the painting, the two mountains are in the same plane, separated by some flatlands and streams. The medium and near distance are a vast expanse of water, a small islet, mangrove reeds, and farmhouses. The trees are in red or green, with dry or wet boughs. A few farmers carry poles, nets, or walking sticks. Cattle, sheep, and scattered grass are also visible, creating a tranquil, pastoral feeling.

# DWELLING IN THE FUCHUN MOUNTAINS

Huang Gongwang (1269–1354)
Ink on paper

Remaining Mountains (referring to the small part at the beginning of Dwelling in the Fuchun Mountains): Height 31.8 cm × Width 51.4 cm, Zhejiang Provincial Museum

Dwelling in the Fuchun Mountains (The Scroll for Master Wuyong, referring to the second part of Dwelling in the Fuchun Mountains): Height 33 cm × Width 636.9 cm, Palace Museum, Taibei

*Dwelling in the Fuchun Mountains* is Huang Gongwang's most representative work. It depicts scenes of both banks of the Fuchun River, where Huang once lived. The Fuchun River is located in the central part of Zhejiang Province, today's Qiantang River, running from Meicheng Town, Jiande City to Wenjiayan of Xiaoshan District. It is known for its beautiful mountain scenery. This is one of the most significant works handed down in the history of Chinese painting, because it is not only of high artistic value, but also represents an exciting legendary life.

## The Scroll for Master Wuyong

Several versions of *Dwelling in the Fuchun Mountains* have been handed down. This, coupled with the copies (that is, putting a paper on top of the original and copying directly in ancient times) and imitations (that is, imitating the original exactly as it is, or roughly so, with the addition of the artists' own creation), make it difficult to determine which is the original. The most familiar scroll is *The Scroll for Master Wuyong* in the Palace Museum in Taibei. Huang Gongwang was a follower of the Quanzhen sect, and around the time of the seventh year of the Emperor Yuanshun's reign (1347), the 78-year-old Huang Gongwang and Chan Master Wuyong, the younger disciple of his teacher, traveled from Songjiang to the Fuchun River. Theirs was a deep, enduring friendship,

**Huang Gongwang**, a native of modern-day Changshu, Jiangsu Province, originally had the surname Lu, but was adopted by the Huang family in Pingyang County, Wenzhou City. He converted to the Quanzhen sect of Taoism, and for a period of time, he made his living by fortunetelling, often traveling among mountains, rivers, lakes, and seas so that he could absorb the essence of nature for his paintings. He often brought paper and brush with him, capturing the Yu Mountains (now Changshu City, Jiangsu Province), Sanmao (now Mao Lake in Songjiang, Shanghai), Jiufeng Mountain (now Jinhua, Zhejiang Province), the Fuchun River, and other natural scenes. He studied Dong Yuan, Ju Ran, and Li Cheng, calling himself "a young apprentice of the Studio of Pines in Snow." The Studio of Pines in Snow was Zhao Mengfu's studio, named after Zhao's alias "Pines in Snow," which suggested the influence of Zhao's personal teaching on Huang. His works are in ink and wash style and light ochre landscape style. His brushwork and ink play are simple and elegant, and his style, vigorous and high-spirited.

and Huang promised to paint a landscape, which he would present to Master Wuyong. It took three or four years to paint the scroll, demonstrating the great importance Huang placed on it. It was finally completed in 1350.

## Legendary Life

**Shen Zhou's imitation based on his memory of *The Scroll for Master Wuyong*.** In the Ming dynasty, *The Scroll for Master Wuyong* was collected by the great painter of the Wumen School, Shen Zhou (1427–1509). He was very fond of the piece, and not only applied his own calligraphy to it, but also asked others to add inscriptions. However, it was later stolen by the son of one of those who made an inscription and sold at a high price. Shen Zhou lacked the financial resources to buy it back, so could only bid the painting farewell. He copied the painting

from memory, and the general composition and temperament of his painting are very close to the original, showing how meticulous a painter Shen Zhou was.

**Dividing the painting into two sections**. After it was stolen, *Dwelling in the Fuchun Mountains* came into Dong Qichang's hands. He sold the painting to a collector in Yixing, Wu Zhiju (dates unknown). Wu left the painting to his third son, Wu Wenqing (dates unknown), upon his death. Wu Wenqing loved the painting very much, practically becoming obsessed with it. His fondness for the painting led him to toss it into the brazier as he himself was dying. His nephew, Wu Ziwen (dates unknown), had the presence of mind to quickly rescue the painting, but not before it had been burned into two sections.

**Entry into the Qing palace**. The longer of the two sections that remained after the

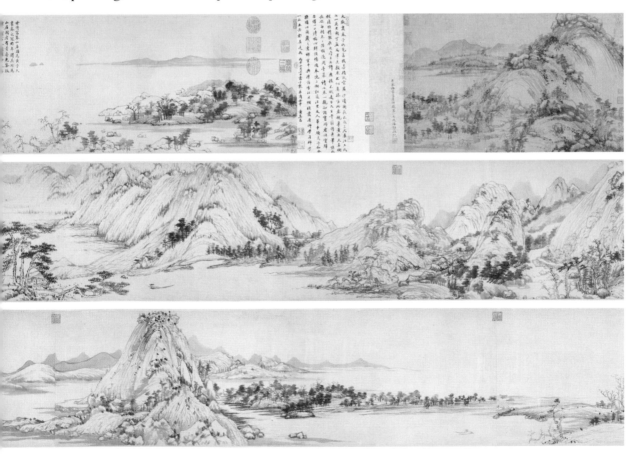

## Fig. 1 *The Remaining Mountains*

This part has been "unveiled" (i.e., the core painting has been removed from its old frame and reframed) numerous times, and as a result has long ago lost its original style. Upon careful observation, one can still find traces of the fire on the painting. Wu Hufan once did a meticulous study of the traces of the fire, and found that the first spot is slightly below the top of the mountain, the second one-third up on the far left side of the distant mountain, and the third on the leftmost portion (i.e., the seal) of the painting.

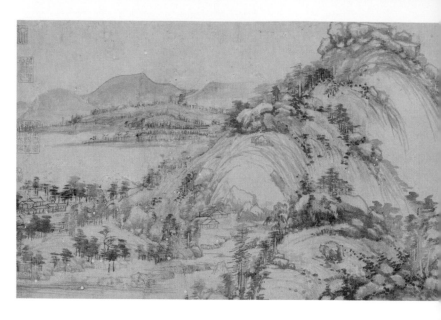

burning was taken into the Qing palace. At the time, there was another scroll by the same name in the imperial collection, which was also often called the "Ziming Scroll." The Emperor Qianlong was very fond of this scroll, adding many inscriptions and imperial seals to it. However, when *The Scroll for Master Wuyong*—which many considered to be more authentic—entered the imperial collection, it remained undervalued by the emperor. This led later generations to look at Qianlong's appreciation of art with something of a critical eye.

**Rediscovering** *The Remaining Mountains*. After being resold several times, the shorter section of the scroll was later named by a Qing dynasty dealer in paintings and calligraphies, Wu Qizhen (dates unknown), *The Remaining Mountains*. There are no more records of this painting changing hands until 1938, when a Shanghai art and calligraphy dealer showed the collector, Wu Hufan (1894–1968) a painting, and the latter immediately recognized, from the traces of the fire and the numerous inscriptions, it as

## Fig. 2 **Long Hemp Fiber Texture Strokes**

Based on the work of Dong Yuan and Ju Ran, Huang Gongwang developed the long hemp fiber texture strokes. This type of stroke is a long stroke painted with shading (that is, drawing the line while shading it). It is particularly suited to painting the mountains of Jiangnan, which are relatively flat and thickly forested.

## Fig. 3 **Lotus Leaf Texture Strokes**

When Huang Gongwang painted the rocks, he did not blindly apply texture strokes, but made some alterations based on the real appearance of the object. For instance, he painted some of the tall mountains with the long hemp fiber texture strokes, while he used lotus leaf texture strokes for some of the lower hills.

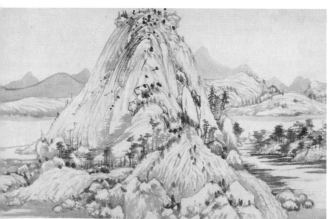

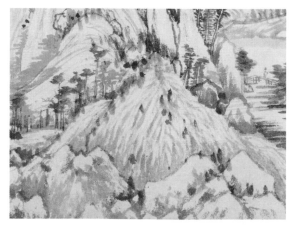

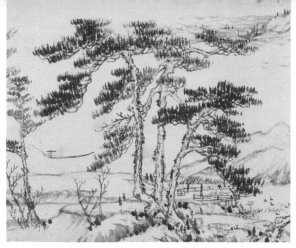

**Figs. 4–5  Technique for Painting Trees**

The trees are painted simply or more complexly. Some of the masson pines are depicted in some detail, apparently utilizing Li Cheng's style of brushwork. Other smaller trees on the stones are painted very simply, using only a few strokes.

**Fig. 6  Fisherman**

Like other Yuan dynasty painters, Huang Gongwang is drawn to the image of the fisherman. In *Dwelling in the Fuchun Mountains*, a fisherman sits on a boat, wearing a hat. Surrounded by the mountains, he looks especially small, appearing quite isolated and independent on the calm lake. This is probably representative of Huang's image of himself.

the shorter section of the painting that had disappeared for so many years. Well aware of its value, he exchanged it for a bronze tripod from the Shang-Zhou period. From that time on, *The Remaining Mountains* reappeared on the scene.

**Final home.** After Wu Hufan, *The Remaining Mountains* found its way to the Zhejiang Provincial Museum, where it became the facility's greatest treasure. The other section went to the Palace Museum in Taibei, along with a large collection of artifacts from the Forbidden City. In 2011, the two paintings were finally exhibited together at the Palace Museum in Taibei, the first time they had been reunited after more than 360 years of separation.

## Artistic Style

*Dwelling in the Fuchun Mountains* brings

the principle of "bringing calligraphy into painting," so much admired by the literati, to its most extreme expression. This sort of idea was highly praised by Zhao Mengfu, Huang Gongwang's teacher. The concept of this style of art is to paint with calligraphic strokes. The sweeping approach of calligraphy generates great coherence in the movements, richness of lines, and variation in ink color. Calligraphy in painting does not aim at similarity in image, but is a means of paying greater attention to the spirit of the object. For this reason, though Huang was firmly rooted in sketching, his paintings are not as sculpted as Song dynasty works, but are more expressive of a natural artistic conception. This is one of the main characteristics of Yuan dynasty painting. Further, Huang used light ink with subtle touch, giving *Dwelling in the Fuchun Mountains* a vague, aloof feel.

# FISHING IN DONGTING

Wu Zhen
Ink on paper
Height 146.4 cm × Width 58.6 cm
Palace Museum, Taibei

*F*ishing in Dongting was painted when
Wu Zhen was sixty-two years old. It
depicts Dongting Lake and the surrounding
mountains, located to the east of Jiaxing,
Zhejiang Province. The painting depicts a
lush autumn scene with strong pines. A boat
floats like a leaf on the surface of the water.

## Fishing

The extant works of Wu Zhen are mostly
themes related to fishing and fishermen. In
Chinese paintings, there are two types of
fishermen. The first is in the act of fishing,
depicting real life, or perhaps to show the
suffering of the people at the lower levels of
society. The other depicts someone dressed in
literati robes, sitting in the bow of a small boat
as he fishes. The intent of this sort of fisherman
is to depict the painter's spiritual sustenance.

For Wu Zhen and other members of the
literati class during the Yuan dynasty, the
environment in those days was not conducive
to scholars expressing any sort of political
ambitions. The current rulers suppressed
all of society, and according to the social

**Wu Zhen**, a native of today's Jiaxing, Zhejiang
Province, was multi-talented. Espousing a life of
purity, he lived in seclusion. In his early years, he
made his living as a fortuneteller, mostly socializing
with scholars or monks. He rarely communicated
with officials or rulers, and he spent most of his life
in poverty. In his capacity as a painter, he excelled at
landscapes, plum blossoms, bamboo and images of
plants and rocks. He was greatly influenced by the
landscape masters Dong Yuan and Ju Ran, and by
bamboo artist Wen Tong. Wu Zhen had a great impact
on the later generations as well. He was crowned as
one of the Four Masters of the Yuan Dynasty, the
other three being Huang Gongwang, Wang Meng
(1301 or 1308–1385), and Ni Zan (1301–1374).

### Fig. 1  Painting with a Wet Brush

The shape of the stones is painted with long hemp fiber texture strokes, beginning with the rocks on the peak of the mountain, using the *fantou* technique, then drawing downward dotting (i.e., using a brush to make straight, horizontal, round, pointed, or other shaped dots to show moss and weeds on the stones, slopes, branches, or roots of the trees) in thick ink. The painter makes full use of ink and wash techniques, demonstrating not only the characteristics of southern landscapes, but also the vitality of the plant life.

hierarchy of the day, Confucian scholars were of lower status than one in shackles. For this reason, Yuan dynasty scholars began to retreat to the mountains and forests in a quest for immortality. Of the Four Masters of the Yuan Dynasty, both Wu Zhen and Huang Gongwang made their living as fortunetellers.

Those Yuan dynasty scholars who harbored ambitions but had no outlet for them were naturally quite depressed. They tended to conceal these sentiments under the cover of literature, painting, and calligraphy. These scholars lived solitary lives detached from the world, and fishermen became an embodiment of the feelings of these hermits.

## Painting Style

Wu Zhen's paintings of the fisherman come in many forms, including vertical scrolls, hand scrolls, and small pictures, but in each one, there is a fisherman in a leaf-like boat. In *Fishing in Dongting*, the blank space in the center indicates the waters of Dongting Lake. In the upper right corner of the painting, a figure sits in the bow of the boat, while the stern reaches to the edge of the picture, as if the vessel has just entered the scene from somewhere outside the scope of the painting. The mountain at the top of the painting and the tall pines beneath it are in contrast to the boat.

From the method used to paint the stones,

it is evident that Wu Zhen draws directly on the styles of Dong Yuan and Ju Ran. His rocks are painted in the long, snaky hemp fiber texture strokes often used by Dong and Ju, and the rocks on the top of the mountains are depicted using the *fantou* technique, a trick often used in the painting of mountains by Ju Ran. The difference in Wu Zhen's work is that he paints with a wet brush. The painting seems to reflect the characteristics of Jiangnan landscapes.

However, Wu Zhen also did not fully integrate the works of Dong Yuan and Ju Ran. The bare roots of the pines in the lower part of the painting, the straight trunks, the pine bark with their fish-scale-like covering, and the meticulous, intentional branches seem to indicate the influences of painters such as those in the school led by Li Cheng and Guo Xi. It is evident that Wu Zhen is not a painter governed by a particular master or style, but rather combines a variety of painting methods.

### Fig. 2  Trees

Compared to the rocks in the upper part of the painting, the trees in the lower part are much more detailed, with the leaves of the two pine trees in front fanning out. Behind the pine trees is a curved cypress tree with leaves painted using thick ink dots.

# SIX GENTLEMEN

Ni Zan
Ink on paper
Height 61.9 cm × Width 33.3 cm
Shanghai Museum

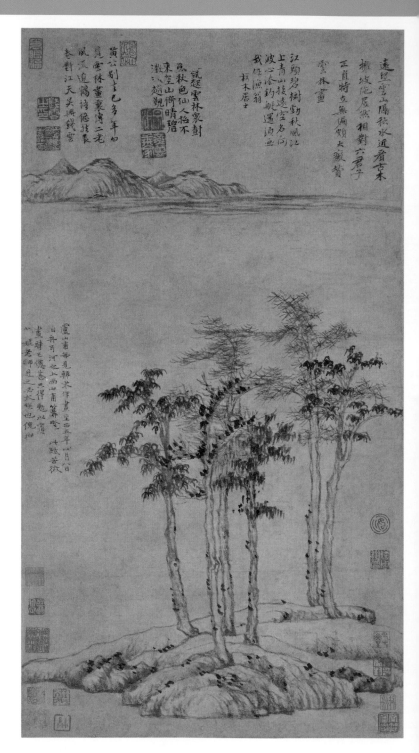

*Six Gentlemen* adopts Ni Zan's typical three-stage composition method. The distant view is of a mountain range, the middle view is the waters of a lake, and the near view is a hillock with trees.

## Ni Zan's Style

This painting is a masterpiece of Ni Zan's style. Its composition includes a three-stage method. The distant view, depicting a mountain range, occupies a small portion of the painting. The middle scene uses blank space to depict water, increasing the depth of the image. In the foreground, six trees occupy a stone, or a small hillock, which is drawn with fold texture strokes, a painting method typical of the Ni Zan style.

## Six Gentlemen

The six trees painted in the foreground convey a sense of great strength. The trees represented here are the pine, cypress, camphor tree, mahogany (*nan*), Chinese scholar tree, and elm, each having its own symbolic significance. The pine branches are proud and the cypress solemn, while the camphor tree stands for good luck, the mahogany for nobility, the Chinese scholar tree for

**Fig. 1  Fold Texture Strokes**

In the painting, Ni employs fold texture strokes to draw the stones. These strokes are created by rubbing the ink onto the paper to create the sides of the rock like belts in reverse. This technique helps to depict the cracks and creases in a rock.

**Fig. 2  Trees**

The trees in the painting are straight and upright, reflecting the character of a gentleman. The leaves are drawn by outlining the shape or dotting the leaves, thick in front and lighter in the back, creating a sense of depth.

academic achievement, and the elm for abundance. Using natural scenery to depict human virtues is a key characteristic of literati painting. Painting these six gentlemen may have been a means of expressing the artist's pursuit of the virtues they represent.

The title *Six Gentlemen* is derived from the poetic inscriptions Huang Gongwang gave to the painting. There are five inscriptions on the painting, one of which is Ni Zan's own. In Ni's inscription, he explains his motivations for creating this work, and offers along with this explanation a self-effacing note, stating that Huang Gongwang would laugh upon seeing the painting. Huang later saw the painting, but he did not laugh at Ni. Rather, he praised the work, saying that the six gentlemen were upright, independent, and impartial.

**Ni Zan**, a native of today's Wuxi, Jiangsu Province, learned much from the ancients, and his family was a well-known wealthy family household in the region. However, Ni Zan himself was not interested in the management of the family business, and he often referred to himself as "lazy." He was very particular about cleanliness. It was said that he bathed and dressed several times a day, and that he had all the clothes he wore brushed frequently and vigorously. The rockeries in his courtyard were spotless, and even the Chinese parasol tree was cleaned daily. From Ni Zan's paintings, the artist's pursuit of simplicity and clarity is readily evident. His landscapes are minimalist, often including sparsely sloping shores, shallow waters and steep cliffs in the distance. The seemingly casual and effortless brushstrokes are full of personality. In Chinese art history, Ni Zan is remembered as one of the Four Masters of the Yuan Dynasty, alongside Huang Gongwang. Wu Zhen, and Wang Meng.

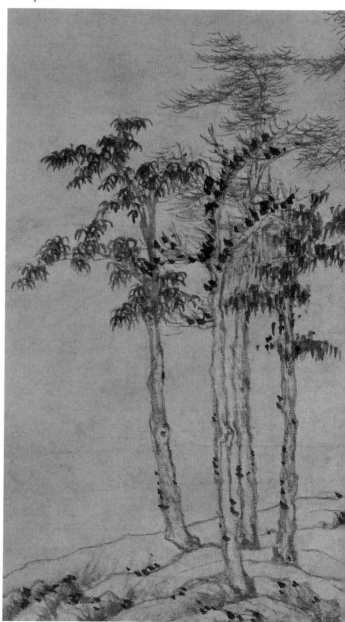

# DWELLING IN THE QINGBIAN MOUNTAINS

Wang Meng
Ink on paper
Height 141 cm × Width 42.2 cm
Shanghai Museum

*Dwelling in the Qingbian Mountains* depicts the imposing character of Mount Bian (Qingbian Mountains) and the quiet atmosphere of the mountains and forests. The technique displayed in the painting is rich and varied, and it embodies Wang Meng's artistic style. Dong Qichang praised the work, calling it Wang Meng's most significant piece.

## Retreat in Mount Bian

Mount Bian depicted in the painting is the main peak in Huzhou, Wang Meng's hometown, located nine kilometers northwest of Huzhou on the southern bank of Lake Taihu. When Dong Qichang once sailed through the area, he sighed and noted that only Wang Meng was capable of depicting this mountain.

A village sits behind the rock on the left side of the screen, perhaps the site of the scholar's retreat. Seclusion is a common theme in Chinese culture. Confucian teaching holds that seclusion is the basic means of maintaining one's moral integrity, avoiding only the unethical world of politics, while not evading human society. Taoist teaching holds

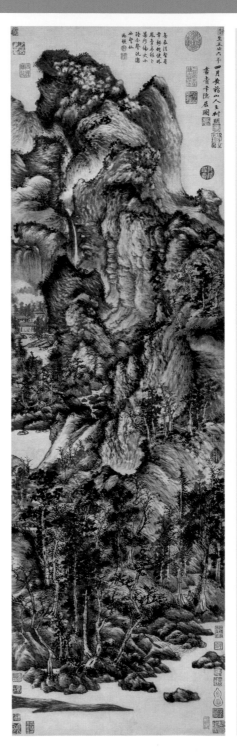

**Wang Meng**, also known as Shuming, was a native of Huzhou, Zhejiang Province. He grew up in painting circles. His maternal grandfather was Zhao Mengfu, and his maternal grandmother was Guan Daosheng (1262–1319), who was also proficient in calligraphy and in painting orchids and bamboos. Zhao Mengfu's son, Zhao Yong (1289–1369), and grandson, Zhao Lin (dates unknown), were both important painters. This family environment had a great impact on Wang Meng. His landscape style was inherited from his grandfather, Zhao Mengfu, which was in turn learned from Dong Yuan and Ju Ran. Wang Meng had originally entered official life, but in the late years of the Yuan dynasty, he retreated to Huanghe Mountain, near Hangzhou, and so was often called the "Huanghe Mountain hermit." In the early years of the Ming dynasty, he was once again made an official, but was soon implicated in a rebellion led by the prime minister Hu Weiyong (d. 1380), for which he was arrested and imprisoned until his death. Wang Meng's hard life made him a great artist. The rich layers, rigorous composition, and fine detailing in his work have become a model for later generations to imitate, making Wang Meng one of the Four Great Masters of the Yuan Dynasty.

## Fig. 1 Techniques for Painting Stones

It is rare to find a painting that makes use of so many techniques of texture strokes. Wang Meng uses "untied rope" texture strokes (a deviation from the usual hemp fiber texture strokes, in which a densely curved brush creates a stroke more like an untied rope, giving the technique its name), hemp fiber texture strokes, ox hair texture strokes (in which the brush is used in a circular stroke in four directions, to create a line as thin as an ox's hair), rolling clouds texture strokes, and others to paint the rocks in this work. He also uses ink smudging, light ink dyeing, and layering to add depth and make the ink distinct. At the tops of the rocks, dotting is employed with a series of touches of the brush.

## Fig. 2 Technique for Painting Trees

The trees in this painting are seemingly rushed, with leaves drawn in lines then filled in with ink or rubbings. It seems as if there is no set method, yet it creates the impression of an endless span of trees.

that seclusion can protect human nature. As a result, ancient scholars often depicted seclusion in their poetry, calligraphy and painting. Wang Meng painted numerous scenes of retreats in his lifetime. It is possible that his own rebellion against officialdom intensified his desire for a secluded life.

## Wang Meng's Masterpiece

Wang Meng was also known as Shuming, following the traditional practice in China of artists being known by one or several aliases. Dong Qichang called this painting "The chief of Shuming's works in this world," or, in other words, Wang Meng's masterpiece. It is indeed true, and the painting is still greatly admired by both painters and art connoisseurs. This painting adopts the "deep distance" composition method. Layers of hills and trees densely cover the canvas, filling the entire picture. It first appears that there are no gaps, but on closer inspection, one finds that while the structure of the hills is tight and full, some blank space remains. Streams, pools of water, clouds, and other similar features have set aside "breathing space" for the painting, demonstrating the great artistic sensibilities of the painter.

# LOFTY LU MOUNTAINS

Shen Zhou
Ink and color on paper
Height 193.8 cm × Width 98.1 cm
Palace Museum, Taibei

*Lofty Lu Mountains* is typical of the "subtle Shen Zhou" style. This painting was created for Shen Zhou's 70-year-old teacher Chen Kuan (dates unknown) when Shen was 41 years old. Its composition is rigorous and meticulous.

## Leading Figure in the Wumen School

The Wumen School was one of the most influential movements in the Ming dynasty. "Wumen" is the former name of the modern-day city of Suzhou, in Jiangsu Province. Because of its economic prosperity during the Ming dynasty, Suzhou nurtured a group of literati painters. In that locale, these painters admired one another's work and learned

from each other, forming the school that flourished in the region, with Shen Zhou as one of its leading figures. Earlier painters in the Wumen School, including Du Qiong, Wang Fu (dates unknown), Shen Zhenji (dates unknown), and Liu Jue (1410–1472), among others, were closely tied to Shen Zhou, and they influenced him greatly. Shen

**Shen Zhou** was a native of today's Suzhou, in Jiangsu Province. His great-grandfather was a close associate of the Yuan dynasty painter Wang Meng, and his father, Shen Hengji (1409–1477), was a student of the early Wumen School painter Du Qiong (1396–1474). Shen Zhou never sat for the imperial exams, and throughout his life, he remained indifferent to fame and fortune, dedicating himself instead to scholarly pursuits, poetry, painting, and traveling. He was amicable and highly respected. Even rural farmers dared to approach him and ask for a painting. He was accomplished particularly in painting and excelled at landscapes and bird-and-flower paintings, and was proficient in figure paintings. His early landscapes are examples of the meticulous, delicate "subtle Shen Zhou" style, while his later works gradually shifted toward a thick, simple, "unrestrained Shen Zhou" approach. Shen Zhou was a true pioneer of the freehand literati style of bird-and-flower painting. He promoted new, expansive themes in the genre, extending the brush and ink techniques used in the form. This had an enduring influence on later generations.

**Fig. 1 Technique for Painting Stones**

**Fig. 1 Technique for Painting Stones**

From the technique used to paint the stones, it is evident that Shen Zhou followed the painting techniques of Wang Meng. Shen uses a variety of techniques in his depiction of rocks and stones. Here, short, thin ox hair texture strokes and "untied rope" texture strokes are used to create the dense faces of the rock. At the same time, he is not bound by this technique, but draws according to the changes in the shape of the rock. The use of hemp fiber texture strokes and other techniques gives a sense of ingenuity and variation.

was later the leader of the Four Masters of the Wumen School, and Wen Zhengming (1470–1559) was his student. Tang Yin (1470–1524) and Qiu Ying were both younger than Shen Zhou, who was already a renowned painter in the region when they were young. He was undoubtedly a great influence on their work.

## In Praise of Longevity

A Chinese idiom says that "tall mountains welcome nobility," literally meaning to lift one's head to look up at the mountains, which embody noble character or morality. Thus, this idiom expresses a sort of admiration or reverence for people of highly moral character.

Chen Kuan, Shen Zhou's teacher, was an especially prestigious figure in Suzhou at that time. When Chen was 70 years old, Shen painted *Lofty Lu Mountains* for him. In it, the towering mountain is surrounded by trees, and a waterfall flows down the cliff. A figure stands at the base of the waterfall, looking up at it. In this picture, Shen Zhou expresses his feelings for his teacher's great learning, using the images of the waterfall and the mountain.

In addition, in Chinese culture, there is often a connection between longevity and mountains. For instance, in wishing one long life, it is often said, "May you outlive Nanshan." In other words, it is wishing one a longevity equivalent to that of Zhongnanshan, the birthplace of Taoism. In Shen Zhou's painting, the way Lu Mountains towers into the sky is an expression of his wishes that his teacher will have a long life.

**Fig. 2 Techniques for Painting Trees**

The pines and cypresses in *Lofty Lu Mountains* are very detailed, the trunks of the trees straight, and the needles of each pine's branches carefully painted. The skills of the painter in depicting realistic details are on full display. When comparing the trees with those depicted in the "unrestrained Shen Zhou" approach, we can see two radically different styles.

# GATHERING AT THE ORCHID PAVILION

Wen Zhengming
Ink and color on gold paper
Height 24.2 cm × Width 60.1 cm
Palace Museum, Beijing

*G*athering at the Orchid Pavilion depicts the story of the Eastern Jin dynasty (317–420) calligrapher Wang Xizhi (321–379), his friend, the politician Xie An (320–385), and other figures gathering in the Orchid Pavilion.

## Gathering at the Orchid Pavilion

It was customary in ancient China to gather at the waters to swim on the third day of the third lunar month, as this was thought to ward off disasters. By the Jin dynasty, it had evolved into an opportunity for the literati to gather to sing, compose and recite poetry, and practice many other arts. The most famous of such gatherings in all of history is the gathering at the Orchid Pavilion.

The convener of this famed gathering was Wang Xizhi. In 353, Wang, Xie An, and 41 other people played the game of "floating goblets on meandering waters" (*liushang qushui*) beside the Orchid Pavilion, in Shanyin, Kuaiji County, today's Shaoxing, Zhejiang Province. The rules of this game were that the guests had to sit next to flowing waters, and

### Fig. 1   Figures

There are two groups of figures in the painting. In one, eight people sit beside a stream. Some sit in pairs, and some face the stream, apparently contemplating their works (see above). Another group of figures appears in the water pavilion at the top left side of the painting, seated around a stone table. One of these figures holds a piece of paper. Perhaps this is Wang Xizhi, reading *The Preface to the Orchid Pavilion Collection* to the other two people with him (see fig. 4). The figure is drawn with finer brushstrokes, followed by the dying of the garments and headwear in color.

a cup of wine was placed in the water. When the wine stopped in front of one of the guests, that person had to compose a poem. On that day, many poems were composed as they drank, and these verses were later gathered into *The Orchid Pavilion Collection*, and Wang Xizhi was invited to write a preface to the volume. *The Preface* is not only considered a brilliant piece of writing, but is also renowned for the charming, robust calligraphy in which Wang Xizhi wrote it, which later generations have since touted as "the world's greatest semi-cursive script in calligraphy."

**Fig. 2   Mountains and Stones**
This painting uses gold paper, which is quite unique. The surface of the paper is relatively smooth, so the lines are painted more fluidly. It is evident from the picture that the painter's control of the line with which he draws the mountain is exceptional, but because of the particularity of the paper, the color floats on the surface, achieving a fresh, elegant visual effect.

## Orchid Pavilion Theme

Wen Zhengming based *Gathering at the Orchid Pavilion* on *The Preface to the Orchid Pavilion Collection*. The scene in the painting corresponds to the preface, which records, "There are numerous mountains, a bamboo grove, and a clear stream. The waters flow in a winding path to the right and left of the pavilion. We use the flowing waters, seated next to their meandering path. Though no music plays, we drink wine and compose poems. This is enough to capture the depth of our feeling."

By the Ming dynasty, admiration of Wang Xizhi and the pursuit of Jin dynasty literati

**Wen Zhengming**, a native to today's Suzhou, Jiangsu Province, excelled in poetry, essays, painting, and calligraphy. Because he lived to an advanced age, he was very influential in his own times. He is called one of the Four Masters of the Wumen School, alongside Shen Zhou, Tang Yin, and Qiu Ying. In his painting, Wen Zhengming excelled at landscapes, orchids and bamboos, figures, and flowers, but he was particularly known for his landscapes. In his early years, he studied under Shen Zhou, then he later studied the paintings of the ancients. In the end, though, he became self-sufficient. His style of painting also varied greatly. His use of a thick brush for an entire painting came down from Shen Zhou, Wu Zhen, and others, and requires a brush wet with ink. His use of a fine brush follows Zhao Mengfu and Wang Meng, creating dense scenery with fine brushwork in blue and green colors.

**Fig. 3   Patches of Moss**
The patches of moss are mostly painted directly in ink. The dots of moss in this painting are quite distinctive, and they have been colored after the circles of ink were drawn.

ideals made the Orchid Pavilion a common theme. Wen Zhengming's *Gathering at the Orchid Pavilion* was painted in 1542, when he was 73 years old. In the painting, the mountains and trees were first outlined and then dyed, fine, rigorous brushwork applied. The wrinkles in the garments and the figures' faces are simple, and their outlines make it clear that they are of the literati class. The entire painting is bright and rich in colors, with blue and green as the dominant color, while light ochre is used to render the foot of the mountain, which is thick, elegant, and beautiful.

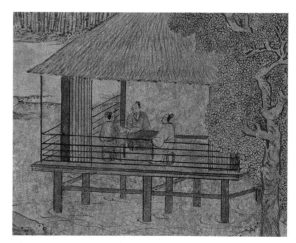

**Fig. 4   Water Pavilion**
The water pavilion was drawn with great care, as if with a ruler. By contrast, the thatched roof has been painted more casually. After filling the thatch with ochre, irregular ink lines were added. It is worth noting that, in order to fit with the theme, flowing water is also depicted. The current generated by the water's impact with the stilts that elevate the pavilion above the water have been drawn with numerous circles, creating the feel of rushing water.

# CONCUBINES OF THE KING OF SHU

Tang Yin
Ink and color on paper
Height 124.7 cm × Width 63.6 cm
Palace Museum, Beijing

*Concubines of the King of Shu* depicts a scene in the harem of Wang Yan (899–926), the last emperor of the Five Dynasties period state Former Shu (907–925). The singing, dancing palace girls in the picture are dressing up in preparation for the king's summons.

## Background of the Painting

Wang Yan was a king who indulged in excessive sexual pleasures. He entrusted his eunuchs with all political matters, while he busied himself only with drinking and other entertainments with the palace ladies and an assortment of hangers-on (i.e., those who accompanied royal figures for various entertainments). Not only that, but he also came up with very specific requirements for the women's adornment. He ordered the concubines in his harem to apply "drunk women makeup," and ordered them to wear golden lotus crowns and priestly costumes. When they were intoxicated, they took off their headpieces and smashed them to bits,

then applied red powder to their faces. This sort of drunken makeup came to be imitated throughout the country. Wang Yan, the Empress Dowager, and imperial concubine of a deceased emperor once toured Mount Qingcheng (situated in today's Chengdu, Sichuan Province). There, they stationed at the Shangqing Palace, where he ordered the palace attendants to draw cloud patterns on their clothing to create the illusion of distant fairies. The story of Wang Yan's indulgence has circulated down through the generations, not only as a show of scorn for this last king of Former Shu, but also as a reminder to the

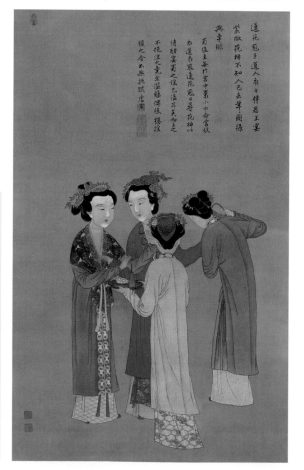

**Tang Yin**, a native of today's Suzhou, Jiangsu Province, was a gifted artist who was named among the Four Great Talents of Jiangnan, alongside Wen Zhengming, Zhu Zhishan (1460–1526), and Xu Zhenqing (1479–1511). In his early years, he was implicated for cheating in his imperial exams, costing him his career. As a result, he made his living by selling his paintings. His lifestyle was wild, but his paintings were meticulous. Following in the footsteps of the masters Li Tang and Liu Songnian, his brushwork and ink play are on display in a random arrangement, but with a clear, elegant style. The figures in his works are in traditional Tang dynasty style, with bright, elegant colors, beautiful poses, and accurate forms. His bird-and-flower paintings were influenced by Shen Zhou and other masters and he is skilled at the freehand ink and wash technique.

**Fig. 1**

**Fig. 2**

**Figs. 1–2 Lotus Crowns and Makeup**

The lotus crown worn by the women in the painting is a Taoist crown cap, named after the lotus flower because of its shape. The lotus crown in fig. 1 is simpler, while that in fig. 2 is decorated with an auspicious cloud and phoenix motif.

Wang Yan once wrote a poem describing a woman's face as having "willowy eyebrows and rosy cheeks." Here, the women's eyebrows are curved like willows and their faces are not sharp. The cheeks are slightly bulged, creating a rich, delicate feel.

**Fig. 3 Exquisite Garments**

The women's garments are very delicate and beautiful. The outer shawl is embroidered with cranes, and the petticoat has a harmonious diamond-shaped plaid pattern.

times for painting the pleats on clothing in which the line is straight, like a string) to present the sleek, smooth, flexible and textured dresses. The patterns on the dresses and crowns are depicted in an especially refined and meticulous way. The colors are clear, and there are strong contrasts between light and cool colors, while the ingenious transitions and matching of similar hues creates a palette that is generally rich and harmonious. The combination is elegant and graceful. The entire painting is characterized by elegance and impeccable taste.

current ruler. Tang Yin's purpose in using this theme was in line with this tradition.

## The Concubines

The four female entertainers in the painting are in line with what is known from historical records. They wear golden lotus crowns, dress in gowns with cloud pattern decorations, and have rouge on their cheeks, which is the image Wang Yan liked to see. Their bodies are well-proportioned, with narrow shoulders and thin backs, and their lips are rosy, their eyebrows arching, while their foreheads, noses, and chins are completely white. This painting makes the ladies look beautiful and delicate, and their faces appear three-dimensional.

*Concubines of the King of Shu* is a prime example of Tang Yin's meticulous or *gongbi* figure paintings with enriched colors. The painter has absorbed the stylistic characteristics of the Tang dynasty painters Zhang Xuan and Zhou Fang, as reflected in the style in which the ladies are drawn, and it is accented with aesthetic characteristics unique to the Ming dynasty. The brush and ink skills are an imitation of those of Du Jin (active in the 15th and early 16th centuries) in recent times, and those of Tang style in more distant times. The clothes are depicted using string outlining (a technique used by Chinese artists in ancient

**Fig. 4 Back View of the Woman**

In the painting, two figures have their backs facing the viewers. One holds a jug, which she tilts up to pour a beverage, and the other holds a lotus tray, turning to face the woman in green. Both of these women should hold a lower rank within the palace.

# FAIRYLAND OF PEACH BLOSSOMS

Qiu Ying
Ink and color on silk
Height 175 cm × Width 66.7 cm
Tianjin Museum

*Fairyland of Peach Blossoms* is based on Eastern Jin dynasty poet Tao Yuanming's (b. 365, 372, or 376; d. 427) *The Land at the End of the Peach Grove*, which depicts an idyllic scene of scholars' casual dialogue and playing musical instruments amid mountains and waters.

## The Land at the End of the Peach Grove

The text of *The Land at the End of the Peach Grove* describes a beautiful fairyland that is home to a life of peace, freedom, and equality. The land is flat and vast, with neat houses, fertile fields, beautiful ponds, mulberry trees, and bamboo forests. Roads crisscross the fields, the sounds of roosters and dogs are heard in the village, people work the fields, and the children live comfortable, enjoyable lives.

The freedom, tranquility, and peaceful paradise described in *The Land at the End of the Peach Grove* is similar to that in British writer Thomas More's (1478–1535) *Utopia*.

**Qiu Ying**, a native of Taicang, Jiangsu Province, later moved to Suzhou. Unlike the other three masters of the Wumen School, Qiu Ying was born in difficult circumstances. Early on, he made his living as a craftsman, painting buildings and mansions. Later, he studied painting, and through self-tutelage, he became a master, making a living by selling his paintings. Most of his inscriptions on his own paintings include only his name, with no other words. Few of his works are still extant. He excelled at painting figures, landscapes, buildings, and other objects. His painting style was delicate, exquisite, elegant, and colorful, particularly those imitating the blue and green landscape paintings of the Tang and Song masters and those of historical events.

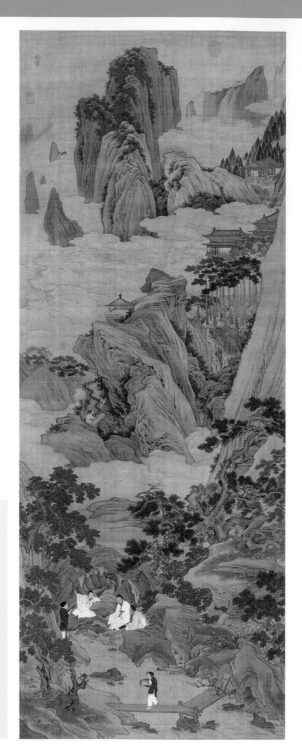

**Fig. 1   Technique for Painting Stones**
The color set mainly consists of blues and greens, so that less smudging is required for painting the rocks. Basically, the outline is drawn with an ink line, then it is filled with color. The shape of the mountains is hard and thin, made up of several blocks, with moss nestled between them.

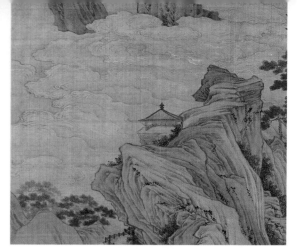

**Fig. 2   Clouds**
In the painting, the clouds are depicted more finely. Unlike other paintings, the outlines of the clouds are painted in thin lines, which are smooth and silky. The layer of clouds surrounding the scene creates the fairyland feel.

To the Western mind, the term "Utopia" immediately calls up scenes of an ideal society. The Peach Grove calls up similar ideas in Chinese culture. This type of beautiful society is what everyone desires. When the literati were dissatisfied with real-world society, they often sustained themselves on thoughts of the Peach Grove. This is why the Peach Grove is a common theme in Chinese poetry, painting, and calligraphy.

## Fairyland of Peach Grove

In the painting, the distant peaks are veiled by a large cloud, giving them an illusory quality, and the pavilion is half hidden in the clouds, just like a fairyland. Nearby, the pines slant

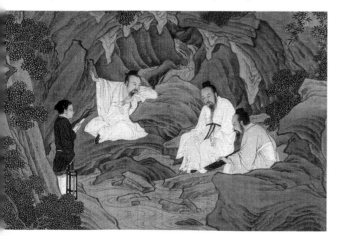

and twist, and ancient vines curl around them, hiding pink peach blossoms among them. It is an elegant scene. Three men in white sit by the river in a relaxed state. One person holds a *qin*, and another listens to him playing, while the third reclines against a rock, waving his arms as if intoxicated by the music. A boy carrying a basket stands unmoving beside them, apparently also listening to the music.

Another of Qiu Ying's paintings in the Museum of Fine Arts, Boston, entitled *Peach Grove*, seems to follow the text of *The Land at the End of the Peach Grove* quite closely. By contrast, this painting expresses the core meaning of the text, which is that of people living in a fairyland-like environment. They wear simple clothes as they sit on stone steps, unfettered by rules or trivialities. There is no suspicion between friends, and there is no distinction between master and servant, with people of all classes living in harmony.

**Fig. 3   Playing the *Qin***
One of the figures in the painting plays the *qin*, an instrument now called the *guqin*. The literati regarded the *guqin* in accompaniment to a scholar's singing as a symbol of elegance. In ancient times, because Boya played the *guqin* well and Zhong Ziqi had a great appreciation of its music, the story of the two becoming bosom friends led to the *guqin* becoming a sign of friendship.

# EIGHT SCENES IN AUTUMN

Dong Qichang
Ink and color on paper
Height 53.8 cm × Width 31.7 cm (each leaf)
Shanghai Museum

*Eight Scenes in Autumn* was painted in the autumn of 1620, when Dong was sixty-five years old. In that year, the Ming Emperor Shenzong (1563–1620, reigned 1572–1620) died and the Ming Emperor Guangzong (1582–1620) ascended the throne. Dong was re-instated to his official post, ending his life of retreat, but Guangzong died unexpectedly a month later. These political ups and downs are reflected in this painting.

## Eight Autumn Scenes

This album set depicts the autumn scenes Dong encountered on his voyage north. The journey took more than twenty days, passing through Songjiang, Suzhou, Zhenjiang, and other locales, each of which appeared as the theme of one leaf with an inscription. Through the inscriptions on the paintings, it is evident that these eight pictures are not only a record of the scenery along the way, but also a reflection of Dong's thoughts at the time.

In the first leaf is a hill with several buildings on it. A passenger boat sails before it, and there are two fishing boats in the distance. The mountains are linked. Dong inscribed a poem by Yuan dynasty painter Zhao Mengfu on this leaf. The poem speaks of the flow of the water's current, and the ancient leisurely appearance is well aligned with the painting. However, Zhao's poem is full of melancholy thoughts. Zhao compared himself to wild peach blossoms, believing that good things cannot last long, and that water only flows constantly eastward

**Dong Qichang**, a native of today's Songjiang District in Shanghai, became a minister of the Ming court by a rather rocky path. It is said that when he took the imperial exam at the age of seventeen, he excelled in his literary talents, but placed second to the competition because his calligraphy was slightly inferior. This event prompted Dong to put great effort into practicing his calligraphy. History does not remember Dong kindly. In 1616 his son's oppression of the villagers resulted in an incident known as the "public ravage of Dong's house" (i.e., the people indiscriminately burning down Dong's house). Despite this negative social association, Dong Qichang's status in Chinese art is undisputed. He proposed the Northern and Southern Schools in Chinese art theory, and in painting practice, he advocated the study of the ancients as teachers, while opposing a merely mechanical duplication of their work. His landscape paintings come in two main styles. One features ink or light ochre in coloring, while the other is tinted in blue and green.

under the bridge. This sense of loss and feeling of impermanence are consistent with the changes Dong experienced at that time.

In the second leaf are several trees, and the distant mountains are covered by clouds.

Through Dong's inscription, it is evident that this painting was taken from his viewing of the works of Song dynasty painter Mi Fu.

The third leaf depicts a pavilion under the shadow of an ancient tree. A mountain

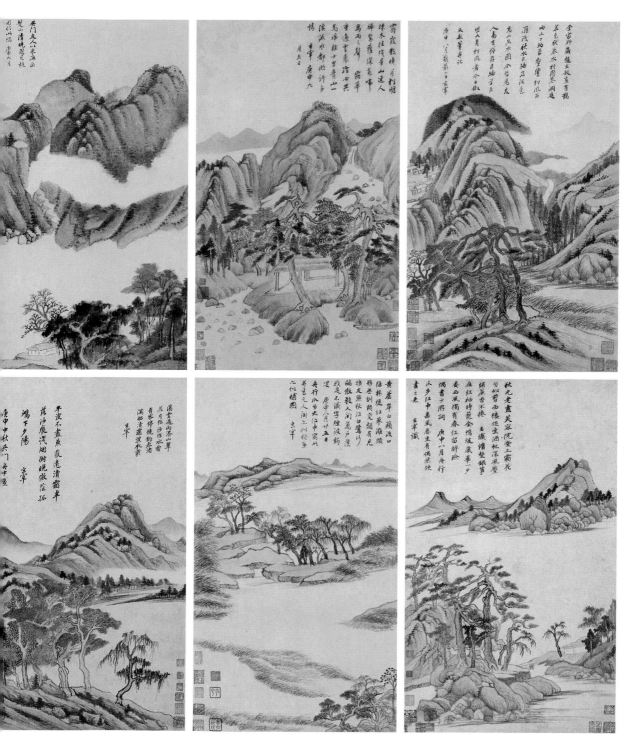

**Figs. 1–2  Imitating the Ancients**

In the inscription on the painting, Dong stated that it is an imitation of Mi Fu's *Early Morning in Mount Chu*. Though he says this, it is evident that there is a gap between this painting and the works more typical of Mi Fu and his son, though the clouds and mountains here are reminiscent of those. It can be said that Dong's work is a sort of "imitation," not completely copying the original, but with a measure of his own conception added.

stands behind the pavilion, and a waterfall runs down the slope. It is a depiction of the inscribed lines, "Ten *li* of green hills and a flowing brook, a landscape full of sentiment."

There are several curved trees on the hill in the foreground of the fourth leaf. The distant mountains are tall, and there is a village on the slopes. Clouds surround the mountains. Dong states that the image in this leaf is depicted by imitating the stroke of Zhao Mengfu.

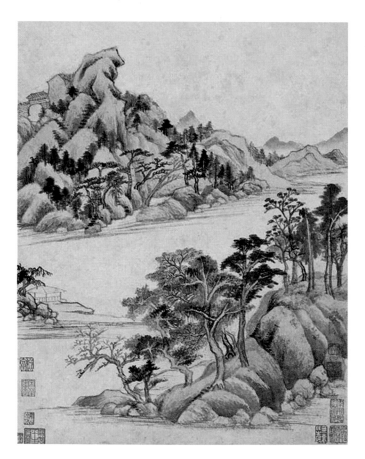

The fifth leaf depicts a boat's journey, with water flowing from right to left of the panel at a downward angle. There is a gazebo in the lower left corner, corresponding to the "long pavilion" mentioned in the poem.

In the sixth leaf, Dong uses a wet brush and ink to paint a scene of mountains and rivers after rain, most likely corresponding to the line in the poem.

The seventh leaf is particularly interesting. In it, Dong transcribes a *sanqu* of the Yuan dynasty (a fixed-

**Fig. 3  Unique Composition**

The composition of this painting is quite unique. Dong Qichang uses here a diagonal composition method. The objects in the lower left hand and upper right hand corners are small and sparsely scattered, while those in the upper left hand and lower right hand corners are tall and dense. This sort of composition is rare in traditional Chinese painting.

rhythm form of classical Chinese poetry), which speaks of golden reeds spreading over the river bank, white duckweed floating around the skiff, green willows on the riverbank, and red wild grasses on the bank. It is as if the painting strengthens the lines of the poem, and the poem strengthens the image of the painting. It is, though, the end of the poem that more fully reveals the meaning of the painting. "Though with no bosom friends around, there are innocent ones who never plot tricks or schemes. They are the gulls who hang freely over the river and the illiterate fishermen on the water's face, all alike despising officialdom." Dong uses this river scene to depict all that he has experienced.

The eighth leaf depicts a late autumn scene. The greenery has receded in this late autumn image, the leaves have fallen, and bare stone is visible. Faced with such an autumn scene, Dong Qichang penned the words of Song dynasty poet Qin Guan (1049–1100), which describe a woman of the Hibiscus Courtyard, whose beauty is fading. Only when she is drunk do her cheeks appear rosy, and only then can her past beauty be seen. Dong uses this to express the discouragement he feels at this stage of his political career.

## Northern and Southern Schools

Dong Qichang makes reference to Mi Fu in *Eight Scenes in Autumn*, taking him as one of the key representatives of his theory of the divide between the Northern and Southern Schools. Based on a large number of observations, Dong combed ancient paintings and proposed this theory, dividing all the major painters into Northern and Southern Schools. The Northern School

**Fig. 4  Scene after the Rain**

According to what we can discern from Dong's paintings, this scene seems to be of a mountain and stream after the rain. For instance, the mountains are not painted with texture strokes, but are directly dyed with color, and the leaves are not drawn in ink lines, but are painted directly in ink. The river banks are painted with just a few strokes in freehand, as if covered by water vapor.

was represented by the colored landscapes of Li Sixun and his son, while the Southern School was represented by Wang Wei. Dong himself advocated the Southern School. Because of his personal preference, Southern School painters Wang Wei, Zhang Zao, Jing Hao, Guan Tong, Dong Yuan, Ju Ran, Guo Zhongshu (d. 977), Mi Fu, Mi Youren (1074–1153), and the Four Masters of the Yuan Dynasty were highly valued by the Songjiang School represented by Dong Qichang. Representatives of the Songjiang School include Dong Qichang, Mo Shilong (1537–1587), Chen Jiru (1558–1639), and Cheng Jiasui (1565–1643), among others, as well as the Four Wangs of the Qing Dynasty (Wang Shimin, Wang Jian, Wang Yuanqi, and Wang Hui).

# EMERALD GREEN SOUTH MOUNTAIN

Wang Shimin
Ink and color on silk
Height 147.1 cm × Width 66.4 cm
Liaoning Provincial Museum

The landscape *Emerald Green South Mountain* was painted by Wang Shimin when he was eighty-one years old. The mountains tower, and the pines are beautiful. Nanshan (South Mountain) was commonly used in paintings to represent longevity.

## Dragon Vein

The painting's composition shows in the foreground a scene of a village and tall trees, and the distant view depicts a waterfall in high mountains, while the trends of the mountains are quite distinctive. The distribution of the trees on the slope fluctuate along an S-shaped pattern, extending from the foot of the mountain to the top. In Chinese landscape painting, such "dragon veins" have been depicted since ancient times. A "dragon vein" is closely related to *fengshui*, Chinese geomancy, which is intricately connected to human illness, death, and fortunes. "Dragon veins" came to be more prominently displayed in Chinese paintings during the Qing dynasty, eventually becoming a theory of its own in Chinese art.

## Imitating the Classics

Imitating the ancients such as Huang Gongwang and Wang Meng was one of the major characteristics of Wang Shimin and the Four Wangs in the Qing Dynasty, whom he represented. Under their weighty

**Wang Shimin**, a native of today's Taicang, Jiangsu Province, came from a line of high court officials, with both his father and grandfather having served in the Ming court. He was also promoted to high office in 1601, but later resigned, retiring from all official posts after the advent of the Qing dynasty. His painting methods looked back to those of Yuan dynasty painter Huang Gongwang, and he was also influenced by the teachings of the Ming dynasty master Dong Qichang. His paintings reflect older styles, and he shows some preference for using a dry brush to accumulate ink, creating a dark, heavy image with burning vitality.

衣夏寫南山圖奉祝

**Fig. 1  Learning from Huang Gongwang**

In his treatment of stone, Wang Shimin learned his vigorous brushstrokes from Huang Gongwang, with frequent use of *fantou* technique and casual, loose, elegant long hemp fiber texture strokes. In many places in this painting, there are rocky platforms, such as that shown in the lower right section of the painting. Such platforms are common in Huang Gongwang's work, and the shapes of the hills here is similar to those in Huang's landscapes. From such details, Wang's study of Huang's methods is evident.

advocacy, imitating the classics became one of the mainstream styles of the early Qing dynasty. Wang Shimin played a major role among painters of this style. He came from a wealthy family who owned numerous ancient paintings, and he had been immersed in this environment since childhood. His grandfather, Wang Xijue (1534–1611), asked Dong Qichang to teach Wang Shimin. Under Dong's tutelage, Wang Shimin imbibed even more deeply of the works of the ancients in the days of his youth. With this influence from Dong, Wang Shimin gradually developed his own theory, which included teachings such as the imitation of the ancients as the highest principle of painting, and that every tree, every stone, and every object could find its origin there. Of the Four Wangs, Wang Jian was also taught by Dong Qichang. Wang Hui was taught by Wang Jian, and Wang Yuanqi was Wang Shimin's grandson. It is evident that the relationship of the Four Wangs was very close, and that a sort of master-apprentice relationship in both painting and theory existed between them, making the elevation of their theory in the early Qing dynasty all the more natural.

**Fig. 2  Learning from Wang Meng**

Although the composition of *Emerald Green South Mountain* is a study of Huang Gongwang's compositional style, the trees are different from his. Huang's trees generally serve as a backdrop dotting the painting, while in *Emerald Green South Mountain*, the trees and moss are more dense, and painted with thick horizontal ink strokes. This method likely came from study of Wang Meng's paintings.

# FLOWERS ON THE RIVER

Zhu Da (1626–1705)
Ink on paper
Height 47 cm × Width 1292.5 cm
Tianjin Museum

*F*lowers on the River is a long ink and wash scroll painted by Bada Shanren in 1697. It depicts a cluster of blooms in a lotus pond. The lotus flowers are not isolated, but are accompanied by rockeries and weeds, with an orchid and bamboo embellishment. The entire scroll is a typical freehand bird-and-flower painting.

## Freehand Bird-and-Flower Paintings

This sort of freehand bird-and-flower painting was first officially unveiled after the Ming dynasty, but it quickly gained acceptance and esteem among painters. Freehand bird-and-flower painting is a different style from meticulous bird-and-flower work. As the name suggests, freehand bird-and-flower paintings are based mainly on depictions of the spirit of the object while meticulous bird-and-flower paintings pay more attention to verisimilitude to the actual object as presented in the image. For the painter, a freehand bird-and-flower painting is more straightforward, and through the cultural associations of the object presented, he pins

down his own emotions that may be hard to express.

In *Flowers on the River*, for instance, Bada Shanren depicts a group of lotus flowers. In Chinese culture, the lotus is rich in cultural connotations. Specifically, it is commonly noted that the lotus grows from the mud, but remains uncorrupted and unsullied. For this reason, the lotus is held in great esteem by the literati. The most famous verse in praise of the lotus says, "Rising from the mud, but unstained; it is cleaned in clear water, but is not seductively charming." It is clear that Bada Shanren painted the lotus to illustrate this concept. The rugged stones and weeds surrounding the lotus likely represent the environment in which the painter found himself.

**Zhu Da**, known more widely as Bada Shanren, was a descendant of the Ming dynasty royal family. After the fall of the Ming, he was in a desperate situation, leading him to retreat to a Taoist temple in Nanchang, where he became a monk. He excelled at both bird-and-flower and landscape paintings. His freehand bird-and-flowers are mainly ink and wash with exaggerated images, bold ink, and variations in the density of the ink. His landscapes are simple, well-structured and harmonious. He is called one of the Four Monks of the Qing Dynasty, alongside Shi Tao (1642–1708), Kun Can (1612–c. 1692), and Hong Ren (1610–1663, or 1664). This group of painters differs greatly from their contemporaries the Four Wangs, and they practiced a completely different painting style.

He uses this image as an expression of his desire to maintain a pure heart and not be tempted by the world around him.

**Fig. 1  Verisimilitude**

This is the most "real" part of the painting, and the most invigorating part. Bada Shanren paints the shape of the lotus leaf, gathering it in the center. A large cluster of leaves join to become one piece, and the color of the leaves are much thicker, while the leaves in the distance are depicted in lighter ink. Though the ink colors are layered, they are not complicated.

In this section, there is a blank space among the lotus leaves, and another in the outlined lotus flower. These blanks seem to be the "breathing aperture" of this painting, adding a lively atmosphere to the dense layout.

**Fig. 2  Virtuality**

An ink painting contains both the real and the imaginary. The rocks in the back section of this painting are just painted with the outlines. This is the most common technique in Chinese painting, called "taking the blank space as the painted." That is, though there is nothing in the picture, leaving a patch of white paper, it in fact allows the viewer space for unlimited imagination. This is a unique feature of Chinese painting, and it invites the viewer to bring her or his own experience into the interpretation of the work.

## Water and Ink

Because freehand bird-and-flower painting pays less attention to the form of the object in favor of pursuing its essence—or, to depict its spirit—the cooperation between brush and ink is extremely important. Because it is not deliberately shaped, there is no repeated shading and depiction, but it requires the painter to present beauty in the variation of each stroke. Taking *Flowers on the River* as an example, the painter does

**Fig. 3  Bringing Calligraphy into Painting**
Calligraphy's appearance in painting was a typical feature of literati painting. As early as the Yuan dynasty, Zhao Mengfu had already proposed "the common source of painting and calligraphy." Later, this was further evolved by the literati, and it was held that calligraphy strokes should be "written into" painting. This approach is evident in this painting, where the shape of the orchid is like a calligraphic stroke.

not depict any particular lotus but instead presents the lotus leaves in merely a few strokes and the lotus stalk in one stroke, with variation in each leaf. The pond in the back section of this painting is painted in a more freehand style, with the ink method, creating the image of layers of lotus leaves. Looking at the entire scroll, one can feel the natural transition from heavy to light ink and the richness in ink coloring, creating the admirable style for which Bada Shanren is known.

# FLOWER ALBUM

Yun Shouping
Ink and color on paper
Height 29.21 cm × Width 24 cm (each leaf)
Nelson-Atkins Museum of Art, Kansas City

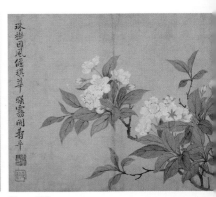

Of the six leafs of *Flower Album*, the first is *Peach Blossoms*, the second *Bamboo and Rocks*, the third *Pear Blossoms*, the fourth *Fava Bean Blossoms*, the fifth *Osmanthus*, and the sixth *Three Friends of Winter*. Each painting has a poem accompanying it. This combination of poetry and painting is a common trait in Yun Shouping's work.

## The Brilliance of the Flower Album

In the first leaf, Yun depicts a peach blossom in full bloom. It is a pink flower with double petals, delicately blossoming. It is a flower on a broken branch, and the image includes cut stems in the lower portion of the branch. In the front stems are several flower buds, and the young leaves that surround the flowers behind those are red. The peach blossom blooms in spring, so the artist inscribed the words "Wuling Spring Colors."

The second leaf depicts bamboo and stone. According to the inscribed poem, the weather-beaten stone in the image is placed on a haystack. After a thunderstorm, two bamboo stalks sprouted up behind the stone.

The third leaf is similar to the first. Only a single pear blossom is depicted, and the white

**Fig. 1**
**Coloring**
In the first leaf, *Peach Blossoms* is closer in coloring to the painting style of Yun Shouping's early years. The color is thick, bright, and beautiful, and the form is realistic and graceful.

blossom is in full bloom. The white flower looks like silver mist from a distance.

The fourth leaf is sketch work. The purple flower on the left is a fava bean blossom, and the red one on the right is a wildflower growing beside it.

The fifth leaf is a sweet-scented osmanthus tree, full of flowers. This painting was made when the painter was a guest in Wumen (today's Suzhou, Jiangsu Province) in imitation of a painting of the Yuan dynasty.

The final leaf is especially interesting. Ancient Chinese painters often depicted the "three friends of winter," which were the pine, bamboo, and plum blossom, but Yun Shouping chooses instead to paint three different plants, oleander, winter sweet, and heavenly bamboo, bringing a fresh view to the old image. Yun Shouping notes with some poignancy in the title that these three plants

**Peach Blossoms**

**Bamboo and Rocks**

**Pear Blossoms**

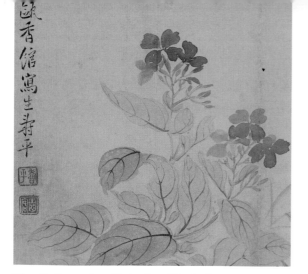

**Fig. 2  Boneless Painting Technique**

The boneless painting technique directly dyes with color, using no ink outline, and thus requires the painter to be especially skilled with water. This forms an elegant, delicate painting style with clear colors and graceful forms.

are devastated by wind and snow, but this does nothing to diminish their beauty.

## Boneless Painting Technique

This album uses Yun Shouping's unique boneless painting technique. In his writings about his theory of painting, Yun often mentions that his boneless technique was inherited from Northern Song dynasty painter Xu Chongsi. But because of the great amount of time that had passed, it is almost certain there were no genuine Xu paintings in the times when Yun lived. Most of his knowledge of Xu's technique, then, must have been attained from written records, and perhaps from other Song-Yuan bird-and-flower paintings still extant at the time. Thus, Yun Shouping's boneless painting technique

**Yun Shouping**, also called Nantian or, more often, Yun Nantian, was a native of modern day Changzhou, Jiangsu Province. He was born in a bureaucratic home in Changzhou, then fled with his father to Fujian Province during the turbulent years of the late Ming, early Qing dynasties, where he joined an anti-Qing faction. He was captured and made a slave, but was later adopted by Governor-General of Zhejiang and Fujian. When he went to Linyin Temple in Hangzhou to worship his ancestors, he was even reunited with his father. From that time, both father and son returned to their hometown, where Yun Shouping made his own living and supported his father by selling his paintings.

In his early years, he learned painting from his uncle Yun Xiang (1586–1655), and his landscape paintings were influenced by Yuan dynasty painters Huang Gongwang and Wang Meng. However, it was said that he felt his landscapes could not compare with those of his close friend Wang Hui. Because he was not willing to be second-rate in his work, he stopped painting landscapes altogether and started specializing in bird-and-flower paintings. He painted flowers, animals, plants, and insects using the boneless painting technique (that is, painting the objects directly in ink or color without outlining). He claimed that he had inherited the boneless painting technique from the Northern Song dynasty painter Xu Chongsi (dates unknown).

was based partly on his study and imitation of Song and Yuan bird-and-flower paintings, but it mostly grew from his own originality.

In his early years, Yun's bird-and-flower paintings were more intense, while his style gradually became lighter and clearer in his later years. His works are mainly based on sketching, and they are not limited to themes traditionally seen in Chinese painting. As a result, his influence on a number of scholars gradually led to the emergence of the Changzhou School in Chinese painting, with Yun as its leader. The most typical follower of his bird-and-flower style was his great great granddaughter Yun Bing (dates unknown).

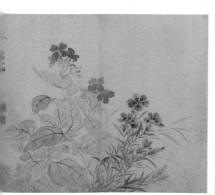

***Fava Bean Blossoms***

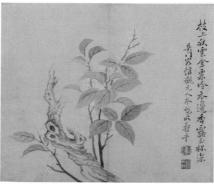

***Othmanthus***

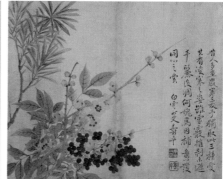

***Three Friends of Winter***

# Dates of the Chinese Dynasties

Xia Dynasty（夏）........................................................................2070–1600 BC
Shang Dynasty（商）.....................................................................1600–1046 BC
Zhou Dynasty（周）......................................................................1046–256 BC
    Western Zhou Dynasty（西周）.........................................1046–771 BC
    Eastern Zhou Dynasty（东周）.........................................770–256 BC
        Spring and Autumn Period（春秋）...........................770–476 BC
        Warring States Period（战国）....................................475–221 BC
Qin Dynasty（秦）.......................................................................221–206 BC
Han Dynasty（汉）......................................................................206 BC–AD 220
    Western Han Dynasty（西汉）.........................................206 BC–AD 25
    Eastern Han Dynasty（东汉）..........................................25–220
Three Kingdoms（三国）..............................................................220–280
    Wei（魏）.......................................................................220–265
    Shu Han（蜀）................................................................221–263
    Wu（吴）.......................................................................222–280
Jin Dynasty（晋）.......................................................................265–420
    Western Jin Dynasty（西晋）...........................................265–316
    Eastern Jin Dynasty（东晋）............................................317–420
Northern and Southern Dynasties（南北朝）.................................420–589
    Southern Dynasties（南朝）.............................................420–589
    Liang Dynasty（梁）.......................................................502–557
    Northern Dynasties（北朝）.............................................439–581
Sui Dynasty（隋）.......................................................................581–618
Tang Dynasty（唐）.....................................................................618–907
Five Dynasties and Ten Kingdoms（五代十国）.............................907–960
    Five Dynasties（五代）....................................................907–960
    Ten Kingdoms（十国）....................................................902–979
Song Dynasty（宋）.....................................................................960–1279
    Northern Song Dynasty（北宋）.......................................960–1127
    Southern Song Dynasty（南宋）.......................................1127–1279
Liao Dynasty（辽）......................................................................916–1125
Jin Dynasty（金）.......................................................................1115–1234
Xixia Dynasty (or Tangut)（西夏）...............................................1038–1227
Yuan Dynasty（元）.....................................................................1279–1368
Ming Dynasty（明）....................................................................1368–1644
Qing Dynasty（清）.....................................................................1644–1911

# Index